CTA:

Creative Talk in Asia　亞｜洲｜創｜意｜對｜話

| CTA 亞洲創意對話 |

是一本介紹亞洲地區不同領域但關於「創意」的刊物，
內容包含創意人及作品收錄，並精選亞洲創意活動與讀者分享。

CTA 試圖透過這樣的對話交流平台，提升亞洲設計活力，
並挖掘創意人作品背後動人的故事。

| Creative Talk in Asia |

CTA is an issue introducing various domains of creativities in Asia.
We collect creators and their works. Also, pick out special creative
activities for our readers.

CTA tries to promote the design energy in Asia and to discover
more touching stories behind the creators' works through such
exchanging platform.

序 Introduction

亞洲近幾年在經濟上的卓越成長，帶動了許多產業上的快速提升，而設計與創意的發展上這幾年更是有著相當豐厚的成果。

因此我們試圖透過「CTA 亞洲創意對話」這樣的媒體平台，將如此精彩的設計師想像的火花和對於創作的激情記錄下來，透過簡要的訪談形式，讓更多對於亞洲設計創意有興趣的讀者們，更加能夠深入瞭解作品背後設計師的用心，並分享如何在兼顧自我理想與商業現實考量中取得完美的平衡。

21 世紀的亞洲除了延續東方美學與傳統哲學觀的美好價值，相信新世代的設計師們更想藉著創作去演繹出獨有於這個時代的新設計語彙，在一個變化無比巨大且溝通快速更替的時代，設計師為大家留下來細膩地優雅地的人文哲思相信更加值得我們去好好品味。

CTA 也希望能夠替擁有無比潛力的亞洲市場盡一份綿薄之力，祝福大家 !!

As the distinguished growth of Asia's economic in recent years, many industries are upgraded quickly, also the development of design and creative industry has generous achievement in recent years.

So we launched CTA, and tried to record the designers' sparks of imagination and passions of creating through this media platform. By a form of brief interview, readers who are interesting in creativity can more understand the designers' intention behind the works. Besides, designers can share how they strike the perfect balance between the ideal and commercial.

In addition to last the value of East aesthetics and traditional philosophy in 21st century, we believe that designers of new generation expect their works can interpret an unique and new design language in this era. In an age of change and the communicative modes replace rapidly, is the designers leave delicate and graceful philosophizing, and we believe it deserve to be tasted by everyone.

CTA group hopes to do our bit for the Asia market with endless potential, best wishes!!

CTA 總編輯　Chief Editor

09
China

1983ASIA
Bentidea
Chen Huarong
David Hong
Guo dabu
Guo Yanlong
Guo Yu-long
Huo Wenjie
Jin Guizi
John Meng
LI Fojun
Lian Meng
Liu Bingying
Liu Juntao
Mitch Zhang
Mooz effie
Qin Bao Gang
Sha Feng
Shi Yuan-xin
Wang Hong
Wang Qiang
Wang Ruifeng
Wang Xiaoxue
Wen Li
Wu Xuandong
Xie Ruikang
Xu Limeng
Yadon Xiao
Zhang Hao

115
Hong Kong

Chu On Pong
Gavin Mokta
Jim Wong
Karman L' Ull
Paul Sin - A Thinking
Moment Design Studio
Toby Ng

139
Indonesia

Andriew Budiman
Sandy Karman

149
Japan

Yuma Harada
(UMA/design farm)

153
Macao

ieong chon man
LAM IEONG KUN
Mic Hoi-Gloss Design Ltd.

165
Malaysia

Keat Leong
LIE

175
Philippines

Inodoro™
Soleil Ignacio

185
Singapore

Black Mongrels
Winnie Wu

195
Thailand

Practical Design
Studio

201
Taiwan

Chang Pu-Hui
Chen Hsin-Yu
DESIGNER+ARTIST
Erica Su
Filter017
Jay Guan-Jie Peng
Jing group
Onion Design
Associates
Shen ZI-Huai
Tien-Min Liao
Wu Mu-Chang

China

中國

Creators

1983ASIA
Bentidea
Chen Huarong
David Hong
Guo dabu
Guo Yanlong
Guo Yu-long
Huo Wenjie
Jin Guizi
John Meng
LI Fojun
Lian Meng
Liu Bingying
Liu Juntao
Mitch Zhang
Mooz effie
Qin Bao Gang
Sha Feng
Shi Yuan-xin
Wang Hong
Wang Qiang
Wang Ruifeng
Wang Xiaoxue

Wen Li
Wu Xuandong
Xie Ruikang
Xu Limeng
Yadon Xiao
Zhang Hao

中國　CHINA

1983ASIA

1983ASIA.COM　　*the_1983@foxmail.com*

一切源於一個信念！

1983ASIA 由蘇素（中國天津）與楊松耀（馬來西亞）在中國深圳共同創立。多年主導項目的經驗，也成就了多個品牌和我們自己；但一次又一次的喜悅過後，留給我們的是無盡的沉思 ... 亞洲成長的我們所處的 " 實體世界 " 是一個基於西方文化為標準衡量的世界。我們自身的 " 亞洲身份 " 漸漸被變得模糊，同時也必須要重新學習如何和這個 " 世界 " 相處 文化的趨同讓我們感到 " 全球化與國際化 " 的缺憾。「亞洲傳統文化在西方的脈絡中有時候是羈絆」我們亦驚覺，只有尋根溯源方能解決內心的矛盾 . 基於自身的亞洲血統與設計師的身份，我們嘗試通過研究亞洲文化，打破觀念的界限，並用藝術設計展示我們的體驗與成果；把看不見的 " 文化 " 轉化成充滿亞洲魅力的視覺與產品，在現今 " 世界 " 中找尋丟失已久的喜悅與幸福。

It comes from a faith.

1983 ASIA is co-founded by Su Su (Tianjin, China) and YAO (Malaysia) in Shenzhen China. After years of experience of handling projects, we made several brands also achieve ourselves. However, after the joy come again and again, it left us endless thought. We grew up in Asia which was measured by western culture. In this case, the identity of Asian is getting vague. We used to let the treasure of us go, but we have to learn how to reunite the world. The cultural convergence left us regret for globalization and internationalization."Sometimes, traditional Asian culture is a fetter of western."We are inspired astonishingly that only tracing to the source can solve the inner contradiction. Based on Asian and designer, we tried to break the bound of concepts and used a rt design to show our experience and achievement through studying Asian culture. Turning invisible culture into glamorous Asian visual product is the lost-for-long happiness that we reach for in the world.

The Happy 8 是馬來西亞一家高品質、結合馬式南洋文化與藝術的連鎖民宿品牌。設計靈感源於當地鮮豔的色彩體系、神秘的民族符號、共融的多元文化；以獨特的方式進行民族文化的重新演譯，並結合地方民宿的魅力所在，在統一的品牌體系下塑造豐富多彩的變化性。碰撞出一份驚心動魄的南洋藝術魅力。「滿心歡喜，相敬共融」讓我們拋下冰冷的都市寂寞，去享受一場熱情盛意的文化藝術之旅吧！

The Happy 8 is a high-quality chain hotels brand of Malaysia. The brand is enlightened from the combination of Nanyang culture and art. Design inspired by vibrant colors in the local system, mysterious national symbols as well as inclusive multicultural. It re-interpreted national culture in an unique way, combined with the advantage of the other local hotels. The brand identity system has achieved a very strong coherent brand experience while giving uniqueness to every touch-points. Customers can experience a fabulous Nanyang culture and art. The hearts filled with joy, mutual respect and culture mixture. Let's leave the inhospitality and loneliness of urban, to enjoy a cultural and artistic journey with passion.

火眼金睛　MONKEY KING ｜ 2012
活——隨遇而安　LIFE ｜ 2012

1　2

1/ 西遊記是中國最具代表性的神話故事；猴王已然化身成為中華文化中勇敢與智慧的象徵；而猴王被關煉丹爐七七四十九天獲得火眼金睛更是為人津津樂道的情節。創作糅合亞洲各國（中國、印度、泰國）對猴王的描述，提倡原創繪畫與設計結合，向傳統文化發出邀請，探索融合設計與地域的和諧與衝突；並借此隱喻美好的結果皆需堅韌不已的修練。

"Pilgrimage to the West" is the most typical fairy tale of China.
The monkey king has turned to be a symbol representing bravery and wisdom of Chinese.
It is a very legendary speaking story that the monkey king was locked inside the Danlu for 49 days which left him a pair of bright eyes.
Combined the description of the monkey king of China, India and Thailand, we recommend to mix traditional drawing and modern design up. We want to explore how to combine design with the harmony and conflict of regions. In this case, we try to let people understand that beautiful ending requires tough practice.

2/ 創作希望立足於當下，以中華傳統文化為基礎，通過戲劇性的手法製造意識上的衝突，用漢字「活」為中心進行設計探討與精神反思。
年輕是一種心境；保持初心、忠於本我、活得自在，亦是一種勇氣。何不捉緊當下，嬉戲設計，暢想生活。

Based on present moment and Chinese traditional culture, used dramatic way to make confliction of consciousness, we wish that our design can take "life" in Chinese as the center to discuss and reflect.
Young is a frame of mind. Keep the original intention and be loyal to yourself ,live comfortably is another kind of bravery.
Why don't you grasp time right now design what you want like you are playing a game and expect your future life.

■ 請問您對於「創作」所擁抱的理念是什麼？從以前到現在，是否有所轉變？

在創作的歷程中，我們一直抱著開放的的態度並保持學習的心去接觸不同的新鮮事物。從開始至今依然如此，唯一不同的是，隨著身份的轉變，我們感覺設計師應該承擔更多的社會責任。

■ 請問您認為該國最棒的是什麼？（如國家的特色或文化等）您的創作是否受其影響？

我們分別來自中國與馬來西亞，我們常以「亞洲」的身份去看待自己。
我們認為隨著時代的變化而相互影響交融的文化碰撞，所產生的「新」事物是非常有意思的！
這些影響開始是無意識的，潛移默化的；隨著年齡與角色的變化，我們非常享受並樂於去分享這種感受。

■ 請問您一路以來的創作歷程（與創意／藝術／設計／插畫的邂逅，踏上這條創作路的歷程，旅途上遇見的瓶頸與突破方式）

保持好奇，保持學習，保持對文化的敬畏！

■ 請問您如何獲得靈感？

旅行和讀書。
縱然是故地重遊，因為角色，年齡與心境的不同也會有不一樣的感官體驗。
時代的穿越就用讀書去完成吧！

■ 請和我們分享您喜歡的書籍，音樂，電影或場所

我們喜歡嘗試各種新鮮事物，也喜歡去舊書店和二手市場。

■ 請問您做過最瘋狂或最酷的事情是什麼呢？

離家出走。

■ 請問您最近最想什麼事情？是否已經著手規劃下一階段的目標或突破了呢？

我們愛自己的亞洲身份，我們希望用很長的時間去研究亞洲的文化，去自我沉澱，我們也盼望用這份誠意回饋社會。

What is your "main idea" while producing a piece/series of work? Have it ever changed before?

During the creation, we have been holding an open attitude and keep learning to contact different new things. It has been, and still is. The only difference is, with the transformation of role, we feel that designers should take more social responsibilities.

What is the best thing in your country? (likes features or culture)
Have it ever influence your creation?

We are from China and Malaysia respectively, we often to see ourselves as "Asian". We believe that with the times change, cultural collision may happen by the interaction and blend, which may produce some new things, which are really interest. These effects was unconscious and subtle, with the change of age and role, we are very enjoy and willing to share this feeling.

Share the story of you creating your pieces.
How did you encounter with creativity/art/design/illustration? And what happened? Have you ever been stranded at a bottleneck? And how did you overcome?

Keep curiosity, keep learning, and keep the revere of the culture!

How do you draw the inspiration?

Travel and reading.
Even if revisit the old haunt, different role, age and mood will bring different sensory experience.
Let's achieve the era crossing through reading!

Share good books/music/movies/places with us.

We like to try all kinds of new things, also like to go to the old bookstore and the second hand market.

What is the craziest or coolest thing you have ever done?

Run away.

Wh... ... nt to do most these ... t up new goals or

... pe to spend a long ... precipitate ourselves.
We ... sincerity to give back to socie...

中國 CHINA

李孟澤 Bentidea

305439160@qq.com

畢業於中國廣州美術學院，平面設計專業。入選第九屆 APD 亞太設計年鑑、中國青年精英基金會海報設計優秀獎、上海亞
洲平面海報設計雙年展入選、十三屆白金創意大賽標誌類優秀獎、HiiibrandAwards2013 第四屆 Hiiibrand 國際品牌標誌設
計大賽優秀獎、靳埭強設計獎 2013 全球華人設計比賽學生組標誌類入圍。2012 年創立 BENTIDA 創意工作室。

Graduated from China Guangzhou Academy of Fine Arts, Graphic Design. APD selected for the Ninth Asia-
Pacific Design Yearbook, China Young Leaders Foundation Poster Design Excellence Award, Shanghai Biennial
Asian plane poster design was selected, thirteen Platinum Award of Excellence Contest logo Hiiibrand Awards
2013, fourth Hiiibrand class international brand logo design contest Excellence Award, Kan Tai keung design
Award 2013 global Chinese student design Competition Finalist. 2012 logo class creative studio founded
BENTIDA.

1　2

滇是雲南的簡稱，月下滇是以雲南特色文化，建築，植物，和雲南神韻為結合的一個雲南特色的餐館。月下滇的主調是神秘浪漫的少數民族文化的一個特色餐館。海報內容都含有雲南的滇特色。

"Dian" is an abbreviation of Yunnan, Yuexiadian is a restaurant combined Yunnan's characteristic culture, architecture, plants, and charm; the main theme of Yuexiadian is a romantic and mysterious culture of minority. The contents of posters are with characteristics of Yunnan.

陳華容 Chen Huarong

bennychan789@126.com

現工作生活於東莞，專注於品牌、包裝、書籍設計推廣及相關環境設計。
作品在國內及國外比賽中獲獎及入選，包括：2012 中國設計大展 - 優秀獎，2011 上海設計展 - 金獎、優秀獎，2011、2013 臺灣國際平面設計獎 - 評審獎、優秀獎，2011 中國之星設計藝術大獎 - 優異獎，2011 澳門設計雙年展 - 銀獎、優秀獎，北京國際商標標誌雙年獎 - 銅獎，"Hiiibrand 2010" 國際品牌標誌設計大賽 - 銅獎、評審獎，2011 香港設計師協會環球設計大獎，俄羅斯《Tamga》國際商標標誌雙年展 - 優異獎，東京字體指導俱樂部年獎 (TDC)- 優異獎，平面設計在中國深圳 GDC09、GDC13- 優異獎

Now working and living in Dongguan city. Focus on branding, packaging, book design and promotion and related environmental design.
His works were selected or won prize in China / abroad competition, Include: the China Design Exhibition 2012 / Merit Award, the 2011 Shanghai Design Exhibition / Gold Award & Merit Award, the 2011 and 2013 Taiwan International Graphic Design Award / Jury Prize & Merit Prize, the 2011 China Star Design Art Competition / Merit Award, the Macao Design Biennial / Silver Award & Merit Award, the Beijing International Logo Biennial Awards / Bronze Award, Hiiibrand 2010 International brand logo design competition / Bronze Award & Jury Prize, the HKDA Global Design Awards 2011, the international trademark and logo biennale / Merit Award, TDC Award / Merit Award, GDC9 and GDC13 / Merit Award......

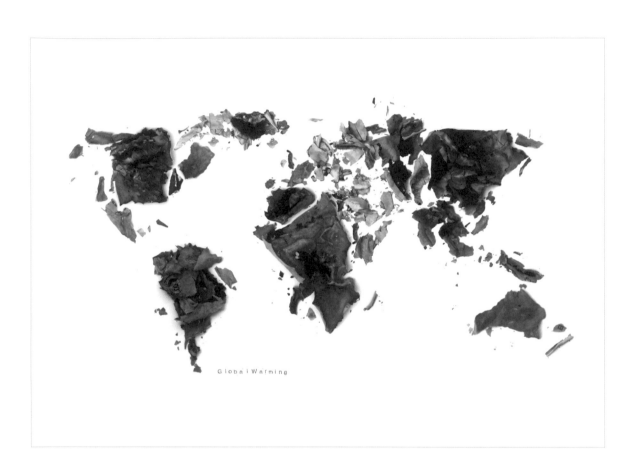

地球冰川冰蓋融化、高溫乾旱天氣增加、颶風肆虐帶來巨量降水還有正在逼近部分國家的沙漠線……，這些都是氣候變暖帶來的極端氣候與破壞，全球變暖已成不爭的事實。
燃燒過後的灰燼成為地球的主角，如果再不採取行動，全球暖化的後果就是地球就會變得越來越熱，所有的東西都會成為一堆灰燼。在此希望這幅海報作品能夠重新引起人們對地球環境的重視和關愛。

The melting of glaciers and ice sheets; the huge amount of pouring of rain brought by hurricanes; the extending border of the desert are currently evading some countries. These disasters, the extreme weather, are all caused by the Global Warming. It is an inconvenient truth.
If there is no action to be taken, the burning ashes will become a common status on Earth. The result of Global Warming, eventually, all things will turn into ashes, as the temperature rising higher and higher. This poster is about raising people's environmental consciousness.

1

2

1/ 版式排版的無盡可能

The endless possible of layout.

2/ 為了生存需要，因環境而進化，幸哉？禍哉？

If we have to evolve due to the environment in order to survive, is it a fortune, or a disaster?

■ 請問您一路以來的創作歷程

做設計這麼久了，一直都是抱著學習的態度去對待設計。

Share the story of you creating your pieces.

Never stop learning; I take such attitude all the way doing design.

■ 請問您如何獲得靈感？

大自然的積累、生活的積累、工作的積累，是創作靈感的最大來源。

How do you draw the inspiration?

The experiences I've learned from nature, the experiences I've accumulated through living and working; these experiences are the resources where my inspirations come from.

■ 請和我們分享您喜歡的書籍、音樂、電影或場所

我只看好的東西，因為好的作品誰都喜歡。至於什麼是好什麼是不好，就看個人的審美和積累了。

Share good books/music/movies/places with us.

I appreciate what is good only. Everyone is fond of good pieces. Yet, whether the piece is good or bad, is determined by personal taste and aesthetics.

■ 請問您做過最瘋狂或最酷的事情是什麼呢？

曾經有段時間消失一個月，不跟外界有任何聯繫。

What is the craziest or coolest thing you have ever done?

There was once I fled away and contact no one for a mouth.

■ 請問您最近最想什麼事情？是否已經著手規劃下一階段的目標或突破了呢？

做出版的事。希望以後可以接觸不同範疇的創作空間。

What are the things you want to do most these days? Have you started to set up new goals or breakthroughs for next period?

I want to do publishing. I hope that I can get involved, be associated with other creative works of various categories.

■ 請問您對於「創作」所擁抱的理念是什麼？從以前到現在，是否有所轉變？

認真生活是創意最好的來源，認真對待每一件事、認真做好每一件事，設計是同樣的道理！我所有生活的每一個細節可能心裡面想的都是設計，很多時候都是這樣的，所以我覺得要投入，要熱愛它、要投入它、要對它負責任。同時設計能解決怎樣的問題取決於怎樣將設計資源如何最有效的整合。

首先別把它當成掙錢的是一個行業，如果要把設計當作是賺錢的事業，那我建議他改行幹別的，這行不是賺錢的行業！其實設計更多在於精神的享受。這樣的信念一直沒變。

What is your "main idea" while producing a piece/series of work? Have it ever changed before?

Work hard living is the when inspirations come to me. I take everything I face seriously, working hard to get everything done; when speaking of design, the same philosophy of mine can be applied the same way, and that's when inspirations come to me. I am thinking about designing while I am living for the most of the time! Even in the most detailed way. Thus, I am so devoted because I have so much passion for designing, and I am responsible for it. How problem can be solved by designing is determined by how to make the most use of the resources.

And don't take designing as a money earning profession. If so, I suggest that he or she to consider changing career. Doing design is not about money making, it's about the mental satisfaction! Such of mine belief have never been changed.

中國 CHINA

孔繁鳴 DavidHong

564844419@qq.com

作品曾榮獲 2013 年靳埭強設計獎學生組金獎、2013 年臺北設計獎評委推薦獎、2013HKDA 環球設計大獎優異獎、第 11 屆莫斯科金蜜蜂國際平面設計雙年展入選獎、第二屆國際「竹·生活」跨界創意設計大賽銀獎、Hiiibrand Awards 入選獎、靳埭強設計獎入選獎。作品曾被收錄於第九屆《APD 亞太設計年鑑》、第十屆《APD 亞太設計年鑑》。

His works have been awarded the 2013 Kan Tai-Keung Design Award, 2013 Taipei Design Awards Jury's Choice Award, 2013HKDA Universal Design Award of Merit, the 11th Moscow International Biennale of Graphic Design Golden Bee Ruxuan Jiang, Second International "bamboo • life "cross creative Design competition Award,HiiibrandAwards Ruxuan Jiang, Kan Tai-Keung design Award Ruxuan Jiang. His works have been included in the Ninth APD Pacific Design Yearbook, Tenth APD Pacific Design Yearbook.

1 2

1/ BEIJING IS HAZE! 該作品用一種幽默的方式去反面襯托出北京這座城市的環境。海報整體風格尤為簡約，內容以手機處於拍照狀態為內容框架，通過上方的短信提醒拍照位置處於北京，畫面中間的對焦框突出手機正處於對焦狀態，而拍攝物件為一塊塊的灰色（讓人深思），灰色代表的就是北京這座城市受霧霾的影響，已經變得全是灰濛濛的一片。海報想通過點出北京已經全是灰色了去感召每一個人關注霧霾問題。

This poster is trying to amplify Beijing's environmental condition in a sarcastic yet humorous way. The style of the whole piece is simple yet concise. The main content, using a smart phone taking snap shots as the frame, and the notification from above expose the current location – Beijing. The autofocus frame is showing it's focusing a grey mist in the middle, which makes people wonder and contemplate. The grey mist represents the smog besieging the city of Beijing, and everything is bedimmed and obscure. This poster intends to raise the pubic awareness of the air pollution issue.

2/ BLOCKADE IS MADE IN CHINA 該作品的設計靈感來源於封鎖線。畫面中由多條封鎖線組成，而封鎖線上的內容來源於在中國境內使用不同社交軟體的介面資訊，中國作為一個生產力大國，全球大部分的產品都是 made in china，同時對網路的封鎖，也是 made in china。

This piece was inspired by the Great Firewall. In the picture, there are many security cordons. And the contents, which is displaying on the security cordons, are the interfaces of the social networks used within the China domain. China manufactures most of the goods in the world. Thus "Made in China" has gradually become a household phrase. But China's reputation doesn't stop there; It's also famous for its "Great wall of internet censorship."

「竹韻堂」以傳統竹編紋樣作為元素，進行視覺化、現代化、潮流化的圖形創新，用一種新的紋樣圖形來迎合當下低碳、藝術、時尚、健康的生活趨勢。這種傳統紋樣的創新化，不僅深受年輕一代喜歡，還可以喚起他們對傳統文化的重新發現。再把新生的紋樣作為「竹韻堂」的品牌元素，貫穿在整個品牌的視覺化系統裡，通過把不同的紋樣圖形進行多元的重組與結合，衍生出饒有興味的創新紋樣，使「竹韻堂」充滿時尚品味而又不失傳統感。

"Bamboo Charm Space" use the traditional bamboo weaving pattern as the main element, to create a visualize, modern and fashionable graphics. Making a new pattern to cater to the mild, artistic, fashionable and healthy life trend. The innovativeness of this traditional pattern would not only win the prefer of the young generation, but also remind them of the importance of re-discovering the traditional culture. In addition, using the newborn pattern as the brand element of "Bamboo Charm Space", and letting it run through the whole visual system of the brand. According to the various recombination of different pattern, it would create some new and interesting pattern and make "Bamboo Charm Space" more fashionable but still keep the traditional sense at the same time.

■ 請問您對於「創作」所擁抱的理念是什麼？從以前到現在，是否有所轉變？

我認為個人的創作就像畫家畫畫、音樂家唱歌一樣，通過創作這個載體來抒發自己的一些情感，通過作品來發聲，說出對社會的憤怒，讓作品和觀賞者產生情感的連接，呼喚起大家對一些社會熱點的關注。

■ 請問您認為該國最棒的是什麼？（如國家的特色或文化等）您的創作是否受其影響？

我認為我國最棒的東西是文字。漢字有著長遠的歷史，同時它又是極具多變的文字。漢字經過了幾千年的演變，逐漸形成了"漢字七體"，即：甲骨文、金文、篆書、隸書、草書、楷書、行書。因此在形式上它是可以不斷變化不斷創新的。漢字對我的創作有著深厚的影響，有很多創作都是用漢字作為載體來創作的。

■ 請問您如何獲得靈感？

一般的靈感來源主要是靠平時對書籍的閱讀和對社會熱點的一些思考。多點閱讀不同類型的書籍，可以使得自己的閱歷得到提高，讓自己可以瞭解更多不同層面的知識。在進行創作的時候，這些平時的積累就會潛移默化地轉化為創作的靈感。

■ 請問您做過最瘋狂或最酷的事情是什麼呢？

在大學裡，因為我原本的專業並不是設計相關的，後來因為對設計的熱愛，所以我開始不去上自己專業的課，然後天天跑去設計專業的課上去蹭課，一蹭就蹭了四年。跟著自己內心走，不要讓自己後悔，我覺得這是最酷的。

What is your "main idea" while producing a piece/series of work? Have it ever changed before?

I think, a creation of a person is the same thing as a painter paints, a musician sings. Through creating, they express their emotions, to express their anger against the society, thus their voices can be heard, and such voices can resonant from within those who heard; connections are built, therefore the public awareness can be raised.

What is the best thing in your country? (likes features or culture)
Have it ever influence your creation?

Words! It's the most fascinating things of my country. Chinese word, character holds a long history. As the history goes, and over thousands of years, 7 types of writing scripts are formed. There are - Oracle bone script, Bronze inscriptions, Seal script, Clerical script, Semi-cursive script, Cursive script and Regular script. As you can see, the style of the character can be innovated through out time. Lot of works of mine was inspired by the Chinese character. It has a great influence on me.

How do you draw the inspiration?

My inspirations come from reading, and some opinions on the social issues. Quantity reading empowers you to gain knowledge from various fields. And the knowledge you accumulated can turns out to be your energy while creating.

What is the craziest or coolest thing you have ever done?

The coolest thing I've ever done is to follow my heart, and never regret doing what I love. My major in college wasn't design studies. But I audited design studies' class for four years, because I have passion for it. And that's the coolest thing I've ever done.

郭大部 Guo dabu

共同創作者 Co-author

陳約瑟 Chen yue se

www.55design.net　　*xulimeng001@163.com*

郭大部與陳約瑟，作品入選第八屆《APD 亞太設計年鑑》，2015 年參加 New Vision 新視角亞洲海報設計邀請展，並收錄在 CTA 亞洲創意對話刊物中。

Guo dabu & Chen yue se, their works are selected for APD pacific Design Yearbook No8. In 2015, they were invited to participate in New Vision exhibition and their works were selected for CTA.

1/ 水墨山水畫 / China Ink Landscape Painting / 2014
2/ A Home for Everyone / 2013

郭延龍 Guo Yanlong

1806800172@qq.com

2013 年德國紅點概念獎入圍、第 26 屆捷克布爾諾平年設計雙年展入選、2013 年韓國海報雙年展入圍、2015 中國 - 義大利設計週佳作獎、2013 年臺灣國際學生創意設計大賽入圍獎、第九屆亞太設計年鑑入選、第十屆亞太設計年鑑入選、第 23 屆金犢獎美術設計類金獎、2014 年白金創意獎公益廣告類銅獎、2014 年靳埭強設計獎優秀獎。

2013 Red Dot Award Finalist concept, The 26th Biennial Brno-average design selected, Poster Biennale 2013 Korea Finalist, 2015 China - Italy Italian Design Week Honorable Mention, 2013 Taiwan International Student Design Competition Finalist, Ninth & Tenth Asia-Pacific Design Yearbook selected, 23th Times Young Creative Awards Gold, 2014 The 15th Platinum Originality, National University Students Graphic Design Competition Bronze, Kan Tai-Keung 2014 Design Award Excellence Award.

1　2

1/ 我們常常說眼見為實，但往往事物太複雜了，你無法真實的去感知。小的時候，思維不成熟看到客觀事物，不能夠理解；長大後，世界太複雜，分不清誰是誰非；暮年老矣，看到了已不再關心。
We always say that seeing is believing, but the things often are too complicated, you cannot percept things really. When young, immature thinking to see things so objectively that cannot understand; when grow up, the world is too complicated to tell who is right and who is wrong; old age and old men, and saw no longer care.

2/ 該海報是中國合肥實驗藝術現場的海報，主題是身的思考。試圖用圖形符號來詮釋身體這一客體，與藝術這一元素的關係。
The poster is China Hefei experimental art scene poster theme is thinking of the body. Trying to use graphic symbols to interpret the body of this object, the relationship between the elements of art.

1　2

1/ 作品用平面的元素來描繪自然、天地、陽光、河流等，充滿東方的韻味和詩意，人與自然共生。

Works use elemental planes to depict nature, earth, sun, rivers, which are full of oriental charm and poetry, people with nature.

2/ 水是人賴以生存的養料，沒有了水就沒有生命，沒有了水就沒有愛等。用圖形符號來闡釋這一概念。

Water is nourishment for the survival of people, there is no water, no life. Without water, there is no love like. Graphical symbols to illustrate this concept.

■ 請問您對於「創作」所擁抱的理念是什麼？從以前到現在，是否有所轉變？

我對於設計相關創作的理念比較隨心。每個人的創作都會跟自己的性格、環境比較有很大的關係，我本身是比較糾結的一個人，恰逢生活在中國當下這個複雜的文化大背景下，有很多說不清道不明的文化因素在影響著你。創作的理念從來沒有固定過，一直在轉變，西方的、東方的都會有所吸收，這也是一直刺激我向前的動力，你永遠不知道下一個作品是什麼。

■ 請問您如何獲得靈感？

首先靈感這個東西是可遇不可求的東西，一個優秀的設計師的水準是一種常態，好的作品是非常態，科班出身的設計師，通過自己訓練的技巧和經驗，來經營自己的大多數的作品。我也不例外，靈感常常像是一種烏托邦式的祭品一樣，有時候是靠一種非常態的思維來激發出來的，有可能是你記憶中一種模糊的痕跡、或是一種超然的剎那，聽起來很玄乎，有點哲學宗教的韻味思辨，但恰恰是這種感覺才會讓你興奮不已，從而用你的經驗和技巧將他捕捉。

■ 請問您做過最瘋狂或最酷的事情是什麼呢？

我感覺做自己喜歡的設計本身是一件最瘋狂、很酷的事情。我不太喜歡做商業設計，一般是跟藝術活動比較相關的設計，每次你做設計時候總會有你的影子在裏面，試圖去用自己的感受去闡釋那一主題，因為你會發現他更接近人性，讓你心裏從未有過的洗禮。

■ 請問您最近最想什麼事情？是否已經著手規劃下一階段的目標或突破了呢？

最近一直在想學哲學相關，當然不是科班的那種，當每每發現許多問題的時候你會有各種困惑，感覺設計師不是一個工匠，設計師應該是一個講故事的人，哪怕是等待的果陀，也是一個激發人性荷爾蒙洗禮的設計，所以我接下來要做的是不做設計，好好的生活，去感受人和社會，跟朋友談聊聊。

What is your "main idea" while producing a piece/ series of work? Have it ever changed before?

I am more following my mind for design-related creative ideas. Everyone's creations would have great relationship with their own personality or environment. I am contradicting myself, and coincidently live in China where has complex cultural background, there are many cultural factors to affect you. I have never fix my creating idea, it always keep changing, and absorb from the West to the East, this is the motion that always stimulate me to go forward, because you never know what your next works will be.

How do you draw the inspiration?

First thing is that inspiration is something cannot be obtained as you wish, an excellent designer's level is normal, and a good work is non-normal, the designers who were trained by class create their works through their training skill and experience, so do I. Inspiration is usually like a utopian offerings, sometimes it would be excited by a kind of mind that is non-normal. It may be a vague memory of your marks, or a transcendent at the moment, it sounds very iffy, a little charm speculative philosophy of religion, but it is precisely that this feeling will make you excited, then use your experience and skills to capture it.

What is the craziest or coolest thing you have ever done?

I think that doing my favorite thing: design, is the craziest thing, it is cool. I don't like to do business design, I'd like to do art-related design generally. You always feel that your design has the shadow of yours, try use you're feeling to express the theme, because you will find it is more close to the humanity, and it will purify your mind.

What are the things you want to do most these days? Have you started to set up new goals or breakthroughs for next period?

I have been wanted to learn philosophy recently, not the kind of class. When discover many questions you will feel confuse about that. I think our designers are not a craftsman; we should be a storyteller, even if the "Waiting For Godot", it is a humanity-inspired design, too. So the next thing I want to do is enjoy the life without design, to feel the human and society, or talk to my friends.

郭玉龍 Guo Yu-long

www.kaibrand.cn 442534663@qq.com

美術指導，設計師。祖籍河南焦作，自幼喜歡書法，繪畫。
多年來一直從事品牌識別設計與傳播工作，曾在國內多家知名設計公司任職。現任鄭州青桐品牌設計公司設計總監。曾經
服務過：中國銀行，秦山核電站，河南博物院，多力葵花油，日東電工，泰陵製藥等多家國內外知名企業。
作品曾入選2015東京TDC字體指導俱樂部獎，2012「嗨品牌」品牌形象類優異獎，第九屆澳門設計雙年展公開組入選作品，
第九屆 APD 亞太設計年鑑，第十屆 APD 亞太設計年鑑，國際設計年鑑，包裝之星，河南之星等設計獎項。

He is an art director and a designer. Native of Henan Jiaozuo, he has love calligraphy, painting since he was a child.
Guo has been engaged in brand identity design and dissemination for many years. He has worked in several
well-known design companies. Now is a Design Director of Zhengzhou delonix regia brand design consultation
(DBDC). He has served: Bank of China, the Qinshan Nuclear Power Plant, Henan Museum, MIGHTY sunflower oil,
Nitto Denko, NT Pharma and many other well-known companies.
Works were selected by Tokyo TDC Annual Awards 2015, won Merit Award in Identity category of Hiiibrand
Awards 2012, the 9th Macau design biennial exhibition open group selected, APD No.10 selected, Excellent
International Design Yearbook selected, and won Package star Award, Henan star Award, etc.

1 2

1/ 初夏的感覺是一個迷離和飄揚的場景，這首詩讓我找到了一種心中的環境──簡單、自然。我用最簡單直接的點線面為基礎，體現琴弦的清脆、水珠的爽白。一種嬉戲、玩鬧的感覺。

The early summer give a feeling of a fluttering yet blurry landscape. This poem helps me find a state of mind – simple yet elegant. I applied the simplest point, line and form to represent crisp, melodious of the strings and the shimmer of a droplet. Create a cheerful yet playful feeling.

2/ 鳳凰單樅茶已有很多表現手法，我想要找到一種不同的手法，既能體現中國傳統的意境，也有現代人飲茶的時尚。用不同的色彩和花型來表達茶的口味，鳳凰圖形也突破常規，用具有「印象」感的細點來塑造。體現茶香回味的記憶，那種說不清是哪種香味，但卻記憶猶新的感覺。

There are already many ways to be used to represent the Feng Huang Tea, and I intended to do the difference. I want to find a representation both includes traditional Chinese concept and modern tea drinking fashion. I applied different colors and shapes of flowers as the flavor of the tea. Also, I applied dots, impressionism style, to give an unorthodox look to the image of the Feng Huang.
To recall the memory of the scent of the tea rippling in your mouth, the fragrance of which you can't distinguish, but the memory is vivid still. This is the concept of which I'd like to visualize.

1/ 提供關於禪修與茶文化有關的物品，標誌體現禪的空靈與寂靜，素雅風格仿佛人們內心的一塊空地讓人嚮往。

Provide objects to do with Zen and tea culture. The logo express the serenity of Zen and the simple yet elegant style represents peaceful empty mind people yearn for.

2/ 吃麵不僅是一個滿足腸胃需求的事情，希望將吃麵做的有趣且有意義，字體用手繪的形式，表現趣味與放鬆的狀態

Eating noodles is not just about satisfying your stomach. I hope to make it to be a thing that is meaningful and fun doing it. I used hand-painted style font to add a little amusement and to express a status of relaxation.

■ 請問您對於「創作」所擁抱的理念是什麼？從以前到現在，是否有所轉變？

每次創作之前都應該事先瞭解項目的背景，整理出創作目的，以及需要傳達的思想。創作不是憑空的「拍腦袋」，我一直都認為創作只是「舊元素，新組合」，創作人更像是一個玩積木的孩子，心中不僅有個蓋房子的想法，事先要找到房子的組件。

What is your "main idea" while producing a piece/ series of work? Have it ever changed before?

When you work on your creation, you should fully understand the background of the item beforehand. And then, followed by the purpose of creating such item, and the ideas you'd like to tell. Creating is not something you do without contemplating or something you do just based on your experiences. I've always considered creating as "old elements, new combinations". And the creator is more like a kid playing with toy blocks; you need not just the imagination but also the right materials to build a toy house.

■ 請問您認為該國最棒的是什麼？（如國家的特色或文化等）您的創作是否受其影響？

就目前我這一段時間，一直在研究「漢字的可能性」，我覺的這是中國的一個偉大寶庫，很多東西都在裡面。當然中國還有很多很棒的東西，比如武術、比如國畫等。我計畫用幾年時間去研究其中一項，這些東西都會不自覺地影響我創作的風格和調性，漢字最早其實就是圖案，有直指、有虛指、有表意、有具象，真的有很多東西都可以運用在設計項目中，我現在有很多專案也都是用「漢字」為基礎開展的。

What is the best thing in your country? (likes features or culture)
Have it ever influence your creation?

I've been studying on the "Possibilities of the Chinese characters" for some time. I think it's a great treasury of China, for it contains so many things in it. Of course, China has lots of other great things, such as: martial arts, Chinese painting, etc. I am planning to spend some years to study one of them. These traditions influence the style of my creation unexpectedly. The earliest Chinese characters it selves, were image. And it selves also include ideogram and other classifications, and there are so many things which can be applied as a concept into the design project. There are many projects I am currently working on is based on the Chinese characters as the concept.

■ 請問您如何獲得靈感？

前面我說過我不相信靈感，一般專案開始都會老老實實的收集資料，就連一直專注的農特產、食品、旅遊三個行業的設計，也不會用經驗去「創意」，尋找基本元素是我覺得最可靠的方式。

How do you draw the inspiration?

I've said that I do not trust the thing "inspiration" previously. I always start a project with information gathering. I don't draw "creativity" with my personal experiences. Not even in agricultural products, food or traveling, these three fields. So, in order to come up with a new idea, the most reliable method, I'd say, is to start working from the fundamental elements.

■ 請和我們分享您喜歡的書籍，音樂，電影或場所

設計的書我都很喜歡，大致可以分為設計素質和設計方法類兩種，前者是道，但不易初學。後者是術，易學但容易迷失。我建議大家結合起來看。日本人做的比較好，《佐藤可士和的超整理術》和原田進的《設計品牌》我推薦看下，同時我很喜歡陳昇的音樂，電影我喜歡看香港片。

Share good books/music/movies/places with us.

I like all the books to do with designing. I recommend <Kashiwa Sato's Ultimate Method for Reaching the Essentials> and <Branding> by Susumu Harada. And speaking of music, I like Bobby Chen's music. About the movie, I prefer Hong Kong's movie.

■ 請問您最近最想什麼事情？是否已經著手規劃下一階段的目標或突破了呢？

是的，我每天都有很多想做的事情，不過都是和設計、和生活有關的。希望未來幾年能把工作室做起來，平衡好工作和生活的關係。

What are the things you want to do most these days? Have you started to set up new goals or breakthroughs for next period?

Yes! I've always wanted to do so many things each day, and all of them are related to design and living. I hope the studio I started that everything can be on the right track within a few years, and I can balance working between living, and enjoying my life.

霍文傑 Huo Wenjie

www.dooodesign.com　　*175466429@qq.com*

Dooo Design Studio 創意總監，作品曾入選芬蘭拉赫帝海報展、丹麥奧爾胡斯國際海報展、香港國際海報展、澳門設計雙年展、GDC 設計獎、中國設計大展、靳埭強設計獎、Hiiibrand 國際品牌設計、ADI 設計獎等知名賽事和展覽，並被 Logo Lounge、Brand!、APD 亞太設計年鑑等書刊收錄。

Creative Director of Dooo Design Studio who was practiced in Lahti Poster Biennial Finland, Aarhus Poster Show Denmark, Hon Kong Poster Triennial, Macao Design Biennial, Graphic Design in China, China Design Exhibition, Kan Tai-Keung Design Award, Hiiibrand Awards, ADI Awards. His works were published by Logo Lounge, Brand! and APD.

WE NEED WORK RIGHT

IT IS DANGEROUS
TO LOOK OUTSIDE

★★★★★

1/ 殘疾人並非不能工作，他們只是比正常人更需要機會。
Disabled man is not unable to work. They need an opportunity more than the normal persons.

2/ 在天朝，向外看是件危險的事。
It 's dangerous to look outside from Tianchao.

1

2

1/ 聯墨互動是一家從事網站建設設計及應用開發的工作室。我們在「INK」這個詞彙之前添加了一個隱形的 L，將名稱含義從「墨水」拓展為「連結」。點狀的 L 在品牌形象中以特殊形態呈現，例如名片、牆面上的鏤空處理。一段有趣的網頁代碼被用在多種物料之中，用以彰顯互聯網行業的獨特屬性。

We always say that seeing is believing, but the things often are too complicated, you cannot percept things really. When young, immature thinking to see things so objectively that cannot understand; when grow up, the world is too complicated to tell who is right and who is wrong; old age and old men, and saw no longer care.

2/ 瘋醫樂隊 2014 年全新大碟，由 P.K.14 主唱楊海崧擔綱製作，摩登天空發行。唱片封面及內頁用了李沛潞的畫作，粗獷、暴力、極富攻擊性。我們從畫作中截取了部分與歌詞意境相符的畫面，並將之與歌詞自由混排，形成局部的圖文造型。多個明黃色的三角形穿插在整個設計中，增強了畫面的張力，並暗含專輯主題「Debris 碎片」。

The New Album of The Fallacy produced by the singer of PK14 was published by Modern Sky 2014. The oil paintings drawn by Peilu Li we used on the cover and the booklet were rough violence and very aggressive. We arrange the paintings and lyrics in a disorder way to create unique layouts. Yellow triangles were placed in different places to symbolize the name of the album, Debris.

■ 請問您對於「創作」所擁抱的理念是什麼？從以前到現在,是否有所轉變？

對於平面設計而言，創作應包含兩重層次：第一層是實現傳達功能，第二層是展現獨特的視覺風格。一直以來，我傾向於較為簡約設計。簡約並不是簡單，而是指作品中呈現的諸多元素都是必要的，都是為表現主題而服務的。

■ 請問您認為該國最棒的是什麼？（如國家的特色或文化等）您的創作是否受其影響？

中國社會的一大特色是民眾缺乏持續性的立場，以我的生活經歷來看，「變化」一直是整個社會的常態，你無法預測接下來會發生什麼。

■ 請問您如何獲得靈感？

在我緊張工作的時候，靈感會偶然閃現。

■ 請問您最近最想什麼事情？是否已經著手規劃下一階段的目標或突破了呢？

長年以來，我習慣於沒有計劃性的生活，不過我想是到了該依照計畫行事的時候了。

What is your "main idea"while producing a piece/series of work? Have it ever changed before?

There are two levels in graphic design, one is achieving the communication, the other is expressing in a unique visual style. Over the years, I prefer minimalism style. Simple but not easy, every the element on the work should express the main idea.

What is the best thing in your country? (likes features or culture)
Have it ever influence your creation?

One of the social features in China is that people are lack of continued opinion. Change is always a normal state of the society from my histories. It's not possible to predict what will happen next.

How do you draw the inspiration?

Inspiration came occasionally when I was busy at work.

What are the things you want to do most these days? Have you started to set up new goals or breakthroughs for next period?

I used to live without any planning. Maybe it's time for me to do something with a clear plan.

中國 CHINA

金貴子 Jin Guizi

119264810@qq.com

金貴子，作品曾入選第九屆亞太設計年鑑，中國新鋭設計師年鑑，中國創意設計年鑑。

Jin Guizi, his works have selected the 9th Asia-Pacific Design year book, China Young Designers Year Book, China Creative Design Yearbook.

long

意

龍 / long / 2015
意 / yi / 2015

孟申暉 John Meng

shenhuimeng@gmail.com

品牌設計師，畢業於中央美術學院信息設計專業，德國柏林藝術大學視覺傳達專業碩士，美國紐約TDC字體指導俱樂部會員。平面設計作品獲2014年德國紅點傳達設計大獎，作品收錄於德國著名設計雜誌《PAGE》，第九屆、第十屆《亞太設計年鑑》等；作品獲2013年"天鶴獎"中國青年設計師大賽交流設計類銅獎；"CCTV－9記錄頻道"標誌演繹大賽入圍；書籍設計作品入圍第八屆全國書籍設計藝術展；字體設計作品獲第60屆美國紐約TDC卓越字體設計獎。

A brand designer, graduated from the China Central Academy of Fine Arts, Information Design. He is the master of Berlin University of the Arts Visual Communication, Member of New York Type Directors Club(TDC).
His graphic design work won the Red dot award: Communication design in 2014. Also his works were published by PAGE, 9th and 10th Asia-Pacific Design and so on.
In 2013, his work won Bronze of Designnova Awards: China international Young Designers Competition, CCTV-9 Logo Deductive Competition nominated, The 8th National Exhibition of Book Design in China nominated, and his font design works won 60th NY TDC Awards.

當手機、電腦、網路越來越發達，越來越便捷，使得人們也開始越來越迷失於屬於網路的時代，作品《失•落》正是表達了這一主題，正如在太空中的失重感，人們已經迷失在這數字的時空之中。

As the develop of phones, cumputers and Internet, people lost on a generation of Internet. The works Media Weight Lessness want to express this issue, as a sense of weightlessness in outer space, people have lost in the digital space-time.

李佛君 LI Fojun

www.iseead.com *sz@iseead.com*

彥辰設計（深圳）有限公司創辦人、藝術總監。
ICOGRADA 國際平面設計協會聯合會會員、SGDA 深圳市平面設計協會會員。
獎項：Tokyo TDC 東京字體指導俱樂部年獎 2015、香港設計師協會環球設計獎 HKDA 多項、臺灣金點設計獎兩項、靳埭強設計獎等近百個獎賞。
參展：華沙國際海報展、字彙中美兩國自體設計展、莫斯科金蜂國際平面設計雙年展、中國設計大展、第八屆全國書籍設計藝術展、韓國國際海報展。
收藏：美國弗吉尼亞州里士滿第 5 美術館、韓國設計中心、韓國視覺資訊設計協會。
發表：全球最佳圖形設計 Gallery、設計、包裝與設計、深圳特區報、視覺同盟。

Art Director of iseead Design Corporation.
Member of ICOGRADA、Member of SGDA(Shenzhen Graphic Design Association).
Awards:
GOLDEN PIN DESIGN AWARD 2014; HKDA Global Design Awards 2011; HKDA Global Design Awards 2013; KAN TAI-KEUNG Design Awards 2011;
North China design art exhibition gold medal; China Star Design Art Awards 2013;
China National Packaging Design Award 2013; Awards of Golden Bee 2012; Awards of Hiiibrand brand design 2011.

作品於極光滑的紙張之上，以奔放的大寫意風格書寫了灑脫俊逸的「風、花、雪、月」四個漢字，筆觸揮灑之間與墨水、清水恰到好處的融合，出現了大量自由、靈動的墨點和滑動的筆劃質感，呈現水墨淋漓之視覺效果，傳達極為靈逸、豐富的視覺感觀。畫面亦以數行精緻的宋體字表現中國古文化中對「風、花、雪、月」的精要闡述。

Works on paper, written in smooth, flowing style of writing with a free and elegant for four Chinese characters; Strokes and ink and water is just the integration, freely and slipping in visual presentation; Screen with some lines of the Song Dynasty words, performance of ancient Chinese culture, elaboration of the Chinese words "The wind, flowers, snow, Moon".

1 2

1/ 作品採用鏽跡斑斑的鐵板背景作底，表現斑駁、滄桑之質感，呈現夢幻、玄妙、光怪陸離之意境，令人懷想，產生豐富想像空間。
Works using the rusty iron plate with the background, deeply, vicissitudes, dream, abstruse, weird, create rich imagination.

2/ 一日一皂，一日一造。作品以46面不同的肥皂泡紋理展示了46日完全不同的生活軌跡，引導觀眾反思當下的每一天，珍惜光陰，認識自己。
One day one soap, one day a building.
Work with 46 surface texture shows different soap bubbles 46 days completely different life trajectory, guide the audience to reflect on the moment of every day, cherish the time, know yourself.

■ 請問您對於「創作」所擁抱的理念是什麼？從以前到現在，是否有所轉變？

我覺得適合的創作才是最好的。適合某一類人群、某一類族群、某一時刻、某一特定場合等的設計才是好創作、好設計。
以前我們太關注於設計的美感、形式、內涵等等方面。現在隨著創作能力和商業認知的逐漸成熟，在創作理念上逐步向：適合、定位準確這個方向靠攏。

■ 請問您認為該國最棒的是什麼？（如國家的特色或文化等）您的創作是否受其影響？

我認為中國最棒的是具有東方魅力的悠久的傳統文化和國學。我的很多創作均受其影響。

■ 請問您如何獲得靈感？

靈感，有的時候可遇不可求。在實在沒有靈感的時候我一般不會強行去創作什麼，如果非要去創作，那麼我會選擇去一個周邊的城市，如香港澳門等地隨意走走。讓身心換一個透氣的機會和空間，或許有新的收穫。還有就是可以做看書和聽音樂、看電影、旅行、越野都是不錯的讓身心放鬆下來從而獲得靈感的方式。

■ 請和我們分享您喜歡的書籍，音樂，電影或場所

喜歡的書籍：書法字帖
喜歡的音樂：beyond
電影：阿甘正傳

What is your "main idea" while producing a piece/ series of work? Have it ever changed before?

I think that a good design has to be 'fit'. Be fit for a certain people, a certain groups, a certain time, a certain occasion, etc. And then it will be a good creation / design.
We used to focus on aesthetics, form, content of design, but now with the mature of creative ability and business awareness, we are toward to 'fitting' and 'accurate positioning' in creative concept gradually.

What is the best thing in your country? (likes features or culture)
Have it ever influence your creation?

I think the best part of China is that it retains the oriental charm of tradition culture and Chinese culture.

How do you draw the inspiration?

Inspiration, it is something just can't be obtained as you wish. I usually do anything but create when I have no inspiration. If I must to create, then I would choice to go to neighboring city such as Hong Kong, Macao and other place just a little walking. Changing a place for a opportunity to get body and mind breathe, maybe it can get some new harvest. Besides, readings, listening to music, watching movies, traveling and cross-country are good way to relax and gain inspiration.

Share good books/music/movies/places with us.

Favorite book: copybook for calligraphy
Favorite music: beyond
Favorite movie: Forrest Gump

連盟 Lian Meng

lianmeng373@sina.com

作品曾連續受邀入選《APD 亞太設計年鑑》8、9、10 卷，入選《字彙》中美兩國字體設計展 2013 中國區巡展，入選第九屆澳門設計雙年展，受邀參選 2020 澳門字體百分百交流設計展，入選 2012 微時代全球字體設計展，受邀入選《國際設計年鑑 2013》，入編《中國設計師年鑑 2011》/ 年度銀獎，《中國設計創意年鑑》/ 年度銀獎，上海印象十大城市形象紀念品設計 / 年度入圍等。

Works were selected for 8th, 9th and 10th APD pacific Design Yearbook. Selected for the US & China Typographic Poster Exchange 2013 Touring exhibition of China. The 9th Macau design biennial exhibition nominated, 2012 Micro-times Global Font Design Collection Activities nominated, the 20/20 Macau font 100% exchange Design Exhibition nominated, International Design Yearbook 2013 selected / Annual Silver Award , China designer Yearbook 2011 / Annual Silver Award, "China creative design yearbook" / Annual Silver Award, Shanghai · Impression - 10 city image souvenir Design Competition nominated, and so on.

不知不覺的來到了天界邊，一切都是那麼的荒誕，什麼也想不起來，眼前卻出現了許多莫名其妙的視覺符號，"它們"就像各種人群說出的話語奇奇怪怪，虛擬無比，不時的呈現出渾沌狀態，沒有記住任何地方，還好它只是一場夢而已。

Coming to the edge of heaven unconscious, and everything was too absurd. I could not remember anything, but many inexplicable visual symbols appear in front of me. 'They' seemed like words or sentences, which were talked by all kinds of people. They were weird, extremely virtual and always in the chaotic state. I could not remember any places. But fortunately, it just was a dream.

1 2

1/ 通過樹樁與漢字筆劃的玩味結合，形成【木】字圖形。以此警示大家保護樹木，回歸自然，別讓鳥兒也尋找不到那些曾經美好的風景。

For remind public to converse the wood, back to the nature as well as the bird can find the beautiful view and life, in this work, the 'wood' word graph is interestingly combined with woodpile and Chinese characters' stroke.

2/ 田州古城的字體海報設計，借用一些特有的視覺圖騰以及勾畫出能夠體現當地特色的圖形符號，線條中也穿插著輕鬆活潑的趣味感，增加著古城的特別之處和遊玩之意。

The font concept and poster design in ANCIENT CITY TIANZHOU, referring to some unique visual totem and symbols, which can represent the local characteristics. Lines are also interspersed with the lively sense of fun, and increase the special meaning of the ancient city.

■ 請問您如何獲得靈感？

基本還是從生活中去發現及攝取，再去結合自己手中項目要求去排列思考，尋找出相對的洞察點把它放大化，直至它完整的浮現在自己腦海中並出現文字...圖像...

■ 請和我們分享您喜歡的書籍，音樂，電影或場所

大部分時間還是專業類書籍看的比較多，最近在補看台灣設計師聶永真的【不妥】。至於場所不知逛街算不算，很享受遊逛中的那份悠閒放鬆的感覺

■ 請問您做過最瘋狂或最酷的事情是什麼呢？

瘋狂，其實挺多的，現在在電腦邊寫這個突然就想起三年多前的那次近 30 小時沒有離開電腦，現在回想真的挺瘋狂了對我來說，貌似還很危險 ~~~

How do you draw the inspiration?

Basically,I'm find and uptake from life, and combined with my own project and independent thinking. I like to Find out the relative point and magnify it, till it completely appear in my mind, showing the text.... image....

Share good books/music/movies/places with us.

Most of the time, professional books account for the most part. Recently, I'm reading the ' no compromise' that write by NIE YONGZHEN, a Taiwanese designer. As for the places, shopping? I'm enjoying the relaxed and leisurely feeling in shopping.

What is the craziest or coolest thing you have ever done?

I must say it's Crazy! Actually VERY much. Now I'm setting in front of my computer and writing this, I suddenly recall the 3 years ago, nearly 30 hours without leaving the computer. Now, it's really crazy for me, and seems dangerous ~ ~ ~

劉兵迎 LIU BINGYING

www.rongyu06.com *529134179@qq.com*

石家庄榮譽品牌設計 / 創意總監
河北大學藝術學院 / 特聘導師
作品榮獲 HiiibrandAwards2013 國際品牌標誌設計大賽優異獎；AGDIE 亞洲平面設計邀請展；2013 傑出華文漢字設計作品展；第六屆中國國際茶葉包裝設計大賽銅獎；第 8 屆烏克蘭生態國際海報三年展；第九屆澳門設計雙年展等國內外重要獎項；作品連續 9 屆入選 APD 亞太設計年鑑。

GAD (GLORY DESIGN) / creative director
College of Art Henei University / Distinguished Teacher
His works won HiiibrandAwards2013 - Excellence Award, AGDIE, 2013 Outstanding Chinese Character Design Works Invitation Exhibition, the 6th China International Tea Packaging Design Competition - Bronze, the 8th '4TH BLOCK' International Eco-Poster Triennial, the 9th Macao Design Biennial, etc. Works has selected APD Asia-Pacific Design year book of 9 years in succession.

這是一組為「養真山房」中餐廳所創作的養生系列海報，其宗旨崇尚「天然食材，樸素養生」的理念。海報設計旨在用一種「安靜」的方式表達出拙樸至真的意境。

This is serious of posters designed for a restaurant called "Yang Zhen Shan Fang (養真山房)". Advocating the concept of "Natural ingredients, simple health", The posters express that "Natural is true" by using a "quiet" form.

1　2

1/ 茅台古鎮主題餐廳，LOGO 設計抓住了代表茅台白酒文化的「酒罈」及象徵苗寨文化的「銀飾」進行創作；標誌中圍合的動感水滴似熠熠生輝的銀飾，意象的詮釋出茅台古鎮悠久燦爛的白酒文化與獨具特色的苗寨風情；視覺推廣中黑色的運用平添了幾分神秘色彩；傳統韻味與民族風情用時尚且具個性的表達方式驚豔綻放。
The theme restaurant MAOTAI TOWN, the logo use the elements of wine jug to represent Mao-tai's culture of Chinese spirits, and use the elements of Silver jewelry to symbol the Miao Village culture; The enclosed drops of logo is similar to a shine silver jewelry, interprets MAOTAI town's long and splendid spirits culture, also shows the unique Miao Village style. As to visual communication, it use black color to add some feels of mystery, and the individuality expression of traditional charm and ethnic style is stunning.

2/「回顧即整理」——整理碎片，整理 7 年來點點滴滴的精彩。海報中數字「7」形如逗號，寓意繼續努力前行，空白的作品標籤與多重相疊加的各類字體所產生的「碎片」效果，增加了幾分作品的神秘感與觀者的期待感。
"Retrospection is sort out." - Sort out the fragment of 7 years. The shape of number "7" likes a comma, it means that we have to work hard and move on. The blank label and multiple types are mixed together then create a effect of "fragment ", it makes work have a sense of mystery, and increases the viewers' expectation.

■ 請問您如何獲得靈感？

「對未知事物的好奇」是獲得靈感的最好途徑。不過，這個獵奇的過程不足以轉化到作品當中，大多情況是要在安靜的狀態，再把這些「碎片」進行回憶、梳理、整合。總之「靈感多爆發於深夜！」

■ 請和我們分享您喜歡的書籍、音樂、電影或場所

推薦被譽為「右手東方，左手西方」音樂家林海，他的曲子悠遠而親切，音樂中既有西方古典韻律，亦保留了一份熟穩的中國氣質。他的作品絲絲入扣、濃而不膩，沁人心田。

■ 請問您做過最瘋狂或最酷的事情是什麼呢？

這個問題讓我忽然間發現自己是個特保守的人。太理性的青春，會錯過好多精彩。下一階段準備要瘋狂一下！

■ 請問您認為該國最棒的是什麼？（如國家的特色或文化等）您的創作是否受其影響？

當然是美食，沒有之一。我是一個吃貨，對餐飲專案的設計情有獨鍾。

■ 請問您一路以來的創作歷程（與創意／藝術／設計／插畫的邂逅，踏上這條創作路的歷程，旅途上遇見的瓶頸與突破方式）

「不忘初心，方得始終」
自 2004 年開始從事平面設計工作，已經整整十個年頭。也許是天生的自信不足，一直在找尋著種種的「認同」，努力使自己得到社會的認可、讓自己的專業得到肯定。生活在石家莊這樣的二線城市，對設計和市場隨性的認知，使我不太拘泥於行業程式化的法則，和我的團隊拼命地通過努力，讓品牌設計在商業中的影響作用不斷地增大，讓更多的客戶體會到品牌設計的存在與力量，為他們贏得更多的利潤空間與價值。現在，很享受執行一個案子，給客戶帶來全新利潤增長地快感，這種滿足感已遠遠超過了設計大賽的獎項。十年間「角色」也一直在發生著改變，從找工作到自己做公司、從設計助理到創意總監、從學生到老師，在這個過程中收穫了太多太多的知識、激情與感動，也慢慢變得世俗與慵懶。現在很想「放空」一下自己，渴望工作和生活的狀態變得就像歌詞裡寫的那樣「很簡單，卻很美好！」

How do you draw the inspiration?

"To be curious about unknown" is the best way to get inspiration. However, this process is not enough to transform into works, in many cases it had to happen in a quiet situation, then I recalled these "pieces", combed these, sorted these. Anyway, "inspiration almost breaks out at night!"

Share good books/music/movies/places with us.

I recommend Linhai, the musician who is regarded as "right hand represents the East, left hand represents the West." His music are old and intimate, with western classical rhythm and stable style of Chinese. His works are amazing and mellow, also deep inside your heart.

What is the craziest or coolest thing you have ever done?

This question let me suddenly know that I am very conservative. If you are too rational in youth, you will miss something Wonderful. I am already to do something crazy in next stage!

What is the best thing in your country? (likes features or culture)
Have it ever influence your creation?

Of course is delicious food. I am a gourmet, and specially love to work with catering project.

Share the story of you creating your pieces.
How did you encounter with creativity/art/design/illustration? And what happened? Have you ever been stranded at a bottleneck? And how did you overcome?

"Do not forget the original intention."
I have been working in graphic design for 10 years since 2004. I was not born with self-confidence, so I always looking for "recognition", working hard to make myself recognized by society and make my expertise to be confirmed. Living in Shijiazhuang such a second-tier city, with the awareness of design and market, I do not stick to the law of stylized industries. My team and I try to make the influence of brand design keep glowing in business market, to let more and more customers realize the existence and power of brand design, finally we can gain more and more profits and value for them. This sense of satisfaction is happier than any design award. In the period of10 years, the "role" changing constantly, form worker to boss, form design assistant to creative director, form student to teacher, I got so many things from this process lot: passion and emotion, even being secular and lazy. Now I just want to get myself "zone out", I hope my work life can change, like this lyrics say: "Simple, but beautiful."

劉君濤 Liu Juntao

liu13149@126.com

SGDA 深圳市平面設計協會 會員、ESSE 本質 合夥人、稀有記創始人
作品曾獲中國設計大展 入選、GDC11 入圍、靳埭強設計獎全球華人設計大獎賽賽 銅獎、字 匯——中美兩國字體設計邀請展、印象太倉平面設計邀請展、平面設計在中國 05 展 入圍、第六屆亞洲冬季運動會會徽設計 優秀獎、杭州城市形象標誌入圍、第十一屆中國廣告節 入圍。
作品曾入選《平面設計在中國05展》、《Brand! VOL.3》、《APD-亞太設計年鑑》、《國際設計年鑑》、《中國設計年鑑》、《中國 CI 年鑑》、《印象太倉》、《中國房地產設計年鑑》、《第十一屆中國廣告節獲獎作品集》、《包裝 & 設計》。

Member of Shenzhen Graphic Design Association(SGDA), partner of ESSE, a founder of " 稀有記 ".
Works won China Design Exhibition / Nominated, GDC11 / Nominated, Kan Tai-Keung Design Award / Bronze Award, US & China Typographic Poster exhibition, Image of Taicang City and Culture Graphic Design Exhibition. Graphic Design in China 05 Exhibition / Nominated, the 6th Asian Winter Games Emblem Design / Excellence Award, Hangzhou city image logo / Nominated, the 11th China Advertising Festival / Nominated.
Works were selected Graphic Design in China 05 Exhibition, Brand! VOL.3, Asia-Pacific Design Yearbook, International Design Yearbook, China Design Yearbook, China CI Yearbook, Image of Taicang, The Almanac of China real estate advertising , the 11th of The China Advertising Festival , Package & Design.

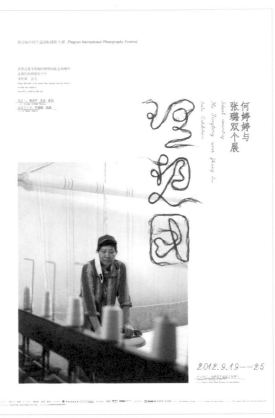

1　　2

1/《墨變 侯拙吾水墨作品展》洞察東西方文字形與義之異同，對之進行拼貼、重組，詮釋侯拙吾先生異象山水畫創造性的全新觀念。
This works observed the different and same of the Eastern and Western words of meaning and shape, then I collaged and restructured it to interpret Mr. Hou Zhuowu's new creative ideas of Chinese landscape painting.

2/《理想國》平面創意與日常生活材質的碰撞相遇。經驗性與實驗性的邂逅。創新的字體設計，剪不斷、理還亂，線元素的使用，表現小市民階層對於生活理想的糾結、同時又堅守的矛盾心理。
"Utopia," a graphic creativity run into life material, the encounter of experience and experiment. With the innovative font design and using elements of line, to express the contradiction mind of general public who are tangled but stick to life.

張浩 Mitch Zhang

ooorig@qq.com

源淶設計事務所創始人，作品曾多次入選《APD 亞太設計年鑑》、《國際設計年鑑》等，現任寧波城市職業技術學院工作室導師，寧波市文化館指定策展設計師。

Founder of ORIG BRAND DESIGN FIRM, works have been selected for APD pacific Design Yearbook, International Design Yearbook, and so on, the incumbent Ningbo City College of Vocational and Technical College of Art and Design Studio Instructor, Ningbo cultural centers designated curatorial designer.

愛情，不僅要用「眼」觀察，用「腦」思考，更要用「心」感悟，2 個人，2 條線，相互交織，從未知到已知的過程，從起點到終點，而設計就如愛情一般看起來複雜卻是單純。海報結合 3D 技術體驗，將複雜的圖形變的簡單而乾脆。(海報需戴 3D 眼鏡觀賞)

Love, not only to use the "eyes" to observe, with "brain" thinking, more should use the "heart" feeling, 2 people, 2 lines, intertwined, process from unknown to known, from the beginning to the end, designed as general looks complex is pure love. Posters 3D technology combined with experience, the complex graphics become simple and simply. (poster should wear 3D glasses to watch)

1 2

1/ 人生沒有終點。
Life has no end.

2/ 劉詩雨，又名點點，海報取「雨」字的四點作為海報的視覺核心。
Liu Shiyu, also known as little, four little posters take "rain" word as posters visual core

■ 請問您對於「創作」所擁抱的理念是什麼？從以前到現在，是否有所轉變？

以人為本。大的方向沒有改變過。

■ 請問您認為該國最棒的是什麼？（如國家的特色或文化等）您的創作是否受其影響？

漢字文化。影響很深，很多作品都是從字體中得到釋放。

■ 請問您如何獲得靈感？

一方面和人聊天，不同的人會給你不同的刺激，另一方面離開電腦，去體驗生活，任何設計、創意都是從人出發，人離不開生活。

■ 請和我們分享您喜歡的書籍，音樂，電影或場所

書籍《約伯斯傳》 / 音樂《卡農》 / 電影《七磅》《聽見天堂》。

■ 請問您做過最瘋狂或最酷的事情是什麼呢？

混入酒會大吃大喝。

■ 請問您最近最想什麼事情？是否已經著手規劃下一階段的目標或突破了呢？

最近在佈置新辦公環境和籌備一個公益專案。正在著手進行規劃一下階段的目標。

What is your "main idea" while producing a piece/series of work? Have it ever changed before?

People-oriented. The direction has never changed.

What is the best thing in your country? (likes features or culture)
Have it ever influence your creation?

Chinese character culture. It impacted me a lot, many works of mine are be released from the font.

How do you draw the inspiration?

On the one hand I chat with people, different people will give you different stimulus, on the other hand, I would leave the computer and go out to experience life, any design or creativity are starting from the people, people cannot live without daily life.

Share good books/music/movies/places with us.

The book Biography of Jobs / Canon music / movie Seven pounds and Red like the Sky.

What is the craziest or coolest thing you have ever done?

Mixed into a wine party and made a pig of myself.

What are the things you want to do most these days? Have you started to set up new goals or breakthroughs for next period?

Recently I am fixing up the new office environment and preparing a public welfare project. I'm going on a target next stage.

木子一飛 Mooz effie

www.oneonedesign.cn mooz_effie@foxmail.com

就讀於臺灣崑山科技大學，選定了以視覺傳達設計作為自己的事業，畢業後三年裡在靳與劉設計有限公司從事品牌設計，2014 年在深圳成立 ONE ONE DESIGN 擔任設計總監，並活躍於本地藝術與設計範疇領域，除工作以外更熱衷與展覽交流和與設計師的分享交流，積極參與各地設計講座、研討會及展覽。

作品多次入選本地及國際設計比賽：曾獲得 50 － 100 全球華人 80 後新銳設計師新人獎、Golden Pin、GDC13、OneShow、KTKAward、Hiiibrand Brand、Mut zur Wut、4th Bloc、9th Macao Design、2th Bamboo Living、Asia-Pacific Design 獎等項。

作品收錄於《APD 亞太設計年鑑 no.10》《50 ／ 100 新銳設計》《新平面》《中國廣告》《中國創意設計年鑑》。作品曾在德國、烏克蘭、臺灣、香港、澳門、北京、上海、深圳、廣州、杭州都有展出。

Mooz effie has Studied in Kunshan University Visual Communication department. Has work for KL&K Design with Brand Design after graduated. He founded ONE ONE DESIGN as a design director in 2014.He is active in local design realm. In addition to works, he is more likely to share and communicate with designer or exhibition; also he takes parts in design lectures, conference and exhibition around the world.

Works selected local and International design competition, for example: the SHDC 50/100 exhibition, Golden Pin, GDC13, OneShow, KTKAward, Hiiibrand Brand, Mut zur Wut, 4th Bloc, 9th Macao Design, 2th Bamboo Living, Asia-Pacific Design, etc.

Works were published by Asia-pacific Design 10, SHDC 50/100, NewGraphic, CHINAADVERTISING, China Creative Design Yearbook, and exhibited in Germany, Ukraine, Taiwan, Hong Kong, Macau, Beijing, Shanghai, Shenzhen, Guangzhou, and Hangzhou.

有些人談空卻又忘空，其實設計和空並無分別，同樣是執取而不放。戀空的人棄絕一切以求一個空字，最後還有一個「空」的意志無法除去。殊不知萬事萬物本空，棄與不棄都是空，有棄絕的念頭便已不空，愛空的念頭已是「有」了。說明了設計和空是不相礙而相同的。執著於設計的人不明白「設即是空」，執著於空的人也不明白「空即是涉」。

Some people talk about the 'empty' but forgot what the real 'empty' is. Actually, there are have no different between design and 'empty'. They are same in having obsessive and don't leave it. Some love 'empty' and throw everything away to reach 'empty', but in the end there is a will of 'empty' that can't be removed. They don't understand that everything visible is empty, to throw away and not to throw away are 'empty', but when you have the thought of 'empty', then the thought of 'empty' is already stand for 'exist'. It descript that design is the same with 'empty', people fixate on design don't understand that 'Design itself is emptiness'; the same to people fixate on 'empty'.

1 　 2

1/ 爵士音樂節海報，以跳躍的音符作爲靈感發源，在音樂的世界裏翱翔，帶動青春的生命，翻越著、滾動著、或靜謐地流動著。難以言語的情緒在瞬間化作音符的篇章，所有的一切巧妙地融合在一起，像一首樂曲，也像一篇詩章。

The Jazz Festival poster. In the inspiration of jumping notes, fly high in the music world. Let the youth lives crossing, rolling, or flowing with silence. The motion which can't tell instantly turned into a chapter, everything is mixed together, like a song, a poem.

2/ 爲再發現 OCT-LOFT 展覽設計的主題 [如夢初覺 -Find Your Dream]，再次發現與尋找我們曾經或者未來的夢想，找回最初夢想的初衷。在故地重遊，和回憶裡的一切相遇，就像是追逐著舊時光裡的自己一樣，感知每一寸的細微交替，在或不在，雲卷雲舒，發現新鮮與陳舊、同與不同，微乎其微，改變或多或少，漫漫長路，不忘歸期。

Find Your Dream - it is the theme of OCT-LOFT exhibition. To rediscover our dream in the past or future, find the original mind of dream. We get back to the old haunt and encounter those memories, just like we are chasing ourselves in the old days. Want to perceive every inch of slight alternation, want to see the cloud gather and then disappear. Discover fresh and old, the same and different, find something change or not. A long way to go, and one day we well return.

■ 請問您對於「創作」所擁抱的理念是什麼？從以前到現在，是否有所轉變？

創作對我而言，好比每天生活的養分一般存在，創作秉持著傳統文化、現代演繹；中國特色、國際視野。一直在不斷探索前行，尋找最核心、最接近的創作表現來詮釋當下的設計。

■ 請問您如何獲得靈感？

創作靈感源於生活感受，少不了平時對生活細微的觀察，發現些有趣、好玩、,感動的小事情，盡量保持好奇心和新鮮感，重新去認識和定義事物，會有不一樣的發現。

■ 請和我們分享您喜歡的書籍，音樂，電影或場所

喜歡書籍有李欣頻的《十四堂人生創意課》，李永銓的《消費森林 X 品牌再生》，音樂有新穎特別的方大同、成熟穩重的李宗盛、平實感動 Allan Taylor。

■ 請問您最近最想什麼事情？是否已經著手規劃下一階段的目標或突破了呢？

最近在嘗試設計以外的事情，讓自己更多參與設計管理、安排、計劃、指導等工作，希望可以更宏觀地看待一些問題，設計是固有的養分，要吸納其他更多的養分。

What is your "main idea" while producing a piece/series of work? Have it ever changed before?

Creating for me is just like daily nutrients of my life. I want to preserve the traditional culture modern interpretation; Chinese specialties and international perspective. Keeping exploring and going forward, searching for creative expression, which is the nearest approximation of core, to interpret the contemporary design.

How do you draw the inspiration?

Inspiration comes from daily life experience, to observe our life carefully, you can find some little things interesting, funny and touching. Try to keep curiosity and freshness, to recognize and define thing again, then you may discover something different.

Share good books/music/movies/places with us.

Book: 《十四堂人生創意課》 written by 李欣頻 and 《消費森林 X 品牌再生》
Music: I love Khalil Fong the singer, who is novelty and special. I also love the music by Jonathan Lee; his music is mature and steady, and Allan Taylor, who has the feature of simple and touch.

What are the things you want to do most these days? Have you started to set up new goals or breakthroughs for next period?

I'm trying something other than design, to make myself involved in the works of design, management, arranging, planning and guidance, etc. I hope to look at some issues with broader sight. Design is my inherent nutrients, got need to absorb more nutrients in addition to design.

中國 CHINA

覃寶鋼 Qin Baogang

whodesign@163.com

八零後，北京印刷學院設計藝術學碩士。先後供職於尤倫斯當代藝術中心，北京正邦品牌顧問服務集團，751 北京時尚設計廣場。
2014 年創立北京如是品牌設計。

After eight zero, Beijing Institute of Graphic Communication master's degree in art design. Has worked Ullens Center for Contemporary Art, Beijing Zhengbang brand consultant services group, 751 Beijing Fashion Square Design Founded Beijing Rushi brand Co. Ltd. in 2014

北京國際設計周－751 國際設計節：2014 年 751 國際設計節的主題是匯設計・慧生活，依照 2013 年六邊形主視覺的基礎上創作了一系列融匯各路設計以及美好燦爛生活的圖形，以體現設計週蓬勃發展發展的願望。

751 IN'L DESIGN FESTIVAL: the theme of Collecting design・Intelligent life, which accordant with the base of a main visual of hexagon, creating series of diverse design and the graphic about wonderful and brilliant life, to reflect the wishes of booming development of Design Week.

沙鋒 Sha Feng

www.facebook.com/feng.sha.10　258899857@qq.com
shafeng2588@hotmail.com

江蘇靖江人,設計師、策展人。義大利佛羅倫斯美術學院在讀碩士。義大利中意設計協會 (ADCI) 主席,國際平面設計協會聯合會 (ICOGRADA) 會員,美國平面設計協會 (AIGA) 會員,視覺戰略聯盟理事,英國 AOI 國際插畫協會會員,中國包裝聯合會設計委員會全國委員,2013 法國 POSTERFORTOMORROW 國際海報節國際評委。2013 首屆中意青年藝術家聯展 / 中方策展人,2014 亞洲平面設計邀請展 / 國際策展人,2015 中意國際設計週 - 進化中的絲綢之路 / 總策展人。作品曾獲得 2014 義大利 A' Design Award 國際設計獎金獎、銀獎、銅獎,美國洛杉磯 IDA 國際設計獎銅獎。作品曾先後入選過 23、24 屆波蘭華沙國際海報雙年展,12、13 屆墨西哥,19 屆美國科羅拉多,俄羅斯金蜜蜂,捷克布爾諾等國際海報雙年展。

Sha Feng Jiangsu, China. Designers, Curator. Associazione di Design Cinese e Italiano in Italia(ADCI) / President,(ICOGRADA) Member, (AIGA)Member, visual director of strategic alliances, 2013 French Poster For Tomorrow international Poster Festival International jury, 2014 Asia international Graphic Design Invitational Exhibition curator. The works have been wined A 'Design Award International Design, Italy: Gold Award, Silver; Los Angeles IDA International Design Award Bronze Award. The Works have been selected for the 23th, 24th Warsaw, Poland, 12th,13th Mexico, 19th Colorado(CIIPE) ,11th Golden Bee, 26th Brno, Slovakia, Greece, Santorin and other International Poster Biennale.

很多女人當進入婚姻殿堂的時候，她們卻發現她們不是妻子的角色，而是丈夫手中的玩偶。她們受到者各種暴力的摧殘，各種殘忍的迫害。白色的婚紗漸漸染成了血紅色。反對家庭暴力、反對玩偶婚姻，還給她們真正的妻子身份。

Many women when entering the marriage, they found they were not the role of the wife; instead, they are dolls in the hands of their husbands. They were subjected to all kinds of violence, destruction, variety of cruel persecution. White wedding gradually dyed blood red. Against domestic violence, opposition doll-style marriage pattern let the wives returned to their true identity.

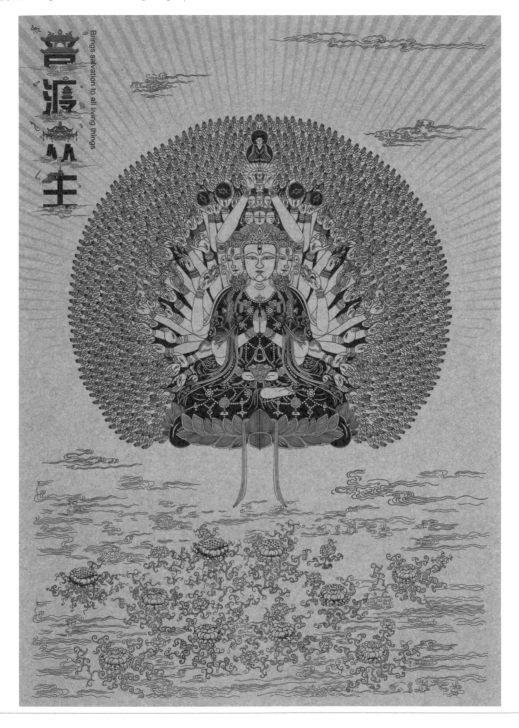

2015 第 19 屆美國科羅拉多國際海報雙年展入選獎
2014 第 13 屆墨西哥國際海報雙年展入選獎
該作品以傳統的觀音佛像為原型，觀音有救世於萬恩，寓意將普遍引渡所有的人，使他們脫離苦海，登上彼岸，最終達到眾生平等。

The work as the prototype of Guanyin Buddha, Guanyin salvation in Wan en, meaning universal extradition of all people, to enable them to misery, and boarded the other side, and ultimately achieve all creatures are equal.

■ 請和我們分享您印象最深刻的結案經驗。

對我而言印象最深刻的是受邀參加《舌尖上的中國 2》海報設計大賽，獲得了銅獎一次非常大的肯定。我一直將中國文化元素與西方海報形式結合來創作。該海報展參賽作品眾多，精品甚多，能獲得銅獎實屬難得。

■ 除了設計師的身份您也擔任策展人，請和我們分享您最特別的策展經驗。

最喜歡的是舉辦《2015 中意國際設計週 - 進化中的絲綢之路》的經驗，原因是該展覽是我第一次以總策展人的身份進行國際策展工作，也是第一個由義大利中意設計設計協會主辦的大型國際設計展。本人也是該協會的首屆主席。該展覽共收到 15 個國家 1210 件作品投稿，最終展出作 225 件，邀請和徵集到了來自美國、義大利、中國、波蘭、墨西哥、韓國、厄瓜多爾、北愛爾蘭、俄羅斯、伊朗等地區 100 多名設計師的參與。其中更包含著名的設計師 AGI 會員，如 Leonardo Sonnoli、Erich Brechbühl、Finn Nygaard、Sabina Oberholzer & Renato Tagli、Peter Bankov 等設計師。讓自己的國際視野變得更加寬闊，也讓中國文化帶入世界。

■ 請問您如何獲得靈感？

我是通過閱讀中國古典典籍來獲取這些元素，例如易經、道德經、鬼谷子等。其次通過翻閱佛教、道教中的雕塑、壁畫元素來進行設計項目積累。興趣是最好的老師，當你喜歡一樣事物時，你會不自覺地去搜集其中的資料，樂此不彼。

■ 請問您對於「創作」所擁抱的理念是什麼？從以前到現在，是否有所轉變？

目前本人正在義大利留學，我一直想把中國傳統文化帶入到西方，將中方的文化底蘊和西方的設計形式相結合，真正的做到中西結合。我的設計作品一直把文化放在首位，一個有內涵的作品才能夠去慢慢品味，而這其中的滋味就在於文化。然後用西方的形式美來相齊點綴，最後達到和融。

Share your most impressive freelancing experience with us.

For me, the most impressive is invited to participate in "A Bite of China2" poster design competition, I won the Bronze Award. For me, it is a very large affirmed. I often create posters to use the China and Western cultural elements. There have many entries, many good works, so it is hard for me to get the Bronze Medal.

In addition to being a "designer", you also serving as curator. Share with us your most special curating experience.

My favorite is held "2015 China-Italy International Design Week- The Evolving Silk Road" experience, the reason is that the exhibition was my first time as chief curator to do international curatorial work, and the exhibition sponsored by the Associazione di Desgin Cinese e Italiano in Italia. I am also the first President of the Association. The exhibition received a total of 15 countries works 1210 submission, the final 225 works on display, invited and collected the more than 100 designers from United States, Italy, China, Poland, Mexico, South Korea, Ecuador, Ireland, Russia, Iran and other regions. Which contains more famous designer such as AGI members: Leonardo Sonnoli(AGI), Erich Brechbühl(AGI), Finn Nygaard(AGI), Sabina Oberholzer(AGI) & Renato Tagli, Peter Bankov and other designers. Let myself become more broad international perspective, but also to Chinese culture into the world.

How do you draw the inspiration?

I get these elements through reading Chinese classics books, such as the I Ching, the Tao Te Ching, and Guiguzi, etc. Second, I admire leafing of Buddhism and Taoism, to collect one of the design elements. Interest is the best teacher, just like when you like something, you will not consciously to gather information which benefited.

What is your "main idea"while producing a piece/ series of work? Have it ever changed before?

I am currently studying in Italy, I was trying to bring traditional Chinese culture to the West, the Chinese cultural heritage and Western design combines form, really do WM. My design work has been used the culture in the first place, one work se has the connotation will be able to savor, and this is that the taste of culture. Finally it can reach origin.

施元欣 Shi Yuan-xin

www.moko.cc/abake/ shiyuanxin@cafa.edu.cn / abake7@163.com

1983 年生於中國廣東省潮州市，漢族，2007 年創辦非盈利設計工作室，2008 年畢業於韓山師範學院美術系獲學士學位，畢業後曾工作於肖勇設計顧問（北京）有限公司，設計師兼專案主管助理。2009 年至今任教於中央美術學院實驗藝術學院，兼行政教學秘書。現生活，工作於中國北京。

一直以來將置身於當代藝術與設計領域研究工作，具有開創性、探索性、作為可持續藝術實踐的實驗者。開創實驗性藝術與設計研究，具有對傳統文化，材料、影像行為等形式語言表達的敏感性，從而探索實踐出藝術與設計的獨立形式語言和對人的思維具有啟發性的價值。

I was born in 1983 in Chaozhou City, Guangdong Province, China. In 2007, I founded a non-profit design studio. In 2008, I graduated from the Fine Arts Department of Hanshan Normal University with bachelor degree. After graduation, I worked for Xiao Yong Design Consultant (Beijing) Co., Ltd., as the designer and the project manager assistant. Since 2009, I taught at the China Central Academy of Fine Arts Experimental School of the Arts, also work as Chief Secretary of teaching. Now I live and work in Beijing, China.

As a practitioner of Sustainable Art, I have been always in the pioneering and exploratory study of Contemporary Art. I start a study of art and design of experimental, with sensitivity to the expression of form languages such as traditional culture, material, and image behavior. Through the exploration and practice, I have found the independent form language of art and design, and helped inspired the human thinking.

漢字是華夏文明的根，是數千年歷史文化的載體。從新文化看漢字、從漢字看新文化，以新鮮見解和豐富資料深刻論述了漢字的文化意義和字裡的「天地乾坤」。凹凸其主要意思莫過於形容事物的外在形式所傳達出來的客觀資訊罷了。而我用全新的設計理念灌入其中。「凹」的體質與「凸」相對，以及兩者的對抗，不如兩者的相互包容而接納。

The Chinese character is the essence of thousands of years of Chinese history and culture, and the root of Chinese traditional civilization. With fresh insights and a wealth of information, Chinese characters make a deep discussion of the cultural significance in words. The Convavo-Convex mainly talks about the objective information that outward forms passes. And my work reflects a different thinking of design that there should be integration rather than discrimination, tolerance rather than fight.

1 2

1/ 在中國古代思想史上，和諧一直是個哲學命題。《六韜·龍韜·立將》：「是故風雨時節，五穀豐登，社稷安寧。」構建社會和諧離不開國泰民安，風調雨順，五穀豐登，人物康阜，真是昇平世界。

Harmony has always been a philosophy problem in the academic history of ancient China. Building a harmonious society means stability and prosperity, the grain to be abundant, as well as a good time.

2/ 說到「家」，不由得讓我們想起了厝（潮汕人常稱屋為「厝」）。「厝」是我們祖祖輩輩居住的地方，也是生我養我的地方，回憶起往日徜徉在幽深而曲折的窄巷，撫摩那悠久而粗糙的牆壁，忘不了「厝」那古老的影子。

Speaking of "home", could not help but let us think of Cuo (Chaoshan people often referred to housing for the "Cuo"). "Cuo" is our lived for generations, is where I was born I have recalled the past, wandering in the deep and winding alleys, smoothed the long and rough walls, forget "Cuo" the old shadow.

■ 請問您對於「創作」所擁抱的理念是什麼？從以前到現在，是否有所轉變？

創作之初主要源於我對現實生活周邊事物的敏感，從日常生活中收集和吸取本土文化，結合我所掌握的設計理論進行創作。

由於視野的開闊所導致對之前的創作有了新的理解，把自我置身於大文化環境中去尋找每個小我存在的價值與定位，尋求與當下社會的某種關係。唯有不變的是我從不迷戀於某種傳統文化符號樣式，也從不固守一種模式去創作，也就是我的「求變」法則。時代在變，我們所處的文化環境也在不斷的變化和發展著，我認為創作要多元，要與這個時代精神的核心價值「相融」或「碰撞」，在這過程中能夠引起人們更深的思考，抑或提供更有營養的精神食糧，想必這是我的創作理念或動力吧。

■ 請問您認為該國最棒的是什麼？（如國家的特色或文化等）您的創作是否受其影響？

中國的特色也就是文化的特色，有傳統文化、當代文化。我比較喜歡觀察與琢磨飲食文化，自認為飲食文化是最為純粹的，也是最為傳統的，它一代傳一代無須杜撰捏造，不同環境所接受的味覺（又味）訓練不同。是的，一直深受我國現當代文化的影響，我想每個人都無法擺脫自己國家大環境的影響，我想有自覺的人會去追溯傳統遺留下來東西，例如通過中華的飲食習慣來展現食物給中國人生活帶來了儀式、倫理等方面的文化。

■ 請問您一路以來的創作歷程

我常把創作和創造混淆在一起去理解，它是為人類生活所需的創造而產生，沒有創造性的創作不是我想要的。如在創作中遇到瓶頸時，我會停下來對著窗外的風景猛力地呼一又氣，把堵住「瓶頸」的那又氣竭盡全力的呼出去,將自己置身在放空的狀態下再緩緩大吸一又氣，這樣的一個過程能達到自我放鬆狀態。創作時要學會鬆弛有度，方能深遠兮。

■ 請問您如何獲得靈感？

創作靈感大都來自於我的日常生活環境中，通過自身的感官體驗，多維度的視覺、聽覺、嗅覺、味覺、觸覺，去捕捉有效的資訊成為創作的靈感來源。也可以說和我的器官發生過碰撞的任何事與物，而這些有意無意的感官刺激會讓我的靈感源源不斷地流動著。

What is your "main idea" while producing a piece/series of work? Have it ever changed before?

I have a keen sense of observation. I create by using the local cultures I've learned through observing my daily life, and combine with the theory of design.

Due to the board of vision, I have new comprehension of my creations, putting myself into a large cultural environment to find the value and location of my existence, and seek for some relationship with contemporary society. The thing that has never changed is I do not obsessed with a certain style of traditional cultural symbols, either to stick to a model of the creation, that is my rule of "keep changing", The culture environment are constantly changing and developing, so I think the creations should be diversified in order to "mix" or "crash" the core value of times spirit. In this process can get people think deeper or offer more nutritious food for thought, this is surely my main idea or motion of creating.

What is the best thing in your country? (likes features or culture)
Have it ever influence your creation?

Chinese characteristic is all about culture. Weather the traditional culture or modern culture, I prefer the food culture of China. It's my favorite. From the most ancient of time since the human exist in the history, so does the food culture. It's being passed on from generation to generation and evolves along with the time. There is no need to fabricate such history. Food culture also has a great influence to Chinese rituals and ethics. In this modern society nowadays, it is hard not to be affected by the contemporary cultures. Yet, for those who have the awareness of that, will start to seek the traditions that remain in the history.

Share the story of you creating your pieces.

Creation and creativity. A creation without creativity is not what I'd like to create. And that's when I encounter obstacle. In this sort of situation, I like to face the window toward the world outside, and take a deep breath then split it out, along with the obstacle that's suffocating me, and keep continuing the process. I've learned to be flexible while creating. Taking a rest helps going further.

How do you draw the inspiration?

My inspirations come from my daily life, by capturing information with all my senses- vision, hearing, olfaction, gustation and feeling. And the captured information stimulates my mind to come up with new notions. Thus the inspirations out flows.

汪泓 Wang Hong

wanghongdesign@126.com

畢業於四川美術學院，碩士，四川美術學院設計藝術學院視覺傳達系講師，在野設計有限公司創始人／創意總監。
作品榮獲 Tokyo TDC 2015／入選，2014 傑出華文漢字設計作品展（臺灣）／入選，亞洲平面設計邀請展（韓國／北京／義大利）／入選，第十二屆全國美展／入選，氣韻中國2014設計邀請展／特邀，20/20 澳門字體百分百設計交流展 2014／特邀，第 24 屆波蘭華沙國際海報雙年展／入選，香港設計師協會 · 環球設計大獎 2013／銀獎，香港國際海報三年展 2014／入選，平面設計在中國 · GDC13 展／海報類／最佳獎，中國設計師年展（北京）／評委提，第十一屆全國美展／入選，迎世博 · 上海國際海報展／入選，第四屆寧波國際海報雙年展／入選。

Wang Hong, Graduated from Sichuan Fine Arts Institute, Degree of Master, Vision Communication Dept. Of Sichuan Fine Arts Institute, Lecturer, Founder& CD of Zaiye Design Co.Ltd.,Chongqing.
Tokyo TDC 2015/ Invited, chinesecharactersdesign2014/ Invited, AGDIE Asian Graphic Design Invitation Exhibition/ Invited, 12th Session National Arts Exhibition/ Selected, China Spirit Design Invitational Exhibition/ Invited, 20/20 Macao Fonts 100% Design Exhibition/ Invited, Warsaw 2014 24th International Poster Biennial/ Invited, HKDA Global Design Awards 2013/Silver, Hong Kong International Poster Triennial 2014/ Selected, Graphic Design in China·GDC13 Exhibition/ Posters/ Best Award, Chinese Designers Exhibition (Beijing)/Judges Nominated, 11th Session National Arts Exhibition/ Selected, Welcome World Expo·Shanghai International Posters Exhibition/Selected, 4th Session Ningbo International Posters Biennial/Selected.

「亞洲綠色設計活動週」是由文化部中外文化交流中心和四川美術學院聯合主辦的大型設計交流學術活動，活動旨在推進綠色設計可持續發展。設計週形象將漢字作為視覺基礎，強調本土性，將生態象形圖式貫穿其中，字體輪廓圓潤、流暢、象形，形如太湖石、假山、流水、林間鳥語撲人。在傳統意識形態上追求設計語言的當下時代特徵，力在探索平面視覺語言的實驗意義。

ASIAN GREEN DESIGN WEEK is a large-scale exchange of academic activities jointly held by the Ministry of Culture, Cultural Exchange Center and Sichuan Fine Arts Institute, which is aimed at promoting green design and sustainable development. The visual image of Design Week is based on Chinese characters, emphasizing indigenous, ecological pictogram style, which runs through the font outline rounded, smooth, pictograms, shaped like Taihu, rockery, running water, birds-singing in the grove The whole design pursued characteristics of the times in the traditional ideology and explored Experimental significance of graphic design.

《意象文字》系列漢字海報分別將「黃金萬兩」、「招財進寶」、「日進斗金」民間吉祥用語重構，通過漢字結構、筆劃組合、輪廓意象重新定義，借用民間漢字拓展漢字設計的空間。

In this series, there are three sets of phrases of blessing. Which are " 黃金萬兩 " – tons of gold, " 招財進寶 " – bringing rich picking and " 日進斗金 " - making fortune each day. Through combining elements - structure, number of brushstrokes, out lines, of each individual Chinese characters. Redefining the way of designing Chinese characters.

■ 請問您對於「創作」所擁抱的理念是什麼？從以前到現在，是否有所轉變？

What is your "main idea" while producing a piece/series of work? Have it ever changed before?

最初學設計時認為設計就是要解決問題，是一個單一的目的。當通過設計為品牌、企業、社會解決了一些問題後，才發現設計的意義並非如此簡單！設計其實是一種方式、一種過程、一種態度，它依附於生活，改變著生活，充滿著責任，設計需要把「美」回饋當下，當然也需要對未來提出質疑。

I used to think that the purpose of design is to solve problems in the beginning. After I did some cases and solved some problems, through designing, for some brands, companies and society. I realized the purpose of making design is not so simple. I realized that design is an attitude, it's a way of living, and it's a progress. It's within the living itself, but holding the power to change from with also. It has the responsibility to bring the beauty to the world, and to call future into question.

■ 請問您認為該國最棒的是什麼？（如國家的特色或文化等）您的創作是否受其影響？

What is the best thing in your country? (likes features or culture) Have it ever influence your creation?

中國最博大精深的就是「傳統」，「傳統」的意義在於傳承。設計的創新需要一端紮根「傳統」，一端著眼「傳統」。在創作中，我經常向過去（傳統文化）學習，去發現土壤中的營養。生活中常常對「老物件」愛不釋手，每到一地，博物館是首要的固定行程。我相信設計尋根是設計的重要營養來源，當然設計不應該是簡單的「借用」傳統，更需要長期的「浸染」，從而在設計中自然轉化。

Tradition is the most profound inheritance of China. So to pass on the tradition is vital. Thus, to design is to find the roots of tradition in innovation. I've been learning a lot from studying the tradition of my country. I love old things, I couldn't get my hands off them, and wherever I go, visiting the local museum is always in my bucket list, it's the most-go spot. I believe finding the roots in tradition becomes the energy of your inspirations. Therefore, "imitating" is not the way it should be done, instead, immerse yourself into the tradition for a long term, and so will your design be transformed.

■ 請問您如何獲得靈感？

How do you draw the inspiration?

這個問題似乎對於設計師是一個十分重要的問題，但我認為它其實並不重要。所謂的靈感一定是建立在長期的經驗、經歷之上，它的出現並非偶然。遊弋於本土文化和外來文化之間是獲取靈感的一種途徑，最奏效的方式就是：旅行。

This seems like a vital question to a designer. But I disagree. The so-called "inspiration" should actually be something based on the accumulation of experiences rather than a coincidence. Thus, how do you start gaining experiences? Well, he that travels far knows much. Roving from your homeland to the foreign seas, that's one way of gaining experiences.

■ 請問您最近最想什麼事情？是否已經著手規劃下一階段的目標或突破了呢？

What are the things you want to do most these days? Have you started to set up new goals or breakthroughs for next period?

最近在準備一個小型的個展，嘗試著做一批實驗性的作品，對設計語言作一些探索。我覺得設計師應該有一些理想化情節，不能只是就問題解決問題，設計不應該一味從專案出發，有時設計師也應該自我反省，思考設計的意義，對不確定的問題進行探索。

I'm doing preparation for a small exhibition. And I would like to do something experimental. I think the designers mind should be unconstrained, to be more idealistic rather than just being particular. In the designer should be able to do critical thinking, thinking about the meaning of design, and to be able explore what is uncertain.

王強 Wang Qiang

94788494@qq.com

現任教於湖南省湘潭職業技術學院講師，作品曾獲得文化部、財政部、全國文化產業創意人才扶持計畫重點扶持對象，中國高等院校設計藝術大賽三等獎、中國包裝創意設計大賽三等獎、中國國際廣告節黃河獎優秀獎、中國之星設計藝術大賽優秀獎、APD- 亞太設計年鑑入編、塞爾維亞國際大學生海報雙年展入展、伊朗德墨蘭國際 Asam-ulHusan 字體海報年度展入展、芬蘭拉赫蒂海報雙年展入展、韓國國際海報雙年展入展、德國萊比錫國際海報展入展。

Now teaching as lecturer in Xiangtan Vocational & Technical College in Hunan. Won the National Culture Industry Creative Talents Awards issued by Ministry of Culture and Finance, the third prize of China's design art competition in colleges and universities, and China's packaging creative design competition, the Merit awards of China's international Advertising Festival, and The China Star Design Art Competition; Works selected by APD-Asia Pacific Design, and exhibited in Serbia World Biennial Exhibition of Student Poster, Iran International Typography Exhibition "Asam-ulHusan", Lahti Poster Biennial in Finland, International Poster Exhibition Korea, and International Poster Exhibition Leipzig.

孔子文化節所設計形象宣傳海報，紀念孔子對人類文化的傑出貢獻，弘揚中華民族優秀傳統文化。將傳統與現代融合為一體來表現當下中國文化的魅力與趣味，給古老元素注入新的活力。

The propaganda poster designed for Confucius Festival is to commemorate Confucius who made an outstanding contribution to human cultures and carried forward the China's fine and traditional cultures. Combined the traditional and contemporary elements, the poster presents the charms and interests of current Chinese culture, which is brought new vitality with the ancient elements.

1 2

1/ 黑人不是標靶！呼籲人權平等，保護黑人權益。
Blacks are not the target! Call for the equal human right. Protect the legal rights of Blacks.
2/ 此作品是為紀念德國第一次世界大戰爆發 100 週年 (1914-2014) 而設計，作品以德國國旗為創作元素，意在讓人民勿忘傷痛，珍惜和平。
The poster is designed to commemorate the 100th anniversary of the outbreak of the World War1 with the German flag as the creative elements, which aims to mind people not to forget the pain and cherish the peace.

■ 請問您對於「創作」所擁抱的理念是什麼？從以前到現在，是否有所轉變？

希望能傳達出個人對社會事物的觀點和看法。以前注重作品外在形式的表現，現在更注重作品理念的傳達。

■ 請問您認為該國最棒的是什麼？（如國家的特色或文化等）您的創作是否受其影響？

傳統文化體現了中國國家的特色，最具有符號特徵，一直以來都潛藏在我們的日常生活與思想意識之中，已經深深融入我們的血脈裡，是一種文化基因的遺傳。如果能在作品中滲入中國傳統文化元素，一定會使人倍感親切，從而產生意想不到的效果。

■ 請問您如何獲得靈感？

靈感來源應該是生活吧，生活中各種資訊、事物都會對你的創作產生影響。平時多看看展覽、雜誌、電影、旅行等等，都可以從一些觀點中吸取營養，再從這些生活累積中找到適合的元素去發揮，所以我覺得持續的補充養分是一個關鍵。

■ 請和我們分享您喜歡的書籍，音樂，電影或場所

我個人比較喜歡韓國導演金吉德的作品，每一部作品帶有金吉德獨特的個人魅力，其中最喜歡就是《春夏秋冬又一春》，以隱喻的形式反應社會現實，影片中遍佈著各種暗示符號，具有極強的形式感。

What is your "main idea" while producing a piece/series of work? Have it ever changed before?

I hope my works can express my points and views to the society. I used to pay attention to the outer presentation, but now, I more care about the inner thinking communication in my works.

What is the best thing in your country? (likes features or culture)
Have it ever influence your creation?

Hidden in our daily lives and thoughts, and integrated into our blood, the traditional culture, as the inheritance of cultural genes, can present our China's features. If the traditional culture elements can be applied to the works, the effects must be marvelous and it can make people feel agreeable.

How do you draw the inspiration?

The inspiration may be from the lives, since lots of information and things in lives could influence your creation. We could absorb the nutrition from some views if we spend more leisure time on attending exhibition, reading magazines, watching movies and traveling, etc., from which the suitable elements can be discovered for further creation. Therefore, the continuous learning and absorbing is the key to me.

Share good books/music/movies/places with us.

Personally, I prefer the works of South Korean director Kinkead, since his own unique charms will permeate through each of his movies. One of my favorite movies is his work Spring Summer Fall Winter and Spring, which was filled with all kinds of implied symbol to reflect the social reality in metaphorical way.

王瑞峰 Wang Ruifeng

besthqn@163.com

傾目堂設計視覺形象總監，多年來致力於品牌視覺形象設計。作品曾榮獲第六屆北京國際商標節雙年獎優異獎、第七、八屆方正字體設計大賽創意字體優異獎及入圍獎、2012 年「龍行天下」全球設計大賽入圍獎、2014 中國「春節符號」全球徵集大賽入圍獎等，另其設計作品入選第七、八、九、十屆《亞太設計年鑑》，2013、2014《國際設計年鑑》、第七、八、九屆《中國設計年鑑》，《2010 中國新銳設計師》等。

I'm the visual design director of Qingmutang design workroom, and work at brand VI design for more ten years. My works have won the Outstanding Award of the sixth session of the Beijing International Trademark Festival. I also got excellence awards in the seventh and eighth sessions of the Founder creative font design competition, and the entry award of CIDC 2012 Global Design Competition. Recently I got the entry award of 2014 Chinese "Spring Festival Symbol" Worldwide Collection Activity. Many works were printed in the many famous design books, including the seventh, eighth, ninth and tenth annual APD, 2013, 2014 International Design Yearbook, seventh, the eighth or ninth session of the Chinese Design Yearbook and 2010 China design outstanding designer, etc..

禁煙是個永恆不變的主題，此款海報以抽煙后吐出的煙圈為設計元素，飄然的煙圈構成骷髏幽靈印象，含義吸煙後的短暫快感實際是與死亡之神的親密 " 接吻 "。煙圈變換出上帝的影像，是召喚還是警示？紅色英文與口形的結合，是發出強有力的無聲抵制！

No Smoking is a constant theme. The main design element of this poster is to spitting out the smoke rings after smoking. Floating smoke rings constitute the skeleton and ghost impressions. It means a short pleasure after smoking just like a kiss with the god of death. Smoke rings transform the image of god, is it calling or warning? The red words combines with the shape of the mouth, that means a powerful silent resistance!

裁衣 Cloth Cutting | 2013
半日浮生 Smell the flowers | 2014

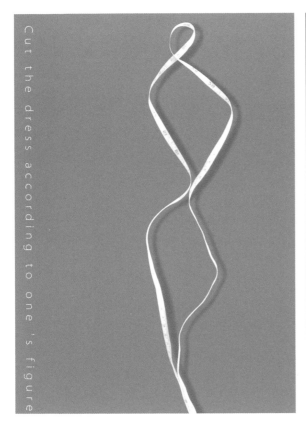

Cut the dress according to one's figure

1　2

1/ 這是一款為女士服飾品牌設計的形象海報，名為「裁衣」，意為「量體裁衣」。一條軟尺構成女性婀娜多姿的身形，突出了該服飾品牌專為女性量身設計，直觀生動地傳遞著其品牌設計之內涵。簡潔是該服飾的風格，亦是此款海報的清晰定位。

This is a poster designed for ladies clothing brand image, named as the "Cloth Cutting", and means "tailored". A flexible rule constitutes women graceful shape. It highlights the clothing brand designed for women, and conveys the connotation of the brand design intuitively and vividly. Brevity is the style of the dress, also is a clear positioning of this poster.

2/ 「蓮生浮屠，半日得閑」，一段靜心念佛的美好時光，恍如蓮開眼前，醉心半日。

"Lotus born pagoda, have a half day to spare"
A good time for chanting quietly, just like lotus opening in front of me. I dreamed for a half day.

■ 請問您對於「創作」所擁抱的理念是什麼？從以前到現在，是否有所轉變？

回歸本源，追尋事物的本質及其規律。
不會轉變。

What is your "main idea" while producing a piece/ series of work? Have it ever changed before?

Returning to the origin, and search for the nature and rules of things.
Never change.

■ 請問您認為該國最棒的是什麼？（如國家的特色或文化等）您的創作是否受其影響？

感覺現在大陸最好的是保留下來的歷史古跡，因為它們真實，可以親眼所見。
恩，有所啟發。

What is the best thing in your country? (likes features or culture)
Have it ever influence your creation?

My feeling now is that the preserved historical sites are the best, because they are real, and can be seen.
Yes, be inspired.

■ 請問您一路以來的創作歷程（與創意／藝術／設計／插畫的邂逅，踏上這條創作路的歷程，旅途上遇見的瓶頸與突破方式）

一切都是從菜鳥開始，慢慢學習，不斷嘗試，敢於接受新鮮的事物。積極關注當下設計趨向，與同行交流，並肩同行。

Share the story of you creating your pieces.
How did you encounter with creativity/art/design/ illustration? And what happened? Have you ever been stranded at a bottleneck? And how did you overcome?

I often learn the foreign best works on the web, and constantly trying or deny myself. I dare to accept new things, and often communicates with other good designers, studying design trend. I also read many about cultural books. In one word, learning is important thing for every designer.

■ 請問您如何獲得靈感？

清空自己，讓自己靜下來，慢下來。

How do you draw the inspiration?

Empty myself, stay with myself, calm down and slow down.

■ 請和我們分享您喜歡的書籍，音樂，電影或場所

在茶室發呆或看看黑澤明的電影。

Share good books/music/movies/places with us.

In the teahouse stunned or see Akira Kurosawa's films.

■ 請問您做過最瘋狂或最酷的事情是什麼呢？

呵呵，這個還真沒有。

What is the craziest or coolest thing you have ever done?

Hei hei......, Nothing.

■ 請問您最近最想什麼事情？是否已經著手規劃下一階段的目標或突破了呢？

旅行，去看看大漠孤煙直......
恩，正在構想如何突破自己。

What are the things you want to do most these days? Have you started to set up new goals or breakthroughs for next period?

Traveling, or looking at the desert solitary smoke straight......
Yes, I'm thinking how to breakthrough myself.

王曉雪 Wang Xiaoxue

xiaoxuelovers@hotmail.com

2008 深圳大運會海報設計競賽優秀獎、2008 可口可樂瓶形象設計競賽銅獎、2011 中國臺灣國際海報設計優秀獎、2011 日本 TDC 銅獎、2011 香港環球設計競賽銅獎、2011GDC11 入圍獎、2012 中國設計大展、2013GDC13 入圍獎、2013No.9 設計年鑑、2015 日本 TDC15。

2008 Shenzhen University Poster Design Competition Merit Award, 2008 Coca-Cola curved bottle design competition Bronze, 2011 China Taiwan International Graphic Design Competition Merit Award, 2011 Graphic Design in China (GDC0 Finalist, 2011 Hong Kong (HKDA) Universal Design Bronze, 2011 Japan Tokyo Type Directors Club (TDC) Bronze(The work exhibitioned) at the ginza graphic gallery in Tokyo and in June at the ddd gallery in Osaka.),2012 China Design Exhibition,2013 Graphic Design in China (GDC) Finalist,2013 The Work Have Been Selected In Asia-Pacific Design No.9,2015Japan Tokyo Type Directors Club (TDC).

這系列海報是關於「人權」的公益海報設計，以此來呼籲人類擺脫一切壓迫、剝削和歧視，鼓勵人類戰勝內心的羞澀，展現才華與個性，因為我們天生如此。

This series of posters is a public service poster design for "human rights," in order to appeal humanity to rid of all oppression, exploitation and discrimination, encourage mankind to overcome inner shyness, show case their talent and personality, because we are born this way.

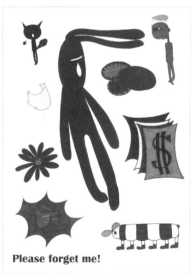

1　2

1/ 在古老的中國，有這樣的習俗，少男少女在訂婚後，未等迎娶過門就因故雙亡。老人們認為：只有舉行陰婚儀式，家宅才能安定。與梁祝的相同之處在於對人類渴望精神與意識的延續，渴望超出死亡的界限。最終實現「亦生亦如死」的永恆境界。

In ancient China, have a custom, the boys and girls died before engagement for some of the reasons. The old people think: just only held a ghost marriage ceremony, the family will security. Similarities with the Butterfly Lovers is that the human desire for the continuation of the spirit and consciousness, eager beyond death. At last we will achieve eternal realm "Alive and death are the same".

2/《請把我忘記！》是關於青春主題的海報，那時我們天真、那時我們浪漫、那時我們開心就笑、那時我們傷心便哭泣、那時我們生氣就發脾氣、那時我們喜歡就在一起、那時我們努力的賺錢。如果你忘記了青春就請把我忘記。

The poster "Please forget me!" is on the theme of youth, when we naive, when we romantic, when we happy to laugh, we cry when we are sad, we get angry when we are not happy, then we would like together when we fall in love, then we strive to make money. Please forget me if you forget youth.

■ 請問您對於「創作」所擁抱的理念是什麼？從以前到現在 , 是否有所轉變？

創作是一條恒久的探索之路，需要天賦和理性思考，同時也需要情感上的揮灑。
從以前到現在，我喜歡創作這件事一直沒有變化。

What is your "main idea" while producing a piece/series of work? Have it ever changed before?

Creation is a permanent path of exploration requires talent and rational thinking, but also need emotional sway.
From the previous to the present, I like creation about it has not changed.

■ 請問您認為該國最棒的是什麼？（如國家的特色或文化等）您的創作是否受其影響？

傳統。傳統是我思想的一部分，讓我一旦接觸到新鮮的事物後，會產生獨特的爆破力。

What is the best thing in your country? (likes features or culture)
Have it ever influence your creation?

It's the tradition. Tradition is part of my thoughts, let me once exposed to new things, will produce a unique blast force.

■ 請問您一路以來的創作歷程（與創意／藝術／設計／插畫的邂逅，踏上這條創作路的歷程，旅途上遇見的瓶頸與突破方式）

羅馬不是一日建成的。一路走來，少不了跬步的積累。因為是自己有興趣，所以精神上也不會覺得累。

Share the story of you creating your pieces.
How did you encounter with creativity/art/design/illustration? And what happened? Have you ever been stranded at a bottleneck? And how did you overcome?

Rome was not built in a day. Along the way, ultimately, the accumulation of small steps. Because they are interested in, so I will not feel tired mentally.

■ 請問您如何獲得靈感？

所有的創作動機大多來自內心受到的影響，不安，心動，誘惑，以及微風的輕撫，大自然的眷顧，日，月，光輝，所有能夠拯救人類內心的力量。

How do you draw the inspiration?

All creative motivation, mostly from heart affected, anxiety, heart, seduction, and the breeze caresses, nature's blessing, day, month, brilliant, all able to save the power of the human heart.

■ 請和我們分享您喜歡的書籍，音樂，電影或場所

我最近在細看《閒情偶寄》，看看古代的人都是怎麼點綴平凡生活的。

Share good books/music/movies/places with us.

I was recently reading a book Xian Qing Ou Ji , I want to know how the ancient people to manage their ordinary life.

■ 請問您做過最瘋狂或最酷的事情是什麼呢？

我開始把自己創作的有關死亡，身體，暴力，暗黑的插畫製作成雕塑作品了，讓看過的人都心潮澎湃。

What is the craziest or coolest thing you have ever done?

I started make illustrations about the death of his own body, violence, dark into sculptures, and let people emotionally.

■ 請問您最近最想什麼事情？是否已經著手規劃下一階段的目標或突破了呢？

我最近在考慮我的雕塑的著色，怎樣的色彩會觸動觀者的心等問題。下一個階段，沒別的，跟著自己的心走，心到哪裡，行動到哪裡。

What are the things you want to do most these days? Have you started to set up new goals or breakthroughs for next period?

I consider coloring about my sculptures recently, what color will touch the viewer's heart and other problems. The next stage, nothing else, to go along with my heart, where is my heart, where is my action.

溫力 Wen Li

www.behance.net/1and1designnet/1and1design 1and1design@sina.com

One& One Design 之間設計創始人、藝術總監、藝術碩士、法國 La Maison Des Artistes 成員；SGDA 深圳平面設計師協會會員。採訪：Design360° 觀念與設計雜誌第 54 期；自化創意；亞洲 25 个知名平面設計工作室。展覽：第十三屆法國肖蒙海報節（法國肖蒙）、GDC2013 影響中國未來的設計展（深圳）、受邀 2014AGDIE 亞洲平面設計邀請展（韓國）。作品發表：GDC2013 影響中國未來的設計、APD 亞太設計年鑑 NO.9、APD 亞太設計年鑑 NO.10、Gallery 全球最佳圖形設計 NO.26、Illustrative Branding、Designing Your Identity、Brand Magazine、中國新銳設計師年鑑 2012-2013、國際設計 NO.4、第二屆華人平面設計大賽作品集。

Creator and Art Director of ONE & ONE Design, Study in France, get a Master's Degree in art, Member of LA MAISON DES ARTISTES in France, Member of SGDA (Shenzhen Graphics Designer Association).
Interview: Design 360° Concept and Design Magazine No.54, Zihua com .cn, One of the 25 well-known Graphics Design Studios.
Exhibition: 13th International Poster and Graphic Arts Festival of Chaumont in France, GDC 2013 Design Exhibition of impacting China's Future (Shenzhen), Invited by 2014 AGDIE Asia Graphics Design Invitation Exhibition (South Korea).
Published Works: GDC 2013 the design of impacting China's Future, APD Asia-Pacific Design Year bookNo.9,APD Asia-Pacific Design year book No.10,Gallery MagazineNo.26, Illustrative Branding, Designing Your Identity, Brand Magazine, China Young Designers Year Book2012-2013, International Design Magazine No.4, 2nd Chinese Graphics Design Competition Collection.

1　2

1/ 俯仰之間，天地自衡。當下的生活狀態中我們無時無刻不在任意兩方尋找平衡點。
The world is balanced itself in the twinkling of an eye, we search for a balanced point between sides at any time in the present living condition.

2/ 這款海報是為廣源麻業所做的形象海報，在做這個設計的時候，頭腦中浮現出了一幅溫暖的畫面。小時候母親親手給我做襯衫，先用粉筆把襯衫的版型圖畫在布料上，再進行裁剪、縫紉，於是一塊方方正正的布料就神奇的變成了一件襯衫……於是，遵循這個溫暖的記憶，我在一整塊麻質面料上按照「麻」字的筆畫結構進行裁剪，用裁剪後被分解的面料重新組合成了新的「麻」字。
The poster is a figure one for GUANGYUAN RAMIE. During this project, a warm and sweet picture appeared in my mind. When I was a child, my mother sewed a shirt for me. First of all, she drew the edition type on cloth with a piece of chalk. Then, she tailored and sewed the cloth. Finally, a piece of square cloth was transformed into a shirt magically...Therefore, we follow the warm memory, cut the strokes' structure of the Chinese character ' 麻 ' (RAMIE) on a piece of ramie cloth. Then make recombination to get a new look of the Chinese character ' 麻 ' with the cut cloth.

從結繩記事到網路日記，人們記錄事件的方式多樣化了。從象形文字到字母文字，文字似乎與圖形或者說影像有著不可分割的因緣關係，數張靜止影像的連接，產生了動感的影像和文字筆畫的不同位移組合成不同的文字，在我看來是一樣的。影像就是一篇流動的文字。

From keep records by tying knots to blog, the way people record events has been variety. From hieroglyph to letter and words, the words and graphics (or images) seem to have the inseparable relationship with each other. The dynamic connection of those several static images; the different combinations and displacement of Chinese character's strokes were composed different text. As to me, images are flow textings.

■ 請問您對於「創作」所擁抱的理念是什麼？從以前到現在，是否有所轉變？

「做有誠意、有堅守，適度的設計」是我個人的創作理念；「用設計師的情懷經營公司」是我工作室的發展理念。我是設計師，同時又在經營著設計公司。因此，這兩種理念的堅守，說來容易，做起來不易，甚至偶爾顯得笨拙而充滿矛盾，但我依然不改初心，在我看來，客戶滿意不是終點，以專業的水準和精神引導客戶，共同提升客戶品牌的特有內涵與視覺氣質才是設計的真正價值。
未來，我想我還會繼續堅守一路以來的理念，我期待在我 60 歲，甚至更年長的時候依然保持創造力，保持一顆純粹的心來做設計。

■ 請問您認為該國最棒的是什麼？（如國家的特色或文化等）您的創作是否受其影響？

我在法國留學八年，一直在巴黎，她是一個可以讓我靜下來的城市。我想我人生最好的時光應該是在那裏度過的，它的文化氛圍是多元而自由的，具有強大的包容性和繽紛而優雅的活力，以及開放的創作空間，帶給我東西方文化差異上的諸多思考。深深地影響了我的設計理念和思維開放程度。更為重要的是這段長達八年的留學經歷讓我能夠站在＂對岸＂重新看待和思考自己的國家和文化，讓我知道哪些是我需要堅持的、哪些是我需要融彙的、哪些是我需要學習的。幫助我完成了一種設計思維方式和視覺語言表達上的＂出山再入山＂的歷程。

■ 請問您一路以來的創作歷程（與創意／藝術／設計／插畫的邂逅，踏上這條創作路的歷程，旅途上遇見的瓶頸和突破方式）

與其說瓶頸，不如說我更願意把它看成是創作歷程上的成長和設計思維在不同時期的演進。大概體現在三個維度上，第一個維度應該是多年前求學和從業初期，所面臨的設計原動力不足，專業知識和設計經驗的缺口，解決的途徑就是通過各種方式擴充自己的專業知識儲備，開拓見識和視野。第二個維度的挑戰出現在回國創業的初期，帶領團隊完成項目的過程中，如何提高團隊的有效執行力，如何最大限度地激發每一位成員的小宇宙，對我而言是比較棘手的問題，至今仍然時常困擾我。只能說隨著管理經驗的增加和工作方法、個人心態的調整，團隊的協作能力正在向我所期待的方向發展。第三個維度應該就是現階段，隨著設計歷程的推進，設計案例的增加，漸漸找到了自己擅長和相對獨特的視覺表達語言，但同時也面臨著如何超越已相對成熟、相對固定的設計思維和表現方式的問題，不斷開拓新的設計可能性。

What is your "main idea" while producing a piece/ series of work? Have it ever changed before?

"Sincere, persistent and moderate design" is my personal design principle. "Manage the company with designer's passion:" is the develop concept of my studio. I'm the designer while I'm also managing the design company. Therefore, adhering to these two concepts is easier said than done. Occasionally, it may even seem awkward and contradicting. Nevertheless, I never change my original intension. In my point of view, customer satisfaction is not enough. The real value of designing is to increase customer's brand connotation and visual qualities together with vocational standards and spirit.
In the future, I believe I'll insist on my initial concept. I hope when I'm 60 or older, I can still maintain imagination and pure heart for designing.

What is the best thing in your country? (likes features or culture)
Have it ever influence your creation?

I had studied in France for 8 years andl often stayed at Paris because this city can calm me down. I thought that I passed the most wonder moment in my life there. It is various and liberal culture which includes the powerful comprehensiveness, graceful energy and opening creative place brings me lots of reflections between the Eastern and the Western. And it also influences my ideas of creation and thinking. The most important for me is that I can rethink our country and culture by standing at the other side. To let me know what I need to keep on, what I need to achieve mastery through a comprehensive study and what I need to learn. It helps me to complete the thinking method and also the experiences of "exiting the mountain than entering the mountain."

Share the story of you creating your pieces.
How did you encounter with creativity/art/design/ illustration? And what happened? Have you ever been stranded at a bottleneck? And how did you overcome?

Rather the obstacles, I do rather say that is the growth of design. It generally appears in three dimension. First is the insufficient of the motive power, specialized knowledge and experiences. The only solution is to find different kinds of way to expand your own specialized knowledge and be open-minded. Second dimension appear when I return my country and began to work. During the leaderships, how can I promote the efficiency of the team and how to arouse every member's maximum limitation. For me, this is a big problem and it bothered me frequently. The improvement of the team management will be better if I change your method of the work and adjust my attitudes. The third dimension is now. We gradually find our special skills and special expression of the eye languages by gaining lots of experiences and increase our cases. At the same time, we have to face some problems, for example, how to cross myself and become more mature. We have to escape our thinking and explore the possibility of design.

吳炫東 Wu Xuandong

509333592@qq.com

自由設計師、攝影愛好者、爬蟲愛好者，希望有一天可以放下一切，驢行大地，也許就是明天。
作品入選第十一屆俄羅斯金蜜蜂國際平面設計雙年展，榮獲第 16 屆全國設計 " 大師獎 " 優秀獎，第四屆 Hiiibrand 國際品牌標誌設計入圍獎，中國創意設計 2013 年度銀獎、銅獎，第十四屆白金創意平面設計入圍獎等，並多次入《中國設計師年鑑》、《中國創意設計年鑑》、《APD 亞太設計年鑑》。

Liberal designer, love to photographing and the insect. Hoping one day I can put down everything and travel around and maybe it is tomorrow.
The works were selected in 11th Moscow Global Biennale of Graphic Design Central House of Artists and win The 16th National Design Master Award- Outstanding Award, The 4thHiiibrand Logo design Award, 2013 China creative design Gold Award and Silver Award, The 14th platinum Originality National award- creative Graphic Design Award and were frequently selected in "China designer yearbook," "China creative design yearbook" and " APD Asia Pacific design yearbook."

1　2

1/ 字體設計 城 入選第十一屆俄羅斯金蜜蜂國際平面設計雙年展，作品靈感來源於偶然一次在公司窗外觀望的時候，一群多層建築的小區結構。
The design of the style of calligraphy was selected in 11thMoscow Global Biennale of Graphic Design Central House of Artists.
The ideas of the creation were come from the structure of multi-stories building, which I occasionally seen outside the window
of my office.

2/ 一個生活的闡述：Life Ice Extinguish Flash
生活不是每天都有閃光點，大多數的時候生活會撲滅你的熱情、你的希望，讓你感受現實的冰冷與黑暗。我們都是無助的遊蕩者。
An elaboration of life: Life Ice Extinguish Flash
Life is not always colorful. At the most of the time, the life might quench your passion, your hope and to let your feel the cold
and black reality. We are the helpless bummer.

天淨沙 秋思 ｜ 2013
杏花村 ｜ 2012

1/ 一組古詞的字體設計，靈感來源於甲骨文刻字的筆順，結合古詞韻味，散發出帛書拓本的味道。

<<Tian Jing Sha, Autumn thoughts >>

A design of the form of the archaism, the inspiration is come from the inscriptions on bones. It combines the aroma of the archaism and distributed the taste of the books.

2/ 一座風景秀麗古鎮村莊，一城中華韻味的部落建築。

It is a beautiful old village and theChinese tribe construction all over the town.

■ 請問您對於「創作」所擁抱的理念是什麼？從以前到現在，是否有所轉變？

其實我獲得靈感的方法有很多，如果是在工作的時候，會不停地畫手稿，隨便畫那種，沒有目的的，也可能停下在窗邊看著窗外。在平時的時候會多關注設計展覽、作品等，如果突然有想法，覺得這個可以做點什麼，我會先把他記下來，然後有時間慢慢琢磨推敲。

■ 請問您一路以來的創作歷程（與創意／藝術／設計／插畫的邂逅，踏上這條創作路的歷程，旅途上遇見的瓶頸與突破方式）

瓶頸期也有過，也失落過，也無助過。不過創作的過程裡還有很多驚喜的，其實我這一路不是堅持過來的，是欣賞過來的。可謂一路風塵一路歌！

■ 請問您做過最瘋狂或最酷的事情是什麼呢？

這 26 年來最酷的一次，應該就是在過年的 7 天假裡，為自己安排一段旅程，一場說走就走的旅程，算是窮遊吧。

■ 請問您最近最想什麼事情？是否已經著手規劃下一階段的目標或突破了呢？

最近可能去登山，泰山。我現在已經著手規劃的是一部單反，一套帳篷，一個背包，風餐露宿，在海邊看日落，在山頂看日出，一定要現在去做，感覺有些事再不做，真的會後悔！

What is your "main idea" while producing a piece/series of work? Have it ever changed before?

In fact, I get inspiration method has a lot of, if is working at the moment, will not stop manuscript painting, draw that, without purpose, may also stop at the window and looked out of the window. Will pay more attention to design exhibition, works at the usual time, if all of a sudden idea, think this can do what, I'll bring him down, and then slowly pondering scrutiny.

Share the story of you creating your pieces.
How did you encounter with creativity/art/design/illustration? And what happened? Have you ever been stranded at a bottleneck? And how did you overcome?

The bottleneck period also had, also lost, but also helpless. But the process of creation and many surprises, I this way not to come over, is to appreciate over. We go all the way all the way song!

What is the craziest or coolest thing you have ever done?

The 26 years of the most cool again, should have the Spring Festival is in 7 days holiday, arrange for a journey for themselves, a go trip, is on a shoestring.

What are the things you want to do most these days? Have you started to set up new goals or breakthroughs for next period?

Recently I want to climb a mountain, Taishan. I have now planning is an SLR, a tent, a backpack, camped, watching the sunset on the beach, watching the sunrise at the top of the hill, be sure to do it now, feel some things don't do, really regret!

謝瑞康 Xie Ruikang

xieruikang.lofter.com *389761248@qq.com*

謝瑞康，畢業於廣州美術學院，現為批批踢獨立設計工作室主理人。曾於南京形下合作設及荷蘭托尼克設計工作室大中華區分部實習，後曾任形下合作設設計總監，參與荷蘭平面幸福百年展中國巡展、南京博物館非理性之美原生藝術展、TEDxNanjing2013 — NEXT、中荷作用、南京十大新銳設計師作品展等活動的形象設計與策展工作。商業設計上曾服務包括 3M、金葉珠寶、第可金飾、泰庫文化產業園等知名企業。獲 2012SHDC-50/100 新銳展一全球 80 後華人 100 位元設計師稱號，作品入選平面設計在中國 GDC13、亞太設計年鑑 APD9、靳埭強設計獎等。

Graduated from Guangzhou Academy of Fine Arts. Now Xie is the owner of the independent graphic design studio called studio PPT .He once worked in collective dedecoding design company in Nanjing and Holland Thonik design agency of china unit. Later he's been the design director in collective dedecoding. Has taken part in multiple projects of activity designing and activity planning, including graphic happiness 100 years of Dutch Graphic Design; Beauty of Irrationality exhibition of Chinese Raw Art of 10 Artists in Nanjing Museum; TEDxNanjing 2013 talk, NEXT; Dutch Chinese cultural exchange program, ten emerging designers exhibition in Nanjing.
Worked as Visual Designer for 3M Company, Gold Jewelry Group, Dekart gold company, Taikul Cultural Industry Park and other famous enterprises. Taken part in 2012SHDC-50/100 Shanghai emerging exhibition and won the title of 100 designers worldwide after the Chinese, graphic design in Chinese GDC13, Asia Pacific Design APD9 and Jin Daiqiang design award.

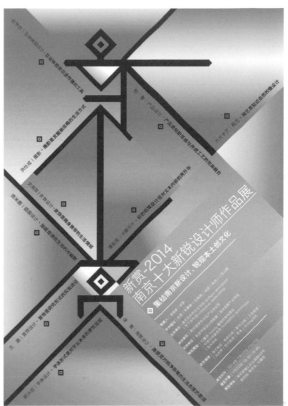

1 2

1/ 這場名為「安家樂業」的開業禮，是生活態度品牌店及創意辦公品牌空間的聯合開業禮，旨在傳播生活與工作互為一體，互為補充的生活態度及工作態度。策劃文案上把生活作為安家，把工作作為樂業，再以「平衡互補」的視覺關係溝通及呈現。
The "settle down and enjoy" is the union opening ceremony of "life Attitude Brand stores" and "creative office space". The aim is to spread that life and work can be one thing, their attitudes are complementary to each other. The copywriting planning is to see life as the peace family, to see work as the delightful industry, and then present the visual relationship of "balance and complement".

2/ 這場名為「新賞」的設計展以「集結南京新設計，銳現本土創文化」為動機，鼓勵有銳點的設計師表達自我，引導觀眾理解設計師對設計的不同觀點，以溝通設計與社會的關係。海報核心資訊圍繞「新銳觀點」收集整理，以「新視角」為視覺元素組織設計呈現。「新賞」新銳設計新視角，銳現南京本土創文化。
" Xin Shang " design exhibition, with the motion "gather Nanjing's new design and show the local culture ", to encourage the Up and Coming Designers to express themselves, and guide to audience to understand designers' different point about design, in order to communicate between design and society. The posters' core information is surrounding with collecting "up and coming perspective", with the visual elements of "New Vision" to organize and design the form. "Appreciate something new "about new vision of up and coming design, and show the local culture of Nanjing.

這場名為「未來」的 TED TALK，旨在通過「如何做出改變」、「這片土地」、「創意與行動」三個環節，引領人們持續思考目的地 - 未來。設計以 A5 小傳單為單位，以紅、綠、藍三色線代表三個環節及方向，再以若干 A5 的連續拼列，形成動態的、無限延展的視錯覺矩陣海報。觀眾甚至可以組合屬於自己的「未來」，通過海報與「未來」溝通互動。

The title "Future" of TED TALK, aims to guide people to think about the destination: future by 3 links: "How to make a change", "This land", "creativity and action". Use an A5 flyer as a unit, with 3 colors: red, green and blue to represent 3 links and direction, then piece these flyer together continuously to form an optical illusion poster which is dynamic and unlimited extension. Even the audience can combine their "future", interact to "future" through poster.

■ 請問您對於「創作」所擁抱的理念是什麼？從以前到現在，是否有所轉變？

理念是：真誠、快樂、簡明。理念沒有轉變，形式是萬變應不變。

What is your "main idea" while producing a piece/series of work? Have it ever changed before?

My main idea is: faith, delight and concise. The main idea has never change, but we change form as many as possible.

■ 請問您認為該國最棒的是什麼？（如國家的特色或文化等）您的創作是否受其影響？

中國最棒是書法。書法在精神層面影響我很大，但還沒有找到一種國際化的設計語言來應用書法和表達書法內涵。

What is the best thing in your country? (likes features or culture)
Have it ever influence your creation?

Calligraphy is one of the best cultures of China. Calligraphy affects my spirit a lot, but I haven't found a king of international design language, to apply and express the connotation of calligraphy.

■ 請問您一路以來的創作歷程（與創意／藝術／設計／插畫的邂逅，踏上這條創作路的歷程，旅途上遇見的瓶頸與突破方式）

尊重設計，不要把設計淪為置換的籌碼。同時保持真誠、快樂、簡明和耐心。

Share the story of you creating your pieces.
How did you encounter with creativity/art/design/illustration? And what happened? Have you ever been stranded at a bottleneck? And how did you overcome?

Respect the design, don't use design as a chip for exchange, and keep faith, delight, concise and passion at the same time.

■ 請問您如何獲得靈感？

讀書、臨帖、打籃球、分析關係、寫寫文字。

How do you draw the inspiration?

Reading, calligraphy, playing basketball, analyzing relationships, and writing.

■ 請和我們分享您喜歡的書籍，音樂，電影或場所

《托尼克力量》、《荷蘭平面幸福百年展》、《井上有一》、《神居何所》。

Share good books/music/movies/places with us.

Power tonic design, Graphic Happiness: 100 years of Dutch Graphic Design, Inoe Yuichi(いのうえ ゆういち), Shen Ju He Suo.

■ 請問您做過最瘋狂或最酷的事情是什麼呢？

穿著閩南關公粵劇服裝，面對幾千人，用拖把在十三米長的棉布上寫「天涯淪落人」

What is the craziest or coolest thing you have ever done?

Wearied "Guan Gong" costume of Cantonese opera which comes from South Fujian faced to thousands of people and wrote the sentence "People in the same sinks boat" on 13-meter-long cotton by using a mop.

■ 請問您最近最想什麼事情？是否已經著手規劃下一階段的目標或突破了呢？

努力做一個真誠、快樂、簡明的人，用設計感染身邊的人，追求真誠、快樂、簡明。

What are the things you want to do most these days? Have you started to set up new goals or breakthroughs for next period?

To be a person with faith, delight and concise, and infected those who are around me with design. Pursue for faith, delight and concise.

徐立萌 Xu Limeng

共同創作者 Co-author
劉寶 Liu Bao　王啟迪 Wang Qidi

www.55design.net　　*xulimeng001@163.com*

中國美術家協會會員，中國設計師協會（CDA）會員，中央美術學院視覺傳達學士。
中華女子學院，北京工業大學耿丹學院外聘教師。ITAT 平面設計大賽終審評委。
畢業於中央美術學院設計學院，參與北京奧運支線（8 號線）地鐵空間形象設計，獲第十一屆全國美展金獎。作品入選第九屆亞太設計年鑑。2008 年為奧運會設計《奧運城市》《奧運建築》畫冊。
多次承擔聯合國、英國大使館文化教育處、交通銀行歷史展廳、敦煌研究院、中國美術館及中央美術學院美術館等單位的設計工作。
2014 年創立 5.5 視覺設計顧問工作室，北京之乎文化藝術有限公司。

He is member of China Artists Association, also a member of CDA. Graduated from the Visual Communication Design Department of The Central Academy of Fine Arts (CAFA) with bachelor degree.
Teaching in China Women's University and Gengdan Institute of Beijing University of Technology. Judge of ITAT Graphic Design Competition. Graduated from the Central Academy of Fine Arts, participated in the image design of the Subway space of Beijing Olympic Line (Line 8).Won Gold Award of 11th National Exhibition of Arts, China. Works have been selected for APD pacific Design Yearbook, And He designed album Olympic City and Olympic construction for Beijing Olympic in 2008.
Served as the design work many times of the United Nations, British Council, history display hall of Bank of Communications, Dunhuang Academy China, The National Art Museum and CAFA Art Museum, etc.
Founded 5.5 Visual design consultancy studio, Beijing Culture and Arts Co. in 2014.

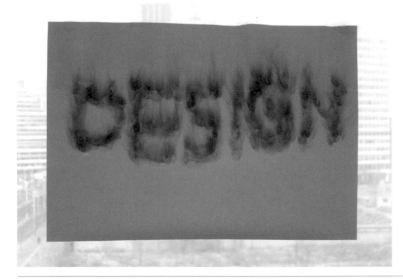

1/「無名天地之始，有名萬物之母」，書法的研習亦是從無到有，從混沌到清晰，站在時間的角度去觀察研習的過程，將過程中作廢的絲絲墨跡通過處理和分析，揉成團，將文字立體化，加入時間的概念，即是一個四維概念，猶如電影《星際穿越》，殘片立體疊加，可理解為站在一個五維的空間來研究字體。

The famous remark from Tao Te Chin: "The nameless is the beginning of Heaven and Earth; The named is the mother of all things." Learning of calligraphy grows out of nothing, from chaos to clarity. From the perspective of time to observe the learning procedure. The process to set aside the slightest ink through processing and analysis, balled, three-dimensional text, adding time the notion that a four-dimensional space, like the movie "interstellar" fragments dimensional overlay, understood as standing in a five-dimensional space to study script.

2/「霧都」已成為近期一個比較熱門的話題，尾氣以及工廠的煙霧排放將一個城市壟罩上了一層陰影，就此，設計師應該如何思考？這是一個字體嘗試，用火在紙上進行燻烤，形成字體。

"The city of fog" becomes a popular talk recently. Because of the pollution, it shrouds a city with the fog. Thus, how did the designer reflect their mind? This is a try for a style of calligraphy. We use fire to heat the paper than the style of calligraphy comes out.

琴器與琴道 | 2014 | 徐立萌 Xu Limeng
無痕 | 2013 | 徐立萌 Xu Limeng，劉寶 Liu Bao 共同創作 Co-author

1/ 琴器與琴道，為北京鈞天坊設計的講座海報，「道在器中」，氣韻道同，琴為器、斫為道、音為表。
The instrument and the lore of guqin is the speech poster designed by Jun Tian Fang, a guqin maker from Beijin. "The lore is in the instrument." Artistic conception and the lore is the same. Qin is the instrument. Plucking is the lore and the music is the expression.

2/ 無痕本為一床琴的名字，以此作為展覽的名字和理念，表達琴人對琴，對中國文化的理解，海報意在塑造雪地中琴人撫琴畢，人去琴留的意境，海報印刷於雪質紙上，由於該紙質地疏鬆，通過印刷摩擦起毛，但恰巧通過印刷中出現的錯誤，造就畫面上面類似飄雪的效果。將錯就錯，以表達意境。
Traceless originally is the name of a guqin. Using it to be the name and the concept of the exhibition shows players' understanding of guqin and Chinese culture. The poster wants to build the image that player is gone but the guqin stays after he touched it. The poster is printed on Matt Art Paper. Since the paper's fiber is loose, it becomes fluffy through the friction of printing. Nevertheless, through the mistake of printing, it gave the image a snowing effect responding to the meaning of the poster which makes the best of the mistake.

■ 請問您如何獲得靈感？

這個問題比較難回答，我就說一下我的習慣，也特別簡單，就一句話：我要做這件事情的時候，我會放下這件事情，而去做另外一件事。

■ 請問您最近最想什麼事情？是否已經著手規劃下一階段的目標或突破了呢？

對於做設計其實我沒有理念，就是覺得不做設計，就是不要為了做設計而去做設計，我覺得設計太虛，它要依附於一件事情而存在，比如產品，比如品牌等等一切事情都可以，我也在尋找一個載體，當然現在都還是在嘗試階段，可能比較感興趣的有幾個方向，比如農村方面，比如文化方面，等等，都還沒有太成熟的想法，還在慢慢的探索中。

■ 請問您認為該國最棒的是什麼？（如國家的特色或文化等）您的創作是否受其影響？

毫無疑問的是文化，但是說起中國文化是一個非常深刻的話題。現在大家都在講中國傳統文化，有些人認為中國文化博大精深，也有些人們人為現在中國是處於一個文化的斷層期，都各有各的道理。我其實認為他們說的都對，只是各自所站的立場和理解不同罷了。當然我對於文化的理解也只是一點點皮毛而已，沒有資格對此發表大論，只是想說一下自己的一些親身感受而已。

我以前做設計，從思想上挺排斥講中國傳統文化，那時候覺得一說傳統文化就覺得土氣，但是自從 13 年無痕展覽開始，發現自己開始有了變化，並且是突然間的變化，對文化也開始慢慢的產生了興趣，也可以說從這個展覽開始我也才真正的有機會接觸中國傳統文化的範疇，一直到現在，我接觸的對傳統文化感興趣和研究的人越來越多，他們有研究古琴文化的，有研究易學的，甚至有研究自然種植的，他們各自都有自己的一個觀點和理論，但是靜心想一下會發現，其實所有的觀點和理論都處於最根本的一句話，那就是「天人合一，道法自然」，從哲學層面上講，也就是說其實最根本的思考就是「從哪裡來，到那裡去的問題」，這就始我慢慢的開始從這個角度開始思考設計「從哪裡來，到那裡去的問題」。慢慢的，我做設計的時候就在考慮到底什麼是設計的問題，以前大家經常說的設計，我認為是狹義的設計，我覺得設計應該更加廣義的去理解，就是事件，我認為設計其實就是一個終端，而我們要做的應該跳出設計本身，站在一個高度上來觀察我們要做的事情，這樣能夠看到我們要做的事情和周圍環境的關係，然後在一層一層的去分析，設計在整個事件當中是什麼樣的關係，什麼樣的位置等等，這樣一層一層的去分析，去思考，直到最後我們就會非常清晰的明白我們所要動手操作的所謂的設計是什麼樣子的了。我認為整個事件的思考才是真正的設計，才是大設計。其實就是我們要用設計的思維方式去思考所有的問題，應用到各個行業中去。

How do you draw the inspiration?

This question is a little bit hard to answer. Let me tell you my habits. It is very simple. I can just use one sentence to complete. That is if I want to do this thing, I will put down this thing and do others.

What are the things you want to do most these days? Have you started to set up new goals or breakthroughs for next period?

I do not have any ideas about design. Don't design because you have to do design. I think design is not reality, it's unreal. It has to attach one thing to exist, such as the brand, etc.. I am also finding a carrier. I know all the thing is not on the rail and I am interested in several aspect such as the rural and the culture. We are exploring all the things because we do not have the tentative ideas.

What is the best thing in your country? (likes features or culture)
Have it ever influence your creation?

The culture is unquestionable. However, Chinese culture is an impressive subject. Recently, people always talk about the traditional Chinese culture. Some people think the Chinese culture is deep and sophisticated, and others think China is in a state of fraction in culture. All of them make sense. In fact, I think all of them are right, and they just have different positions and understanding. Of course, I only know a bit of culture, and I am in no position to publish statement. I just want to describe my personal experiences.

I eliminated to talk about traditional Chinese culture in mind when I designed. At that time, I felt uncouth when people talked about traditional culture. However, I found I have changed since the exhibition without trace 13 years ago. The change was immediate. In addition, I have been interested in culture little by little. It could also say that I had the chance to contact with the traditional Chinese culture from this exhibition. Until now I have contacted with more and more people who research and have interested in traditional culture. Some of them study the culture of guqin. Some of them study China Fate. Even some of them study planting. They have their own points and theories. However, after thinking with meditation, you would find out that all of the points and theories are belong to one sentence which is "Harmony between Man and Nature, and Imitation of Nature." In the aspect of philosophy, the basic thinking is "the question where comes from and where goes." Then, it makes me begin to think the design in this aspect. I think what design is when I design gradually. I think the design which people usually said before is in a narrow sense. I think the design should be understood in a broad sense, which is an event. Moreover, I think the design is a terminal, and we have to think outside of the design, and stand in an attitude to observe what we are going to do, so we can know the relationship with the things we are going to do. Then, analyze it layer by layer, and design what the relationship and position are in the whole event. Therefore, analyze and think about it layer by layer until we realize what the design we are going to do is. I think the understanding of the whole event is the design, a huge design. The fact is that we use the thinking of the design to think about all the questions, and apply it in every industry.

蕭亞丹 Yadon Xiao

weibo.com/yadanxiao　　*xiaoyd@126.com*

自由平面設計師，現居上海，從事品牌形象設計，作品榮獲蘇格蘭平面設計節國際海報展、AGDIE 亞洲平面設計邀請展、第九屆烏克蘭 "4TH BLOCK" 生態國際海報三年展、首屆中國霧霾主題公益海報優秀獎、銘記 1213" 國家公祭日國際海報邀請展、作品編入《APD 亞太設計年鑑》第九卷、ShanghaiType 動態字體秀邀請展、第四屆 hiiibrand 國際品牌標誌大賽銅獎及入選獎、靳埭強設計獎優秀獎、第九屆 CCII 國際商標雙年獎優秀獎等獎項。

Freelance of graphic design, now live in Shanghai, Works won Graphic Design Festival Scotland International Poster Competition, The exhibition invitation for Asian Graphic Design, IX International Eco-poster Triennial "the 4th Block," China's first charity poster theme haze Excellence Award, The international invitational exhibition poster, Works incorporated into the ASIA-PACIFIC DESIGN NO.9, ShanghaiType, Hiiibrand Bronze and Ruxuan Jiang, KAN TAI-KEUNG Design Award, CCII Award of Excellence.

1　　2

1/ 提煉海派元素 (石庫門、霓虹燈等元素)，將海派元素時尚化，色彩時尚、明快。
Refining seaside elements (Shikumen, neon and other elements), the Shanghai style and fashion color.

2/ 霾，是一種慢性殺手。傷害人、動物的身體，海報中有被切斷的手、腳、肺和動物的身體，來說明「霾」傷害人類和動物的身體。「霾」
可以讓人聯想到噁心的蜘蛛、蜈蚣、蟾蜍等等，血腥的畫面讓人產生恐懼。
Haze, is a chronic killer. Harm people, animals, body, screen has been cut off hands, feet, lungs and animal body, to reflect
chronic killers harm to humans and animals, while the haze can make people feel sick to think of spiders, centipedes, toad, etc.
bloody pictures make people fear.

1/ 霾，由污染物顆粒、汽車尾氣、工業排放等游離氣態組成，海報畫面中有帶刺的字體 HAZE 組成，同時結合能讓人聯想到有害游離態的氣體纏繞著字體，雜亂無章的形式感體現霧霾的特點。

Haze, by pollutant particles, vehicle exhaust, industrial emissions that free gaseous composition, posters screen fonts have barbed HAZE composition, combined with energy from harmful free state reminiscent of the residual gases around the font, messy sense of form reflect the characteristics of haze.

2/ 以漢字「南京」二字為創意點，將「南京」二字和人體的骨架巧妙結合起來。。

Chinese characters "Nanjing" word for the creative point, The "Nanjing" word and the body's skeleton cleverly combined.

■ 請問您對於「創作」所擁抱的理念是什麼？從以前到現在，是否有所轉變？

以前創作的目的更多的是考慮作品怎麼好看，走形式主義，但是現在我覺得創作的每一副作品都要考慮到的是能否給社會帶來價值，能否給企業帶動銷售，帶來利益。

■ 請問您如何獲得靈感？

「創意源自生活」，我是非常贊同的。工作之外的生活我會好好的享受每一個假期，放空後總會感受到重生，充滿激情，擁有好的心情才是靈感來源的重要動力。當然我平時也很喜歡閱讀古籍，喜歡研究中國文化，喜歡收集古怪不尋常的東西，這些都是我靈感來源的重要途徑。

■ 請問您認為該國最棒的是什麼？（如國家的特色或文化等）您的創作是否受其影響？

每個國家的文化我都會喜歡，喜歡日本細膩的設計風格，喜歡法國浪漫主義的設計風格，喜歡德國嚴謹的設計風格，喜歡北歐自然的風格，不同國家的文化對自己創作有不同的影響。當然作為一名設計師，探索屬於自己本國的設計風格是一直以來的任務。。

■ 請問您一路以來的創作歷程（與創意／藝術／設計／插畫的邂逅，踏上這條創作路的歷程，旅途上遇見的瓶頸與突破方式）

設計是我從小就有的夢想，一直覺得自己很幸運，慶幸自己走上設計這條道路，因為我愛設計，我把創作當作是一種享受。

What is your "main idea" while producing a piece/ series of work? Have it ever changed before?

I considered more about creating a work is how to look good visually and took formalism before. But now I think creating every work should consider whether bring value to the society and giving sales growth and benefit to a enterprise.

How do you draw the inspiration?

"Creativity comes from life," I quite agree with it. I enjoy every holiday in my spare time and always feel rebirth and full of passion after emptying myself. A good mood is the important motivation. of inspiration. Of course, I also like reading ancient books at ordinary times , studying Chinese culture and collecting odd unusual things. These are the important way of my inspiration.

What is the best thing in your country? (likes features or culture)
Have it ever influence your creation?

I would like each country's culture, like Japan's exquisite design style, like the romantic design style of the French, like the German rigorous design style, like the Nordic natural style. The culture of different countries has different influence on my creation.

Share the story of you creating your pieces.
How did you encounter with creativity/art/design/ illustration? And what happened? Have you ever been stranded at a bottleneck? And how did you overcome?

Design is my dream when I was young. I always feel so lucky that I took the path to design because I love design and I put the creation as a kind of enjoyment.

張昊 Zhang Hao

www.tinodesign.com tinozhang@foxmail.com

張昊，本名張浩，深圳市平面設計協會副秘書長，深圳圖書館設計主管，天諾設計創作總監，方正、漢儀特邀字體設計師。近年致力於品牌策劃和字體設計研究，包括正文字體，品牌字形和漢字模糊識別。入選、獲獎包括：靳埭強設計獎未來設計大師獎、金獎、優秀獎；Morisawa 森澤國際字體設計大賽人氣一等獎；方正中文字體設計大賽二等獎、三等獎、評審委員獎、人氣一等獎、人氣二等獎、優秀獎；漢儀字體之星類黑單元大獎；Hiii Typography 中英文字體設計大賽銀獎、優異獎；國際品牌標誌設計大賽銅獎、優異獎；GDC 平面設計在中國展；深港設計雙年展；中國設計大展；墨界當代視覺藝術邀請展；KECD 亞洲設計師招待展；亞洲平面設計邀請展；TIGDA 臺灣國際平面設計賽。出版、收藏包括：《TYPOGRAPHY》，《包裝與設計》，《新平面》，《APD》，《中國形象年鑒》，《深圳設計家》,廣東美術館、關山月美術館、上海美術館。"

Zhang Hao, Deputy Secretary-general of Shenzhen Graphic Design Association, Design Supervisor of Shenzhen Library, Creative Director of Tino Design Co. Ltd, and Guest Font designer of Founder Type and Hanyi Fonts. He is devoted to brand planning and font design research, including Typeface, Logotype and Chinese fuzzy recognition. His works have won awards including Future Design Master/Gold award/Honorable Mention of KAN TAI-KEUNG DESIGN AWARD, 1st Prize of Peoples' Choice (Latin Category) in Morisawa Type Design Competition, second and third prize in Founder Chinese Fonts Design Competition, unit award of Boldface in HANYI Font Star competition, Silver award and recognition award in Hiii Typography, bronze medal and Recognition award in Hiiibrand Awards. Besides, his works have been selected in Graphic Design in China, HK-SZ Design Biennale, China Design Exhibition, MOJIE Modern Visual Art Exhibition, KECD Designers' Invitational Exhibition, AGDIE, and Taiwan International Design Competition. In recent years, his works has been published and collected in Typography, Packaging and Design, Hiiibrand, APD, Yearbook of Chinese brands, Shenzhen Designer, Guangdong museum, Guan Shanyue Art Museum, and Shanghai Museum.

1

2

1/ 合體字為中國傳統吉祥圖案的壹類（如唯吾知足、招財進寶等），視覺美感和寓意俱佳，但創作難度很高。上海圖書館六十周年慶典海報，我從傳統中汲取營養，並借鑒傳統"壽"字紋，創作了"萬卷書香"合體字，並采用現代設計語言來表達。其中還隱含了上海簡稱"申"和六十的別稱"甲子"，體現了"上海"、"圖書館"、"六十華誕"、"豐富館藏"等眾多內涵。
This work is designed for the ceremony celebrating the 60's anniversary of the establishment of Shanghai Library. It is the combination of four Chinese characters " 萬卷書香 ," which means "thousands of books and good for reading." It is one of the traditional Chinese lucky patterns, which has great visual beauty and good meaning. But because of the difficulty of creating such combinations, there are not much excellent works widely spread. Chinese compound is one of the traditional Chinese lucky patterns, with the combination of visual beauty and good meaning. But due to the complexity, it's hard to design. Here is a series of Chinese combinations which I try to design and interpret with modern language, based on Chinese traditions.

2/ 西施浣紗，打動人的不單是美人和絹紗，更是青山碧水的自然環境；海報背景是汙染嚴重的河道照片，排放的汙水和白沫在河面形成輕紗一般的圖案，反諷的意味強烈。"浣紗"二字拆開，成為"水完絲少"，是對現代社會汙染嚴重的最好解讀。命名曰"新浣紗圖。
What touches people in the story"Xi Shi washes silk yarn"is not only the beauty and the silk, but also the beautiful environment. This poster takes seriously polluted river as the background, which is strongly contrasted with the light silk pattern formed by the polluted water and the foam. The Chinese characters of "Huan Sha"are split as "shui Wan Si Shao",which means the water dries up and the silk yarn nearly runs out.
This sarcasm is a new illustration of the serious pollution in modern society.

1

2

1/ 中國古代寫在絹帛上的文書謂之「帛書」，反應了由篆入隸的過程，設計師吸取漢代「帛書」風格特點，設計了這套字體。橫筆劃方入尖收，左波右磔對比強烈、骨氣洞達、神采豐厚。字體的神韻恰好表現了《鵲橋仙》跨越時空的悲歡離合和情思。
The writing which was written on the silk at the ancient times in China was called "Book copied on Silk". It reflected the changing process from the seal character into the clerical script. The designer adopted the main characteristic of "Book copied on the Silk" and created this style of calligraphy. The horizontal stokes starts from square form and ends with pointed form. The left side and the right side contrast strongly and have a munificent expression. This style of calligraphy shows the crossing space-time vicissitudes of life and the emotions of the old Chinese tale The Weaver Girl and the Cowherd.

2/ 從傳統中獲得靈感，包含兩套：碑線來源於鐵線篆和碑刻，筆劃纖細如線、剛勁如鐵，篆的圓融和碑刻的拙樸兼備，整體飽含韌勁和力道，仿佛在歲月侵襲中愈加充滿張力；雅楷來源於從竹、蘭、柳等水墨題材，提煉其秀雅的感覺，在楷書基礎上，將漢字結構和筆劃進行解構重組，整體似蘭葉、如墨竹，幽雅秀麗、清新挺拔。
The inspiration of the name of this script came from Iron wire seal script and inscription. The strokes are as slim as wire, as strong as iron. Compared with seal character, the structure of this script is more unadorned but less mild. The overview appears full of power and strength, reflects abundant tensions during years of erosions. Bamboo, orchid and willow are typical themes of Chinese ink and wash painting. The composer extracts the elegant sense of these plants, reconstructs typical structures and strokes of Chinese characters based on regular script. The overview of Elegant regular script looks like orchid-leaves, like ink bamboo, which shows elegant and pure feelings.

■ 請問您認為該國最棒的是什麼？（如國家的特色或文化等）您的創作是否受其影響？

四大文明傳承至今的只有中華文明，這與漢字是緊密相關的。漢字我們記錄語言、承載文化的符號體系，他的最大特性就是「壹而不變」，幾千年來流轉變化卻從未斷裂，可以說他是中華文明的DNA，其中蘊含積澱的智慧和哲理，超越了普通符號體系的概念。前人的金石、瓦當、篆刻、書法、雕版……，是世界上最好的平面設計和字體設計。而且漢字除了音、形、義之外，還有數、象、理，其奧妙我們窮此壹生也難以窺萬壹。近年我專註字體設計研究，包括正文字庫、品牌字形應用和字體探索實驗等多個方面。而我目前涉獵的大多數設計研究項目，如字庫、品牌、文創、海報、書籍等，都與漢字設計緊密相關，十分感恩漢字。

■ 請問您如何獲得靈感？

俗語說行千里路、讀萬卷書，多看多想多做總是能激發靈感的。這裏我想重點說的是關於書籍的閱讀，我們總是想獲取最新鮮熱辣的國外資訊，其實看看前人的金石、書法、雕版等資料，從傳統的美學和智慧海洋中輕舀一瓢，就能激發無窮的創作靈感和熱情。

■ 請問您最近最想什麼事情？是否已經著手規劃下一階段的目標或突破了呢？

近年我創作了不少正文字形，近期準備著手將其中一兩套逐步完善成為字數較全的字庫。但這項計劃非常不易，不敢輕言突破，惟願靜下心來慢慢磨練。

What is the best thing in your country? (likes features or culture)
Have it ever influence your creation?

The four great civilizations passed down and only the Chinese Civilization is closely related to the Chinese characters. The Chinese characters are the symbolic system which was used to record the languages and inherit the cultures. The main characteristic of the Chinese characters is that it never changes. They last for thousands of years and never stop. They can be called as the DNA of Chinese Civilization and they include the profound wisdoms and philosophy and they transcend the general idea of the common symbolic system. The predecessors' gold and precious stones, ancient eaves tale, seal cutting, Chinese calligraphy and engraving are the best graphic design and handwriting design in the world. The Chinese characters not only contain the voice, the shape and the meanings but also the numbers, the phenomenon and the fate. The mystery inside is really deep and it would not be understand even we spend our whole life observing it. Recently, I concentrate on studying the design of the writing system, it includes the character set of traditional Chinese characters, the application of the font of brands and the wring exploration experiments etc. Now, I focus on mostly the character set, brands, cultural and creative industry, and books, and these are closely related to the Chinese characters. I really appreciate the invention of the Chinese characters.

How do you draw the inspiration?

There is a saying goes to travel far and to read voluminously. To see more, think twice and do more is always helpful to stimulate inspiration. I think the point here is about reading books. We would always like to learn the newest and timely abroad information. In fact, after studying the materials of ancient people such as epigraphy, calligraphy and engraving. Just scoop a spoon from the ocean of the traditional aesthetics and wisdom, then it will be easier to stimulate unlimited inspiration and passion of creation.

What are the things you want to do most these days? Have you started to set up new goals or breakthroughs for next period?

Recent year I had created some main text form. And now I am preparing to finish the words bank. This plan is not simple, so I cannot promise. The only thing that a can do is to calm down and steal myself.

Hong Kong

香港

Creators

Chu On Pong

Gavin Mokta

Jim Wong

Karman L' Ull

Paul Sin- A Thinking Moment Design Studio

Toby Ng

朱安邦 Chu On pong

be.net/feverchu *feverchu@gmail.com*

畢業於香港浸會大學數碼圖像傳播系，11 年加入靳與劉設計顧問，主力參與內地企業的品牌形象設計工作；服務過多個國內知名品牌。任職期間前往丹麥哥本哈根參與香港創意中心－元創方 PMQ 的形象設計，與歐洲頂尖的設計公司交流合作；12 年被上海設計協會選為 100 位最優秀全球 80 後華人設計師；13 年與 6 個年青設計單位代表香港，參加柏林 DMY 國際設計展。14 年成立好好設計工作室，遊走於中港兩地，致力為客戶量身定製好好的設計。

Fever Chu studied Digital Graphic Communication at Hong Kong Baptist University. He discovered graphic design and soon developed a passion for it at the university. After graduating from college he joined ChinaStylus as designer and developed a wide range of skills. In 2011, he joined one of Hong Kong's leading design companies, Kan& Lau Design Consultants, and has since worked across the board - branding, packagings, posters and books.
In 2014, he founded his own design workshop: GOODGOOD DESIGN WORKSHOP provides radical ideas, rational solutions and playful design experiences.

世界上沒有人可以不為人民幣服務，如果
No one can resist the temptation of Chinese Yuan, if...

Uneven College 是一本來自香港的獨立實驗雜誌，探討各種跟生活藝術有關的領域：設計，藝術，攝影以及文字。創刊號以設計師的垃圾箱為主題，呈現設計師在生活中搜集的各種想法與 " 垃圾 " 。

Uneven College is a self-published zine focusing on different aspects: visual, design, photography and culture. It provides a platform and show case for artists, designers and writers to explore the possibili- ties of images and text.

■ 請問您對於「創作」所擁抱的理念是什麼？從以前到現在，是否有所轉變？

「創作」其實是一種修煉，透過不斷累積生活體驗與人生閱歷，我們對創作的理念都會有不同層次的解讀，這個觀念我從來沒有改變。

對我而言，「創作」一個很核心的理念就是「為了尋找一個好答案的過程」，無論是為了解決自身或者客戶的問題。「創作」是一種解決問題的方式，過程總是充滿樂趣和痛苦。樂趣是在有限條件內成功找到一個好的解決方法，是讓人非常滿足的一件事，同時你又不知道哪天會有人比你做出更好的答案，讓自己可以學習提升。痛苦就是在有限條件內不能找到滿意的解決方法，而又不得不妥協，讓方案出街。

What is your "main idea" while producing a piece/series of work? Have it ever changed before?

Sometimes "Creating " is actually a kind of practice, through the continuously accumalation of life experience, we would have different levels of interpretation about the creating ideas, and this is a main idea what I have never changed.
For me, the core concept of "Creating" is "a process of finding a great answer," whatever the answer is to solve our or customers' problems. "Creating" is a method to solve the problems, and there are full of fun and pain in this process. The fun is to find a good solution to solve problems sucessfully, and it is very satisfactory, at the same time, you never knew that someday others people would make the better answer than yours, so you can learn to improve yourself. While the pain is that you can not find a satisfactory solution, you have to compromise and then give a proposal.

■ 請問您認為該國最棒的是什麼？（如國家的特色或文化等）您的創作是否受其影響？

任何創作都離不開生活，而香港現在的社會與政治鬧劇特別豐富精彩，讓人產生很多想像空間，反思空間，學習空間和體驗空間。漸漸學會如何面對對立，學會怎樣包容，學會怎樣自力更新。透過這這些體驗，讓我的創作更加俱有人性，更加貼近生活。

What is the best thing in your country? (likes features or culture)
Have it ever influence your creation?

Any creationss can not live without life, and now the Hong Kong's social and political farce are especially sufficient and wonderful, making a lot of spaces for imaging, thinking, learning and experiencing. Gradually learned how to face the opposition, hot to tolerate, and how to rely on myself. Through these experiences, my creations are more with humanity, and more close to life.

■ 請問您一路以來的創作歷程（與創意／藝術／設計／插畫的邂逅，踏上這條創作路的歷程，旅途上遇見的瓶頸與突破方式）

自小喜歡繪畫，先自己創作玩具，到處塗鴉，再幫鄰居和同學畫人像和機器人，再到正式學習中國畫，體驗繪畫的嚴謹與系統。慢慢意識到自己愛上美的東西，而這種美是有溫度的，是能和別人產生互動的，是能提升人的生活品質的。幸運的我在進入大學後接觸到設計，並且與它一見鍾情，從此我看待美的東西又多了一個深度。

每次遇到瓶頸，我有兩個處理方法：第一是找朋友聊天，因為旁觀者總能提出各種好的壞的建議，收集這些刺激，往往能啓發自己再推進一步。第二就是完全放下手上工作，幹幹別的，回來繼續糾結，再去幹幹別的，又回來繼續糾結，如此重複，直到神仙來搭救你；或者死線到來，宣告戰爭失敗。不要小看每一次的失敗，它們也是所有創作人的好朋友！

Share the story of you creating your pieces.
How did you encounter with creativity/art/design/illustration? And what happened? Have you ever been stranded at a bottleneck? And how did you overcome?

I have fond of painting since the childhood, from creating toys, graffiting everywhere, drawing portraits or robotics for my neighbors and classmates, to officially studying Chinese painting, I experienced the strict and system of painting. Gradually I realized that I love the beautiful things, while this beauty is with temperature, and is able to interact with others, to enhance quality of peoples' lives. Fortunately, I was in touch with design after entering the university, and I was fond of design at first time, since then I can look at beautiful things deeply. When there has a bottleneck with my job, I usually have two methods to process it: one is to chat with my friends because the spectator can always give a variety of good and bad advices, then I collected these stimulus which can inspire me to move further, and the second method is completely put down the works, try to do anything else, and go back to fight with it; repeat it until the gods rescue you, or wait for the deadline coming, then declare the failure of war. But don't underestimate every failure, they are also the good friends of all creators!

香港 Hong Kong

莫柏俊 Gavin Moktan

www.gavinmoktan.com *gavinmoktan@gmail.com*

Gavin Moktan(莫柏俊) 畢業於觀塘職業訓練中心平面設計系，畢業後在出版社、網頁設計公司及教育機構工作。之後，他加入了 Dash Co. 任職設計師。在 2014 年獲得由香港設計師協會頒發環球設計大獎 2013 年優異獎。

Borned in Hong Kong in 1984. Gavin Moktan graduated from Kwun Tong Vocational Training Centre with diploma in graphic design. After graduation, he had worked in publishing, web design and education Company. After that, he has joined Dash Co. as designer. In 2014, he has a merit award of HKDA Global Design Awards 2013 of corporate website.

#click #the #like #fucking #button #bitch #!

friend in my screen

give me the fucking credit, mothafucker!

friend in my screen

每天在網路上掃過的臉。
what i flick over everyday in web.

黃嘉遜 Jim Wong

www.gd-morning.org/jim　　*jim@gd-morning.org*

黃嘉遜，80 後香港平面設計師。他與夥伴創立了工作室 Good Morning，專注於形象標識、展覽和出版物設計。他認為唯美動人並非創作的重心和最終目標，優秀設計應傳達出資訊的本質，並以提升人類生活快樂為宗旨，傳播積極向上的價值。作品曾收錄於香港設計師協會環球設計大獎，東京字體俱樂部年鑑，亦多次刊登於國際設計雜誌及出版物。

Jim Wong is a Hong Kong graphic designer of the' 80s generation: creative, innovative and energetic. He co-founded the creative workshop "Good Morning" that specializes in identity, promotion, exhibitions, prints and publication.
Jim believes that aesthetic beauty is not the be-all and end-all of a good design, which should also communicate the essence of social message, and spread positive values with a view to increase the sum of human happiness. His works have been selected in HKDA, Tokyo TDC Award Annual, and published in design magazines and publications internationally.

由牛房倉庫舉辦，詩＋設計是一個以澳門詩人和設計師互動的展覽。從詩人邢悅的作品中取得靈感，黑白相間的斑馬線狀圖形交織在一起，形成中文的「路」字，正是詩中作者與友人相遇的地方，亦暗喻了所謂人生的道路。

Poetry + Design is a collaborative exhibition by Macau poets and designers, organized by Ox Warehouse.
The poster was designed base on the poetry from Elvis Mok. Zebra cross like graphic has been designed to form a Chinese word "road".

1/ 受香港設計師協會邀請為 7 個年輕設計師協作者之一，我為〈香港設計師協會 環球設計大獎 2013〉的主提〈論設計〉創作了這海報。〈設計師喜愛作品被關注〉的英文被隱藏在 DESIGNERS(設計師) 之中，有趣地表現出設計師喜歡在作品上加上設計者名字的微妙動作。

I was invited to be one of the collaborator to create the visual for the HKDA Award 2013. With the theme "Design Issue", 7 young designers were asked to think of a statement about the theme and design the visual using typography only. The statement "Designer(s) love their works to be seen" is hidden in the word designer(s), playing the humor that designers like to add their credits in their works subtly.

2/ 受印尼設計工作室 Sciencewerk 邀請參與 "designer's type" 這個項目。以〈媒體痴迷〉為題，我創作了〈思想控制〉這件作品。科技的進步令我們很容易從不同的電子或網上媒體接收大量難分真偽的資訊。大眾應思考社交平台與媒體對我們的影響。

Collaboration work for the project designer's type. Invited by Indonesia Design studio Sciencewerk, I have designed the poster based on the theme media obsessed. As the technologies grow rapidly, we receive lots of information everyday. Social media and the mass media can influence us easily.

■ 請問您對於「創作」所擁抱的理念是什麼？從以前到現在，是否有所轉變？

當我在工作的時候並不會特別有任何的理念。但在建立設計風格的時候，我總是提醒自己去思考目的，有時候我喜歡在作品當中放進一些隱藏的訊息，讓觀眾去發現。

■ 請問您如何獲得靈感？

和不同的人交談，探索未知的事，或集中注意力。

■ 請和我們分享您喜歡的書籍、音樂、電影或場所

最近在看這本書：《一個中國獨立設計者的當代藝術史：何浩書籍設計 2003-2013》。

■ 請問您最近最想什麼事情？是否已經著手規劃下一階段的目標或突破了呢？

我最近才剛完成一件展覽識別的專案，對於未來我不會想太多，相較之下，我更專注於現在所做的事。

What is your "main idea" while producing a piece/series of work? Have it ever changed before?

I don't have particular philosophy when working on the project. But I always remind myself to think objective when developing the design and style. Sometimes I like to make some hidden message inside the work and let the audiences to discover.

How do you draw the inspiration?

Talk with different people and go explore something you don't familiar or pay attention with.

Share good books/music/movies/places with us.

Recently I am reading the book A Designer's Decade of Contemporary Art in China: The Book Designs of He Hao, 2003-2013.

What are the things you want to do most these days? Have you started to set up new goals or breakthroughs for next period?

I have just finished an exhibition identity project. I didn't think too much for the future as I rather focus more on what I am doing in the present.

Karman L'Ull

karman@gd-morning.org

Karman L' Ull，來自 good morning 團隊，一個年輕的香港設計勢力，2008 年由 Jim Wong 建立。我們的主要業務為平面設計，其中包含企業識別、視覺識別、行銷活動、展覽及印刷品。
祝福您有一個美好的早晨，與美好的一天。
入選作品：東京字體指導俱樂部年獎 / 亞太設計年鑑 / ifva 獨立短片及影像媒體比賽 / 香港設計師協會。

It's Karman L' Ull from good morning,a young Hong Kong-based design forceformed with Jim Wong since 2008. We mainly focus on graphic design, including corporate identity, visual identity, promotion campaign, exhibition and printed materials.
Have a nice morning, and have a nice day.
selected work in: Tokyo Type Directors Club Annual Award / Asia-Pacific Design / IFVA Awards / HKDA

1 2

1/ 設計了新的草原地圖商標，加上標誌性的「草鹿」標記，附上手繪各種露營用具的親切感。

With a new designed Lawnmap logo, and the iconic "grass deer" event logo, this sweet and friendly poster is created with hand-drawn camping geers.

2/ 此次活動是草原地圖一年一度的重點節目，草地 x 音樂，今次首次為活動創作了以鹿為吉祥物的活動商標，也由於首次引入露營活動，為了突顯這點，所以在主視覺上加進鮮明的黃色營帳圖案和線條。

Grassfest is a event which is combining grass and music. We created a unique event logo which is using "deer" as a mascot. And this is the first time for adding camping in this event, we tried to emphasize that by using the sharp yellow lines.

深圳和香港，真的一定要走在一起嗎？
Shenzhen and Hong Kong, they really have to go together?

■ 請問您對於「創作」所擁抱的理念是什麼？從以前到現在，是否有所轉變？

「創作」在小時候會想是「從零到一」吧，無中生有，那才是創作。可是，現在做過的事多了，看過的世界大了，創作好像是變了「從一到二」，因為好像很多東西也有人做過，有時候反而是根據前人的創作再引發相關的作品，那樣也很有趣。

What is your "main idea" while producing a piece/series of work? Have it ever changed before?

When I was young, "creation" may be simply like "from 0 to 1". "Create from nothing", that should be the meaning of creation. However, after I have done certain works and seen more creations which made by the others, "creation" is more like "from 1 to 2". As nearly all the stuff have been tried or made by the other people, that may be more interesting that you would have a chance to develop a new work which is based on the old work.

■ 請問您一路以來的創作歷程（與創意／藝術／設計／插畫的邂逅，踏上這條創作路的歷程，旅途上遇見的瓶頸與突破方式）

這應該是因為小時候接觸到漫畫這個媒體，讓我初次領會到圖像的力量可以是很大，自此就開始留意繪畫，留意設計，直到現在。

Share the story of you creating your pieces. How did you encounter with creativity/art/design/illustration? And what happened? Have you ever been stranded at a bottleneck? And how did you overcome?

The manga made a huge influence to me I guess. It makes me firstly feel the power of graphic. Then I start drawing, start doing design, until now.

■ 請問您如何獲得靈感？

聽著歌，在街遊走思考。

How do you draw the inspiration?

Listen to the music, walk on the street, and think.

■ 請和我們分享您喜歡的書籍、音樂、電影或場所

所有井上雄彥繪畫的漫畫。

Share good books/music/movies/places with us.

All of the manga drawn by Inoue Takehiko.

■ 請問您做過最瘋狂或最酷的事情是什麼呢？

從零開始，和朋友一起辦了一個三日兩夜的「草民音樂營」活動，應是最瘋狂了！

What is the craziest or coolest thing you have ever done?

Creating a brand new 3 days event called "Grasscamp", that should be the craziest thing I have ever done!

Paul Sin - A Thinking Moment Design Studio

www.a-thinking-moment.org info@a-thinking-moment.org

"A Thinking Moment" 是一間香港的平面設計工作室，2009 年由平面設計師 Paul Sin 成立，主要專注於各種設計項目，包括品牌設計，藝術指導，字體設計，海報，書籍設計和包裝。我們相信，平面設計可以觸動人的眼睛和心靈，並觸發更美的世界！

"A Thinking Moment" is a graphic design studio based in Hong Kong, established by graphic designer Paul Sin in 2009; focus on a range of project including branding design, art direction, typography, poster, book design and packaging, We believe graphic design can make an impact on peoples' eyes and brain, and make a change for a better world!

2012 年巴塞隆納 Neue Showusyourtype x OFFF 設計展特別入選的海報設計。視覺的概念是應用圖型元素做成抽象的字體「OFFF」，混雜平面設計與複合媒材，傳達視覺衝擊的組合。

A poster design specially elected for "Neue Showusyourtype x OFFF Barcelona 2012". The visual concept of the application of this abstract typography "O F F F" is the presentation of graphical elements intertwining graphic design and multimedia to deliver a visually striking composition.

1 2

1/ 替「人本澡堂」設計的視覺藝術海報，人本澡堂是香港一個專業組織，向組織的成員與一般人提供藝術治療。LOST-AND-TO FIND 就是這個視覺藝術海報的概念：幫助那些迷失的人們（包含我們本身），去找回自己。以三 D 渲染創造出「迷失」給人的視覺衝擊，而觀眾若深入去觀察，可以從中「找到」隱藏的臉。

A visual art poster is designed for "Person-Centered Center", which is an organization of professionals providing art therapy for its members and general public in Hong Kong. "LOST-AND-TO FIND" is the concept of this visual art poster: For those who are lost, and we, to help them to find himself; an impact "LOST" visual is created by 3D rendering, while audience may "FIND" that hidden face when they look deep into it.

2/ 實驗海報創作，創作理念：生命應該是輝煌燦爛的，活出自己，愛你所愛。

An experimental poster design work, with the concept - Life should be brilliant, live the way You live, love the one you love.

■ 請問您對於「創作」所擁抱的理念是什麼？從以前到現在，是否有所轉變？

當我在創作海報作品的時候，我會去找一些東西，新的、特別的、令人振奮的事物，能夠衝擊人們的視覺與大腦。如何去定義好的設計？對我來說好的設計就是能夠觸動人心的想法，另一方面，海報的功能不只是單純敘述故事而已，還要對人們有所啟發。

■ 請問您如何獲得靈感？

做設計的時候，我通常會聽搖滾樂。有時候，我的靈感來自電影、書籍或詩句。當你找到一些能夠感動你的事物，那些事物就會讓你靈光乍現。

■ 請問您做過最瘋狂或最酷的事情是什麼呢？

在我出差到哥倫比亞一星期後，我愛上當地的女孩子。我只會說英文，而她只會說西班牙文，我們雖然言語不通，但我們還是非常相愛，最後成為一對戀人。

■ 請問您最近最想什麼事情？是否已經著手規劃下一階段的目標或突破了呢？

我想要環遊世界，認識各式各樣的人與文化，得到更多靈感。現在，我正在南美洲旅行。

What is your "main idea"while producing a piece/ series of work? Have it ever changed before?

When I work on an idea or creating a piece of poster work, I always look for something new, something unique, something exciting, something that can impact people's eyes and brain. How to define a good design, for me is an idea which can touch people's heart, on the other hand, it's not just a piece of work to tell story, but also an inspiration to people.

How do you draw the inspiration?

I used to listen to rock music when I doing design work. Sometimes, my ideas are come from movies, books or poetry. When you find something which can impact you, there should be a spark of idea.

What is the craziest or coolest thing you have ever done?

After a week in Colombia of my business trip, I fall in love with a Colombia girl. I can only speak in English, and she can only speak in Spanish, we are lost in communication, but we still love each other so much and become a couple.

What are the things you want to do most these days? Have you started to set up new goals or breakthroughs for next period?

I would like to travel around the world, meet different people and culture, get more inspiration. Today, I'm on my trip in South America.

伍廣圖 Toby Ng

www.toby-ng.com　　*mail@toby-ng.com*

伍廣圖畢業於倫敦中央聖馬汀學院。憑著創意及對身邊事物的觸覺和慧眼，伍廣圖的設計廣受歡迎，並獲得不少國際獎項。作為一個備受肯定的平面設計師，他於 2014 年榮獲香港青年設計才俊獎，並於同年獲 Perspective Global 選為亞洲首四十位 40 歲以下的設計師之一，亦得到 Designnet 雜誌譽為亞洲最傑出三十六位青年設計師之一。伍氏亦於 Tedx 講座、國際會議及不同大學分享他的設計及理念。2014 年，伍廣圖創立設計及品牌顧問公司 Toby Ng Design，為更多引人入勝的設計意念築建諾大的發展空間。

Toby Ng graduated in Central St. Martins, London. With a combination of creativity, experience and wit, Ng's design have been well-received, winning global awards. Being a recognized graphic designer of the generation, Ng was honoured the Hong Kong Young Design Talent Award in 2014, selected by Perspective Global as one of the top 40 design talents under the age of 40 in Asia and named as one of the 36 Young Designers in Asia by Designnet magazine. Ng also shares his works and ideas in Tedx talk, international conferences and universities. In 2014, Toby Ng Design a design and branding consultancy was founded, opening a place to plant new intriguing wisdom to life.

1

2

1/7300 萬，是一筆龐大的數目。或許不是，在香港，每年有 7300 萬隻鯊魚因為身上的魚翅而被捕殺，有超過七成的魚翅在香港進行貿易。這個城市被貼上主要魚翅經銷商的標籤。針對香港魚翅龐大的消費需求量，這個展覽替鯊魚發聲，並提出警訊。過去的 50 年內，鯊魚的數量已經銳減超過八成。大魚受到威脅，生態系統也遭殃。聚光燈已照亮在這個議題上面，就看你願不願意去關心。

73,000,000 is a great number.Maybe not, for Hong Kong. This is the number of sharks killed for their fins every year, out of over 70% are traded in HK. The city is flagged as the major shark fin dealer. Big appetite for fins roars the exhibition alarm for sharks. In 50 year's time some have declined for more than 80% in population. The big fish is threatened, so is the ecosystem. The spotlight is on, if you care to see.

2/ 在 2010 年 6 月 1 日，香港報紙報導：一間大型的在地壽司連鎖商店因為黑鮪魚料理獲利 136 萬。世界自然基金會 (WWF) 曾公佈：「如果地中海地區不停止濫捕行為，黑鮪魚就將要瀕臨絕種。」而聖經寫著：「人活著，不是單靠食物。」(馬太福音 4:4)

On 6.1.2010, Hong Kong papers read: A large local sushi chain won the bid for a Bluefin tuna with 1.36 million.WWF had told the world: 'This species [Bluefin tuna] is at serious risk of extinction if unsustainable fishing practices in the Mediterranean are not stopped. 'And the Bible says: 'Man does not live by bread alone' (Matthew 4:4)

If the world were a village of 100 people

FEAR

20 live in fear of death by bombardment armed attack, landmines, or rape or kidnapping by armed groups

80 don't

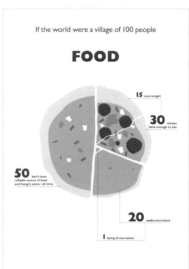

If the world were a village of 100 people

FOOD

15 overweight

30 always have enough to eat

50 don't have reliable source of food and hungry some / all time

20 undernourished

1 dying of starvation

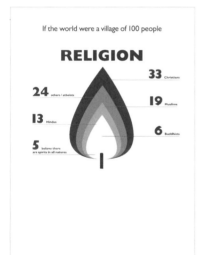

If the world were a village of 100 people

RELIGION

24 others / atheists

13 Hindus

5 believe there are spirits in all natures

33 Christians

19 Muslims

6 Buddhists

1

If the world were a village of 100 people

SKIN COLOUR

70 non-white

30 white

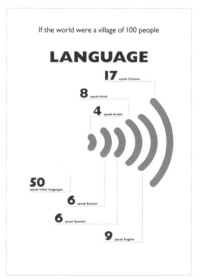

If the world were a village of 100 people

LANGUAGE

17 speak Chinese

8 speak Hindi

4 speak Arabic

50 speak other languages

6 speak Russian

6 speak Spanish

9 speak English

如果世界是一個擁有 100 人的村莊，那會是由哪些人組成的？這一組海報，透過統計世界上的人口分佈，做出各式各樣的分類。這些數據都轉變成圖形，賦予另一種感覺——用看的方式，來感受這個我們生活著的世界。

If the world were a village of 100 people, what would its composition be? This set of 20 posters is built on statistics about the spread of population around the world under various classifications. The numbers are turned into graphics to give another sense a touch - look, this is the world we are living in.

■ 請問您對於「創作」所擁抱的理念是什麼？從以前到現在，是否有所轉變？

Ideas 是我在設計當中最重要的元素，我不相信去依賴任何一種風格，我總是試著想出好的點子，而且執行起來要最合適、簡單，以及很棒的美感。

■ 請問您一路以來的創作歷程？

我以前在以 A-leverls 的學術資格在英國學純藝術，那時候我對於設計一無所知，我的藝術老師建議我嘗試平面設計的學位，雖然我有中央聖馬丁藝術與設計學院的基礎，但我在藝術與平面設計學位間拉扯，我覺的靠藝術好像很難生活或找到工作，而且對平面設計中的字體設計還有創意發想很有興趣，我就這樣進入設計的圈子……。
在經過與香港、新加坡和倫敦不同的知名企業、大師底下工作之後，去年我開設了一間屬於自己的公司。

■ 請問您如何獲得靈感？

從每天的生活，閱讀、電影、音樂、食物、對話、自然……。

■ 請問您做過最瘋狂或最酷的事情是什麼呢？

去年開始營運我個人的公司，而且沒有太多資產、顧客和有來往的業務。

What is your "main idea" while producing a piece/series of work? Have it ever changed before?

IDEAS is the most important elements of my design. I do not believe in permit any one style. I always try to come up with a good idea execute with the most suitable, simple with great aesthetic.

Share the story of you creating your pieces.

I was doing fine art in my A-levels in UK and I do not know anything about design at that time. My art teacher suggested me to try Graphic Design for my degree. While my foundation study in Central St. Martins, I was choosing between fine art or graphic design for my degree and I thought fine art seems like impossible to make a living or get a job, and I am quite interest in typography and the creative ideas of graphic design. That's how I get into that...
After working in Hong Kong, Singapore and London for with different reputed companies and masters, I started my own company last year.

How do you draw the inspiration?

In everyday life, read, movies, music, food, conversation, nature...

What is the craziest or coolest thing you have ever done?

Started my design company last year without too much money, client nor connections.

Indonesia

印度尼西亞

Creators

Andriew Budiman

Sandy Karman

Andriew Budiman

www.butawarna.in *kata@butawarna.in*

Andriew Budiman 是設計合作聯盟 Butawarna 的設計師，Butawarna 的目標是提升設計的實踐與對話。Andriew Budiman 同時也是獨立工作室 C2O library & collabtive 的視覺傳達總監，負責成立、策展還有主導一項計劃：Design It Yourself (DIYSUB) 泗水會議，這是城市裡的年度設計討論會與節日，宗旨是去抓住真實、宣揚情境式的設計對話。他在 Ayorek!，一個雙語的城市知識網路平台裡擔任藝術與傳播總監，並在印尼平面設計師協會的泗水分公司擔任董事會的顧問。2015 年初，他策畫 Perak Project，一個為了探索在貿易與全球化扮演重要角色的泗水港而舉辦的藝術展覽，藉此能夠直接參與這個重要港口城市的整個歷史。

Andriew Budiman is a designer at Butawarna, a design cooperative unit that aims to develop design practices and dialogues. He also works as Visual Communication Director at C2O library & collabtive, an independent library and a collaborative lab, where he has co-founded, curated, and directed one of its major programs, Design It Yourself (DIYSUB) Surabaya Conference, an annual design conference and festival designed to capture and disseminate factual and contextual design dialogues in the city. He serves as Artistic & Communication Director at Ayorek!, a bilingual urban knowledge network platform, and as a board of advisors at the Surabaya branch of ADGI (Indonesian Graphic Designer Association). In early 2015, he curated Perak Project, an art exhibition that aims to explore the role of Surabaya's port as a key point of trade and globalisation, thus engaging directly with its fluctuating role as a port city throughout history.

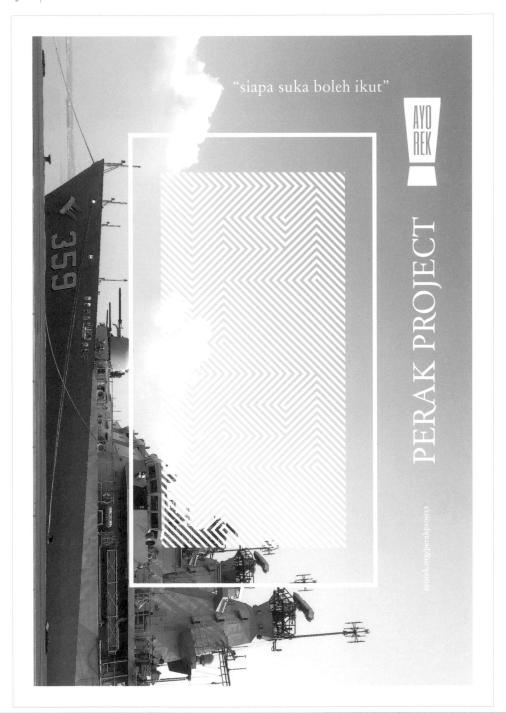

這是替 Perak Project(霹靂企劃) 設計的宣傳海報，我是這項計畫的策展人。其目標是鼓勵觀眾對霹靂港產生興趣、想要深入了解，並共同描繪霹靂港的故事。霹靂港是泗水的指定區域，這項企劃同時也讓我們能夠了解泗水比較大的議題與相關的動態，丹戎霹靂港是印尼泗水第二大港口，現在這個地區在社會的經濟的變遷與發展上正面臨著莫大的挑戰。

This is a promotional poster for a project that I was involved in as a curator, called Perak Project. The project aims to encourage interests, understanding, and participation in shaping the stories of Perak as one specific area in Surabaya, while also giving us an understanding about the larger issues and interrelated dynamics in Surabaya. Tanjung Perak is Indonesia's second largest port based in Surabaya. Now the area is facing tremendous challenges along with socio-economic flux and development.

Ayorek！是一個泗水城的動態知識平台，內容是收集、組織和傳播豐富的城市經驗與動態知識，特別是在泗水這個城市。我們在泗水市建立一個計劃鼓勵參與知識的創造、並架設網路平台。我們設計出一套識別系統、圖示與字體，讓它可以很容易轉換到各種類型的媒介上面。從網站、印刷、書籍／編輯設計、明信片、貼紙和郵票。簡單的元素就能夠融合取材自民間、甘榜環境與現代環境的業餘攝影。這個計畫會不斷地進行與合作，以動態的知識庫的形式持續成長並發展下去。

Ayorek! Surabaya's Urban Knowledge Dynamics platform is a platform that aims to collect, organise, and disseminate the rich dynamics of urban experience and knowledge, specifically in the city of Surabaya. Building a program to encourage participatory knowledge production and networked platform in Surabaya. We create an organic set of visual identity, icon and typeface, with an easy going attitude that can easily translated in wide array of medium type. From website, toprint, book/editorial design, to postcard, sticker, and stamp. The simple strike element can easily blend both with amateur photo taken from folk, kampong environment and a modern environment. It's an ongoing and collaborative project that will grow and develop as the nature of knowledge dynamic itself. http://ayorek.org

■ 請問您對於「創作」所擁抱的理念是什麼？從以前到現在，是否有所轉變？

通常我先從擬定和塑造想傳達的本質來著手，然後根據內容的需求建立起敘事系統，這是很標準化的作業流程，我覺得。但也最費時（至少對我來說），而且隨著資訊與傳播的生態不斷改變，比起過去只會越來越複雜化，設計師們除了需要有心力將複雜的情報去蕪存菁，還要去了解現況的本質與內容。

What is your "main idea" while producing a piece/ series of work? Have it ever changed before?

Usually I'll start by elaborating and shaping the essence of the communication, and then develop the narrative system according to its contextual requirements. It's very normative, I think, but it works (at least for me) most of the time. And within increasingly more complex, ever changing ecosystem of information and communication, more than ever, designers need to develop not only their mind and ability to cut into the essence, but also the empathy to understand the nature and context in today's situation.

■ 請問您認為該國最棒的是什麼？（如國家的特色或文化等）您的創作是否受其影響？

食物！我們非常以自己國家多樣性的烹飪美食為榮，但這或許對設計師的心靈不太好，我們太容易被滿足了！

What is the best thing in your country? (likes features or culture)
Have it ever influence your creation?

Food! We're quite proud of our culinary diversity. But probably it's bad for the designer's mental. We're so easy to be content.

■ 請問您一路以來的創作歷程（與創意／藝術／設計／插畫的邂逅，踏上這條創作路的歷程，旅途上遇見的瓶頸與突破方式）

盡量在表面與核心問題之間取得平衡點，盡可能在自己的記憶庫裡蒐集多一點參考資料，詳細闡述內容、內容、還有內容！不要害怕嘗試混合新的事物（我們會隨著時間而熟能生巧），還有遇到瓶頸的話就四處走走吧。

Share the story of you creating your pieces.
How did you encounter with creativity/art/design/ illustration? And what happened? Have you ever been stranded at a bottleneck? And how did you overcome?

Try to see beneath the surface, dig to the core problem. Collect as many references as you can in your memory library. Elaborate context, context, and context! Don't afraid to do the new remix (We'll learn to do it wisely in time). Walk or go around somewhere.

■ 請問您如何獲得靈感？

靈感對我來說是個神祕的字眼、一種神祕的概念，我不太明白，也無法仰賴它，這需要靠一定的運氣。當我要調查某件事的時候，我就跟大多數人做的一樣：問、說、看、聽、閱讀，還有實地訪查。

How do you draw the inspiration?

Inspiration is a mysterious word and concept to me. I don't get it, I can't rely on it, but at the same time, there's a certain serendipity to it. Whenever I have to look up for something, I do what most people do: ask, talk, see, hear, read, walk.

印度尼西亞　Indonesia

Sandy Karman

www.sandykarman.com　　contact@sandykarman.com

Sandy Karman 是一位獨立海報藝術家和平面設計師，出生在雅加達，萬隆理工學院視覺傳達系畢業。2004 年在 Total Design(阿姆斯特丹) 工作，2005 年到 2007 年在 Leo Burnett Design 和 Ogilvy one (雅加達) 工作。
他的海報曾在受邀在巴黎平面設計插畫節展出，其作品也曾受國際海報雙年展、三年展，以及其他平面設計展之邀請在許多國際型博物館展出，像是日本富山縣近代美術館、波蘭華沙海報博物館、芬蘭拉赫第海報博物館、香港文化博物館、首爾藝術殿堂、莫斯科中央藝術之家、釜山會展中心……等。舉辦過的個展：A Post(er): Sandy Karman 海報展和 Sandy Karman: 向印尼英雄們致敬。

Sandy Karman is an independent poster artist and graphic designer, born in Jakarta, graduated from visual communication design – Bandung Institute of technology. Having worked for Total Design (Amsterdam)in 2004, Leo Burnett Design and Ogilvy one (Jakarta) 2005-2007.
His posters have been exhibited in LaFête du Graphisme Paris (the graphic art festival), Paris invite le monde and international museums such as the Museum of Modern Art Toyama, the Poster Museum Warsaw, Poster Museum Lahti Finland, Hong Kong Heritage Museum, Seoul Arts Center, the Central House of Artists, Moscow, Busan exhibition &convention center , etc. In international poster biennials and triennials worldwide, as well as other graphic design exhibitions. Sold exhibitions such as a post(er): Sandy Karman poster exhibitions and Sandy Karman: tribute to Indonesian heroes.

Doea Tanda Mata (Tokens of Remembrance) | 2015
Tiga Dare (Three Girls) | 2015

1 2

1/ 致敬印尼的經典電影海報。

Tribute to Indonesian Classic Films poster.

2/ 致敬印尼的經典電影海報。

Tribute to Indonesian Classic Films poster.

■ 請問您對於「創作」所擁抱的理念是什麼？從以前到現在，是否有所轉變？

理念始終是作品本身所傳達的內容與訊息，但在這個過程中，我認為設計師如何將訊息轉劃成設計創作也是和理念本身同樣重要的存在。

■ 請問您認為該國最棒的是什麼？（如國家的特色或文化等）您的創作是否受其影響？

我喜歡我們國家的食物、多樣性還有文化！但我最喜歡印度快樂的人們，無論他們的生活有多麼辛苦，他們還是會聚集在一起並開心的笑著，這個國家的人們非常樂觀，樂觀就是力量。而我的創作的確深受國家影響，我覺得國家會使創作者們的作品有所不同。

■ 請問您一路以來的創作歷程（與創意／藝術／設計／插畫的邂逅，踏上這條創作路的歷程，旅途上遇見的瓶頸與突破方式）

當我讀大學而選擇平面設計時，我並不太知道平面設計是怎麼回事，我只知道我熱愛繪畫。現在，平面設計對我來說不只是一種職業，也是一種思考的方法。我喜歡海報，也喜歡創作海報，歐洲的同行朋友常說我是個「浪漫主義者」，我想這是事實。

■ 請問您如何獲得靈感？

從日常生活、從新的經驗、從我看見的事物、從我聽過的音樂、從我讀過的書裡面、從我從未預期過的地方、從運動與工作、還有從案子裡去得到靈感。

■ 請問您做過最瘋狂或最酷的事情是什麼呢？

我不太懂瘋狂是什什麼，但我很喜歡旅遊，一個人，好幾個月。包括溜到禁區旅遊。

■ 請問您最近最想什麼事情？是否已經著手規劃下一階段的目標或突破了呢？

平面設計的部分嗎？我正在替新的工作室找地點落腳。計畫方面，我最近想運用當代的方法重新點亮傳統印尼文化與遺產，我覺得擁抱在地文化和傳統、去思考與創新，對印尼的設計師(還有其他亞洲國家)而言是非常重要的事。

What is your "main idea" while producing a piece/series of work? Have it ever changed before?

The main idea is always the content the message of the work itself. But during the process, the execution of how translating the message into a piece of design is just as important (if not more important) that the content itself.

What is the best thing in your country? (likes features or culture)
Have it ever influence your creation?

I like the food, the diversity & the culture! But what I like most Indonesia is that the people are happy. It seems like whatever & how hard they're going through, at the end of the day, they're gonna gather round and laugh. It's a very optimistic country, and optimism is power. And yes, definitely where we come from somewhat makes a difference on our creation.

Share the story of you creating your pieces.
How did you encounter with creativity/art/design/illustration? And what happened? Have you ever been stranded at a bottleneck? And how did you overcome?

When I chose graphic design at the university I didn't really know what it was all about. All I knew was I like drawing and painting. Now, graphic design to me is not just a profession, but a way of thinking. I love posters and love designing them. My fellow poster artists/designers friends in Europe say that we are a 'romantic.' I guess it's true.

How do you draw the inspiration?

From everyday life. From new experiences. From the things I see. From the music I listen to. From the writings I read. From a situation where we don't expect. From exercising and working out. From working for a project. And from within.

What is the craziest or coolest thing you have ever done?

I don't know about crazy, but I like to travel. Alone. For months. Including traveling to restricted areas.

What are the things you want to do most these days? Have you started to set up new goals or breakthroughs for next period?

In terms of graphic design? I'm looking for a new place for my new studio. Among the daily projects, I'm currently exercising on doing contemporary approach on traditional Indonesian culture and heritage and bring it to new lights. I think it's significantly important for Indonesian designers (as well as other Asian countries) to embrace the local culture and heritage and make it thoughtfully and innovatively contemporary.

Japan

日本

Creators

Yuma Harada

原田祐馬 Yuma Harada

http://umamu.jp/ uma@umamu.jp

1979 年在大阪出生，修成建設專門學校畢業後，2000 年開始就讀京都精華大學藝術學部的設計科學科，專攻建築。之後在 2000 年從修成建設專門學校畢業，第七屆 IMI 大學學生，2002 年畢業後，成為 IMI 映像大學研究所第七屆學生，4 年後畢業。2003 年和增井辰一郎共同發起クリエイティブ・ユニット「archventer」。2007 年他設立 UMA / design farm，負責設計書籍、平面作品、展覽等項目。
2005 年開始在京都造形藝術大學擔任講師，同時在 2008 至 2012 年兼任 ULTRA FACTORY 總監一職，2009 年任「DESIGNEAST」總監、2011 到 2012 年任「GALLERY9.5」總監、2013 年任「design studio ZZZ」和瀨戶國際藝術祭 2013(醬の郷 + 坂手港計畫) 總監、2014 任「アート小豆島・豐島 2014」(醬の郷 + 坂手港計畫) 總監。

Born in 1979 in Osaka. Enrolled as an architecture major in the design course of Kyoto Seika University's art department after graduating from Shusei Architectural Academy in 2000. Enrolled as part of the seventh batch of students at the Inter Medium Institute (IMI) after finishing university in '02, remaining there for 4 years. Launched the creative unit archventer in '03 with Shin-ichiro Masui. In '07, he established UMA / design farm, designing books, graphics, exhibitions and so on.
Began working as an part-time lecturer at the Kyoto University of Art and Design in '05. Also acts as director of CRITICAL DESIGN LAB from '08 to '12, DESIGNEAST from '09, GALLERY 9.5.from '11 to '12, design studio ZZZ, and Setouchi Triennale 2013 (Hishio no Sato and Sakate Port Project) from '13, Art ShodoshimaTeshima 2014 (Hishio no Sato and Sakate Port Project).
Co-author of "relational tourism" (SeibundoShinkosha | 2014)

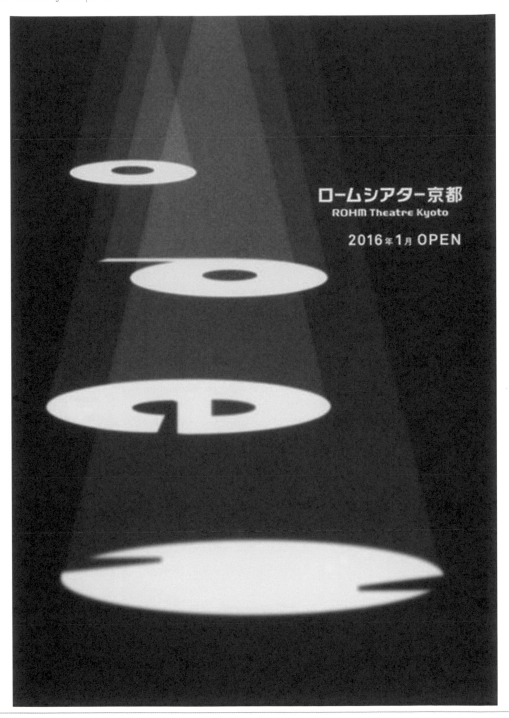

我認為執行專案重要的地方不只是要追古溯今的去做調查，還有需要去探討最初的想法，真正實際地理解它。因此，我們從深入了解理念與客戶的想法來設計這幅作品。

I think it's important to not only survey the upstream and downstream of a project, but also explore its initial thought and really understand it physically. So, also we designed these this works from deep understanding concept and clients' thoughts.

Macau

澳門

Creators

Ieong Chon Man

Lam Ieon Kun

Mic Hoi-Gloss Design Ltd.

楊俊文 Ieong Chon Man

topman320@yahoo.com.hk

出生於澳門,2011 年畢業於澳門理工學院平面設計系並以學士學位畢業,2008 年至今為澳門原創服裝品牌 RIBS CLOTHING 擔任 T-SHIRT 圖案設計和品牌形像推廣的工作、作品包括澳門禮記雪糕、義順牛奶公司與 RIBS CLOTHING 聯名出品的圖案設計,曾獲第八屆澳門設計雙年展 - 澳門學生設計新星獎、第十二屆白金創意全國大學生平面設計大賽 -ADI 新星獎、靳埭強設計獎 2011- 學生組優秀獎、滿記甜品怪獸徵集 - 學生組優秀獎 。

Topman Ieong was born in Macao. Graduated from Macao Polytechnic Institute in 2011 , Department of Graphic Design and a bachelor's degree graduation, original clothing brand in Macau RIBS CLOTHING since 2008 as the T-SHIRT, graphic design and brand image promotion work including Macau Lai Kei Ice Cream,I Son Milk Company crossover with RIBS CLOTHING T-Shirt graphic design Project, won the 8th Macau design Biennial - Macau student design Rising Star Award, 12th Platinum Originality National University Students Graphic Design Competition -ADI Rising Star Award, Kan Taikeung design award 2011 -- Excellence Award of student Section , Honeymoon Dessert monster collecting - Student group award.

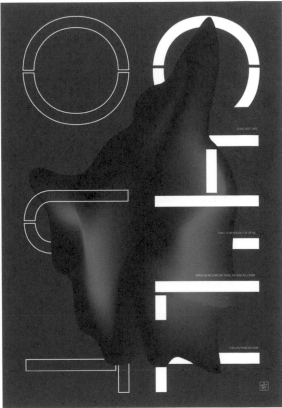

澳門 Macau

林揚權 Lam Ieong Kun

cargocollective.com/HAKA_LAM *fire24682000@yahoo.com.hk*

2014 年畢業於澳門理工學院平面設計學士學位課程。九十後設計師，熱愛設計和插畫。
2013 年獲靳埭強設計師獎學生組銅獎，第十四屆白金創意全國大學生平面設計大賽銅獎二項，第三屆中華區插畫獎 " 評審特選獎 "2 項，優秀獎 3 項。2014Hiiibrand Awards 國際插畫大賽 best of the best 獎。作品分別入選 GDC11 平面設計在中國，第 11 屆莫斯科金蜂國際平面設計雙年展、第二屆上海亞洲平面設計雙年展、2014 澳門視覺藝術年展、《第十屆 APD-亞太設計年鑑》、《第九屆 APD- 亞太設計年鑑》。

He has graduated from Macau Polytechnic Institute, Graphic Design degree courses. A designer, post-1990 generation. Loves design and illustration.
Won Bronze Award of the KAN TAI-KEUNG Design Awards in 2013, 2 Bronze Award of the 14th Platinum Originality National University Students Graphic Design Competition, the 3rd Greater China Illustration Awards, 2 Judge's Choice & 3 Certificate of Excellence, 2014Hiiibrand International Illustration competition, the best of best. His works have been selected by the GDC11, the 11th Moscow Golden Bee International Graphic Design Biennale, the 2nd Shanghai Biennial of Asia Graphic design, Macao Annual Art Exhibition 2014, Asian-Pacific Design No.10&Asian-Pacific Design No.9.

「如果我們不能讓一個大街上的普通人走進美術館，那麼至少我們可以讓美術館中的藝術走上街頭。」從人民角度出發的藝術方式，把藝術方式融合在社區文化當中。從社區的特色元素為出發點建立起社區的自發性、自主性、自信心的藝術活動。以集體行動提升社區藝術的品質為目標。增進居民日常生活地區中重要的集體記憶。藝術應該在根基的地方給予養分，才能得以茁壯成長。本次活動會在澳門各堂區設置 ARTGOGO 創作海報，亦在海報周圍放置各種創作用的工具，只要剛好經過看見每個人也能在海報上進行創作，並不規限創作方式，到最後的成品是大家共同創作的成果，讓民眾主導這場藝術展覽。藝術創作並不是如此難以接觸，讓我們生活在藝術，藝術是生活。

"If we can not let ordinary people on the street go to an art gallery, at least we can make art galleries go out on the streets." Mixed the art into community culture, and create art foam at peoples' perspective. The aim is to conduct art activities which using characteristic elements to establish the art quality of spontaneity, autonomy and self-confidence in community, and enhance important memories of residents in daily life area. The art should grow up by giving nutrients to its root; this event would set ARTGOG creative posters in every parishes of Macao, also it would place various tool nearby to create works. All the people pass by can create on the poster, and any ways of creating are unlimited, and the final produces is created by everyone who take part in, it is the crowd leading an art exhibitions. The art creation is not too hard to reach, let's live in art, and the art is life.

A candle lights others and consumes itself.

生命只能活一次，就像火柴只能燃燒一次，同性戀不應該遭受到歧視，他們勇敢染亮自己的生命，並不是每個人都有著這般的勇氣，希望大家能將心比己，反對歧視。

We only live once, likes matches only can burn once. So are the homosexuality, they should not be discriminated, they are dare to light the lives themselves, and not everyone can have the brave heart. I hope that we should put ourselves in their shoes, and fight against discrimination.

■ 請問您對於「創作」所擁抱的理念是什麼？從以前到現在，是否有所轉變？

希望用設計改變生活。

■ 請問您如何獲得靈感？

靈感來源於生活。還有一些與朋友無聊的對談內容。

■ 請問您做過最瘋狂或最酷的事情是什麼呢？

最瘋狂的事是挑選了設計這條路吧。

■ 請問您最近最想什麼事情？是否已經著手規劃下一階段的目標或突破了呢？

我一直在想如何好好利用時間，但最後總是沒有確實做到。

What is your "main idea" while producing a piece/ series of work? Have it ever changed before?

I hope to change life with design.

How do you draw the inspiration?

The inspiration comes from my life, and some boring content of chatting with my friends.

What is the craziest or coolest thing you have ever done?

The craziest thing maybe is choosing the design road.

What are the things you want to do most these days? Have you started to set up new goals or breakthroughs for next period?

I have been always thinking about how to make good use of time, but in the end I still did not achieve.

Mic Hoi
高斯設計 Gloss Design Ltd.

gloss.com.mo　　*glossmic@gmail.com*

Mic Hoi 在 2011 年由澳門理工學院畢業，主修平面設計。高斯設計有限公司 (澳門) 創辦人 , 作品曾在烏克蘭 , 芬蘭 , 俄羅斯 , 丹麥 , 斯洛伐克 , 和德黑蘭 / 伊朗展出。

Mic Hoi In 2011 graduated from the Macao Polytechnic Institute, majoring in Graphic Communications.He Works in the Gloss Design Ltd.(MACAO). His works have been exhibited in Ukraine, Finland ,Moscow,Dansk,Slovakrepublic,and Tehran/Iran .

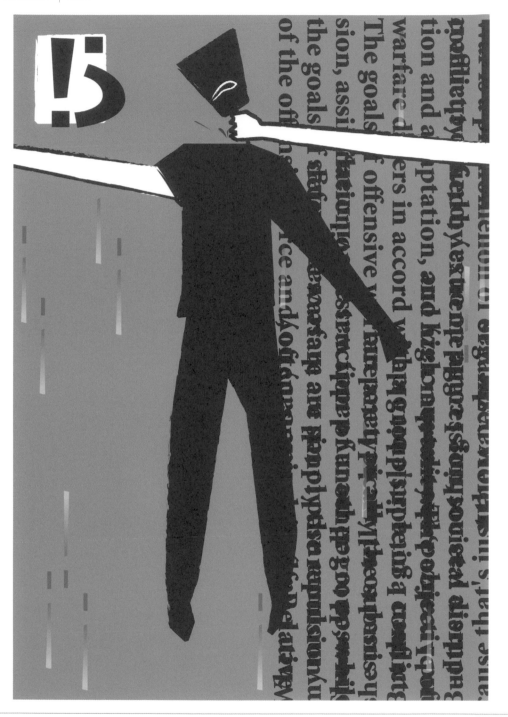

剝削其它人的同時，也在受到同樣處境。

As unjust benefit, exploitation involves a persistent social relationship in which certain persons are being mistreated or unfairly used for the benefit of others.

1 2

1/ 物質都在改變，我們看到的是哪個方向？在我大學畢業的那一刻，進入新領域，觀點和出發點都改變了：這是一種奇妙的感受，對事物的內與外產生了更大的求知慾。

Substances are changing, and which direction we can see? At the moment I graduated from college, and entered into the new field, my views and the starting point have changed; this is a wonderful feeling, which generates greater curiosity about the inside and outside of all things.

2/ 品牌系列，繽紛而具穿透性的獨特風格。

Colorful and unique style with penetrating.

■ 請問您認為該國最棒的是什麼？（如國家的特色或文化等）您的創作是否受其影響？

這裡是個很有趣的地方，周圍都充滿中西融合的氛圍。對於創作需要放鬆而具推動力的心態，這是很適合的環境。

■ 請問您如何獲得靈感？

從生活入手，生命的一切都是獨特而奇妙，每件事與物都可以用不同方式分解重組，聽聽音樂，玩單車，四處遊蕩，只要可以放鬆心情的方式都可以取得更好的思考。

■ 請和我們分享您喜歡的書籍、音樂、電影或場所

史努比狗狗 - The Good Good
希雅 - Elastic Heatrt（韌心）
Irma - Save Me

■ 請問您最近最想什麼事情？是否已經著手規劃下一階段的目標或突破了呢？

近期喜歡畫畫與實驗性的創作，在設計與藝術間找到平衡，從而發掘新的媒介，這是不容易但很有趣的玩法。

What is the best thing in your country? (likes features or culture)
Have it ever influence your creation?

Here is a very interesting place, in which surrounded by arefull of integrationof East and West. As to the need for creating with relax and the attitude of within driving force, this place is very suitable.

How do you draw the inspiration?

My inspiration start from life, all of live are so unique and wonderful,andeverything can be restructured with different way; such as listening to music, riding a bicycle, and roaming around. As long as we can relax, the thought can get better from our life.

Share good books/music/movies/places with us.

Snoop Lion "The Good Good"
Sia - Elastic Heart
Irma - Save Me

What are the things you want to do most these days? Have you started to set up new goals or breakthroughs for next period?

Recently I liked to draw and create some experimental works,to find a balance between design and art, and thus explore new media.It is not easy but very interesting.

Malaysia

馬來西亞

Creators

Keat Leong

LIE

梁海傑 Keat Leong

www.keatleong.net *hkeat7@gmail.com*

梁海傑的人生用在探討藝術、設計與動態圖像的數位創作過程。在得到電影與動畫學位後,開始了動態設計的創作職業生涯,之後,他待在新加坡與台北的動態設計工作室。

目前他在吉隆坡是獨立的創意總監,他還在摸索數位藝術的新境界,試著從轉換螢幕上的像素到畫布,產生實驗性的視覺效果。這些創作表達出感謝與反思,如同展開一段心靈之旅。梁海傑的作品在當地展出,作品也被《Asian Creatives Book》、《Advanced Photoshop》、《Motion Graphics Served》收錄。

Keat Leong explores the process of digital crafting in art, design and motion. After graduating with a degree in Film and Animation, his career began with creating motion designs that mesh beautiful aesthetics and fluid animations. Since then he has worked with motion design studios in Kuala Lumpur, Singapore and Taipei. Currently, he is based in Kuala Lumpur as an independent creative director. He also explores the realm of digital fine art, translating experimental visuals from on-screen pixels to the canvas. These visuals are expressions of gratitude and reflections to being on a yogic journey. Keat's art was exhibited locally and published in Asian Creatives Book, Advanced Photoshop UK and Motion Graphics Served.

如同宇宙之於星星那樣的遼闊，對細胞來說，人也龐大的像是宇宙。生命無邊無際，與萬物相比之下，人類居然可以既偉大又渺小。卡爾·薩根曾說「我們都是星塵。」，而這系列的作品，就是要表現他說的話。

As the vast space consists of a universe of stars, so is the body a universe of cells. Life is so boundless and this contrast of scale is so grand. It is truly humbling as a person being so big yet so small at the same time.
Carl Sagan once said that "We are made of starstuff" and this series is also reflective of that.

大自然的壯麗在於萬物在同時間出生與死亡；植物、動物、人類、星球，都是同樣的東西。葉子的蓬勃與枯萎都同樣美麗，如果植物與動物有一天能合而為一，這是多麼具有想像力的畫面啊。

One magnificent quality of nature is how everything is living and dying at the same time, Plants, animals, people, planets, or stars are all the same. There is as much beauty in a dying leaf as there is in a living one. And this is the imaginary vision if plant and animal could one day unite together as one.

■ 請問您對於「創作」所擁抱的理念是什麼？從以前到現在，是否有所轉變？

我發現自從瑜珈走入我的生活之後，我的人生觀也就此改變。我的心像水一般自由地流動，我很感激能夠嚐到生命的喜悅與偉大，我想在自己的藝術裡表達我發掘到的事物。這些靈感來自於生活、直覺與誠實，無論是個人創作或是客戶的專案，我都盡量讓自己坦白真誠。

■ 請問您認為該國最棒的是什麼？（如國家的特色或文化等）您的創作是否受其影響？

我喜歡自己家鄉多元豐富的文化。在一天當中，我可以嘗試各種類型的食物，或是遇見各式各樣的人，舉例來說，點飲料的時候我說印尼話，和朋友聊天時用英文，與家人則用廣東話交談。我還喜歡觀察生活週遭的紋理還有形貌，雖然現在蓋了許多大樓，但我仍然喜歡那些老街道與房子。在我的作品裡頭也有許多層次紋理，說不定這就是國家影響我的地方。

■ 請問您如何獲得靈感？

靈感通常在寂靜的早晨造訪，就在我冥想，或是獨自旅行的時候。在大自然裡，例如山丘、草原，也會幫助我整理思緒。我從冥想、書籍、旅行、環境與人之中獲得靈感。

■ 請和我們分享您喜歡的書籍、音樂、電影或場所

最近我讀的書是電影導演雅絲敏·阿莫的傳記《Yasmin How You Know?》，由她的朋友們分享對於雅絲敏的回憶，我深深被她的精神所感動，她並非拍電影出身，但對我來說，她的電影確實描繪出我們國家真實的靈魂與感情。

■ 請問您最近最想什麼事情？是否已經著手規劃下一階段的目標或突破了呢？

就我個人而言，我想過簡單的生活，只做對我而言有價值的事。今年我仍然在找尋自我，我希望能確立自己，然後專注在自己的藝術上。我也正在積極與畫廊 Artseni gallery 合作展出當代數位藝術的創作，我非常期待這件事。

What is your "main idea" while producing a piece/series of work? Have it ever changed before?

Since yoga came into my life, my perception has been changing. So I accept that ideas and myself will always be flowing like water. I am thankful to taste the joy and magnificence of life and try to represent what I discovered in my art. These ideas come from life, intuition and honesty. Whether personal or client projects, I make it as honestly as possible.

What is the best thing in your country? (likes features or culture)
Have it ever influence your creation?

I love that my home country is a mix of many cultures. In one day, I can enjoy many kinds of food and meet with many kinds of people. For example, I will order a drink in Bahasa, chat with friends in English and then speak Cantonese with my family. I also like to observe the textures and forms in my environment. There are many new buildings coming up, but it is always the old streets and houses that I like. My works are also a mix of many layers and textures, maybe that is how my country has influenced me.

How do you draw the inspiration?

Inspirations usually come up during moments of silence, while meditating or traveling alone. Being in natural spaces like hills and parks also helps to clear my head after researching on a subject. I draw inspiration from meditation, books, travels, environment, and people.

Share good books/music/movies/places with us.

The most recent book I read 'Yasmin How You Know?'. It is a biography of the late Yasmin Ahmad, a Malaysian filmmaker. After reading this book, I was very touched and inspired by her spirituality and being. She's not from film background, but for me her films really portray the true spirit and sentiment of our country.

What are the things you want to do most these days? Have you started to set up new goals or breakthroughs for next period?

Personally, I want to simplify my life to do and have the things that are valuable. I am still finding myself but this year I wish to establish myself properly and focus on my art. I am also actively showcasing contemporary digital art in art exhibitions this year with Artseni gallery. It will be interesting to see how it works out!

LIE

www.wearenotlie.com

LIE 是「每日小點子」的縮寫，它是來自馬來西亞吉隆坡的平面設計工作室，在 2011 年由 Driv Loo 所創立。LIE 的工作內容包含各式各樣多元的視覺傳達專案。

每天不斷地嘗試並且尋找嶄新的方式，替客戶提供創新又漂亮的解決方案，並以相同的態度處理自身的專案企劃。不僅固於傳統規範或模式，我們相信設計總是會有更多探索的空間。

LIE is an acronym of Little Ideas Every day, a graphic design studio based in Kuala Lumpur, Malaysia. Founded by Driv Loo in 2011, LIE works across a diverse range of visual communication projects.

Constantly practice and seek for fresh approaches every day, provide innovative, beautiful solutions for clients, as well as self-initiated projects. Not sticking with the norm or patterns, we believe there are always room to explored in design.

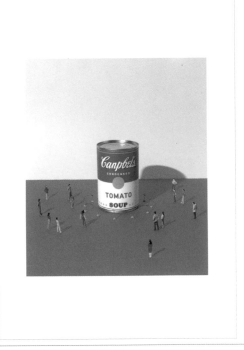

每日課題，發想天馬行空的點子。

Daily practice on nonsense ideas.

1/ 替 Makanlah Buah-Buahan Tempatan 創作的系列稿，這個展覽用藝術與設計歡慶馬來西亞在地的水果，用海報的視覺捕捉我們民族性格細微、必然的成長過程。

A series of images created for "Makanlah Buah-Buahan Tempatan" – an exhibition celebrating Malaysia local fruits through art and design. The visuals capturing the subtle yet inevitable growing process of our personality and nationality.
(Art Director: Driv Loo / Photographer: Tian Xing / Stylist: Ling Chong)

2/ 替達爾尚藝術學院發起的平台所做的出版物，匯集了校友組織的創意群體當中過去與現在的故事。

Publication initiated by Dasein Academy of Art to create a platform to assemble past & present stories among the creative community of Dasein Alumni.

■ 請問您認為該國最棒的是什麼？（如國家的特色或文化等）您的創作是否受其影響？

是的，我每天的生活與週遭的任何事物都會影響我的設計。我個人非常喜歡這個地方的隨性，作為一個種族多元化的國家，馬來西亞融合了馬來、中國與印度的文化，儘管藝術與設計行業仍然處於不是很成熟的階段，但這也代表我們有很大的可能性去探索與改進。

■ 請問您一路以來的創作歷程（與創意／藝術／設計／插畫的邂逅，踏上這條創作路的歷程，旅途上遇見的瓶頸與突破方式）

每個案子都會出現不同的問題，這是個充滿挑戰性但又有趣的職業，在我遇到瓶頸的時候，我通常會先退一步，讀一些書、和人說話，與團隊討論，然後再回來工作。

■ 請問您如何獲得靈感？

找到一些漂亮的地方，然後在那裡迷路。

■ 請和我們分享您喜歡的書籍、音樂、電影或場所

書籍——佐藤可士和的超整理術。
電影——猜火車，丹尼·鮑伊導的。
場所——檳島、馬來西亞。

■ 請問您最近最想什麼事情？是否已經著手規劃下一階段的目標或突破了呢？

我們最近正在執行一些出版計畫，希望今年晚些時候能順利出版發行。我們未來會傾向在馬來西亞舉辦多一點展覽或座談，藉此能夠多培養設計群。

What is the best thing in your country? (likes features or culture)
Have it ever influence your creation?

Yes. My design is always influenced by my daily life, everything that surrounds me. Personally I love the randomness of this place, as a multiracial country, Malaysia has a good mixed of Malay, Chinese & Indian cultures. Even though the art and design industry is still at a very immature stage, I think it also means that there are plenty of possibilities for us to explore and improve.

Share the story of you creating your pieces.
How did you encounter with creativity/art/design/illustration? And what happened? Have you ever been stranded at a bottleneck? And how did you overcome?

There's always different problems on different projects, it's a challenging yet interesting career. Usually I will take a step back whenever I'm stuck at work; read some books, talk to people, discuss with the team and then return to work again.

How do you draw the inspiration?

Find some beautiful place to get lost.

Share good books/music/movies/places with us.

Book – Ultimate Method for Reaching the Essentials by Kashiwa Sato.
Movie – Trainspotting directed by Danny Boyle
Place – Penang Island, Malaysia.

What are the things you want to do most these days? Have you started to set up new goals or breakthroughs for next period?

We're working on some publication projects recently, hopefully can get the book produce and launch by later this year. We tend to organise more exhibitions or conferences in Malaysia to help cultivate better design community in the future.

Philippines

菲律賓

Creators

Inodoro™

Soleil Ignacio

Inodoro™

www.inodoro-design.com *inodoro.design@yahoo.com*

Inodoro™ 是 PJ Ong 創造的個性簽名，Inodoro™ 替客戶服務的項目包含現代設計、品牌，其身份既是獨立個人也是公司。被譽為是菲律賓最傑出的設計師之一，曾合作過的客戶有美國航空、奧斯頓‧馬丁、菲律賓群島銀行、豐田、Janty 電子菸 (比利時)、Manny O. 葡萄酒和知名的時尚設計師 Cary Santiago。曾受邀在重要的設計研討會發表演說，像是 Visual Design Conference 2011、Pecha Kucha 2012、Cebu Creative Industries Summit 2013 和 GraphicCon Davao。因為擁有鮮明的設計風格，他的作品許多當地及國際性的媒體和出版品接連報導，像是 BluPrint 雜誌 (馬尼拉)、Channel [V] 菲律賓、Asian Creatives(日本) 和 Beautiful Decay(美國)。Inodoro 的作品也在國際間展出，如柏林的 AMOS Showtime、杜拜 WristShop 的 Project 1440、2011 年馬來西亞的吉隆坡設計週、2013 年在芝加哥當代藝術博物館展出的 Glitch Art 0P3NR3P0.NET Share Fest。2012 年他的網站還被提名為 CSS Web Award 最佳網站之一。

Inodoro™ is a creative signature of PJ Ong that produces modern design, branded for lifestyle clients, both independent and corporate. Acclaimed as one of the outstanding designers in the Philippines, he has done work for American Airlines, Aston Martin, Bank of the Philippine Islands, Toyota, Janty E-Cigarette (Belgium), Manny O. Wines and renowned fashion designer Cary Santiago. He has been invited to speak at major design conferences such as Visual Design Conference 2011, Pecha Kucha 2012, Cebu Creative Industries Summit 2013 and GraphiCon Davao. With distinctive style of design, he was featured on various media and publications locally and internationally such as BranD Magazine(Hong Kong), BluPrint Magazine(Manila), Channel [V] Philippines, Asian Creatives by Ubies(Japan) and Beautiful Decay(USA). Inodoro's work has also been exhibited internationally at AMOS Showtime in Berlin, Project 1440 by The WristShop in Dubai, Kuala Lumpur Design Week 2011 in Malaysia, Glitch Art 0P3NR3P0.NET Share Fest 2013 at the Museum Of Contemporary Arts, Chicago, USA to name a few. He was also nominated for a CSS Web Award for Best Website back in 2012.

1 2

1/ 共振是我的一件舊作，想描繪出聲音的增強與延長，同時也算是我隨意的實驗。

Resonance is an old work depicting intensification and prolongation of sound as I was doing random experimentations at the time.

2/ 由噪音迷幻樂團—— Bombo Pluto Ova 委託我設計他們的 EP，"Filioque。當時設計的概念是想表現出聲波的流動，而且要在這張實體專輯上成為突顯樂團特質的 icon，特製的字型也能幫助增加個性。

Bombo Pluto Ova, Filioque description - The idea was to design an artwork that would interpret the flow of sound waves while having to project as being the band's icon for this specific album.

1 2

1/ 這幅作品是來自宿霧市首屈一指的時尚精品店 LOALDE 所委託的案子，設計 / 品牌再造精品店的主視覺，並負責執行品牌活動──「LOve AlI the DEtail」。必須提升並穩固 LOALDE 品牌在店內的存在感，而且要提供給這個品牌獨特的視覺語言與定位。進其所能讓它被顯露出來，在時尚圈之間能有吸引力，具有誘惑力。創意總監、設計與字體都是由 Inodoro™ 操刀。

Commissioned by Cebu's leading fashion store LOALDE to design/rebrand their window shop visual with a word play and enforcing the brand's campaign "LOve AlI the DEtail". It should elevate and secure LOALDE's brand presence in-store but also provide the brand a unique visual language and position. All to make it relevant, attractive and desirable among fashionistas. Creative Direction, design and bespoke typeface by Inodoro™.

2/ 這件作品是 Inodoro™ 的個人創作。

This piece is Inodoro's Personal work.

■ 請問您對於「創作」所擁抱的理念是什麼？從以前到現在，是否有所轉變？

我設計的根基一直是抽象和實驗性，強調現代化乾淨美觀的原則。在接案子的時候，不讓作品影響到設計的功能性與客戶要求的目標。另外，我也很熱衷於微小的細節，在我得到能開發出獨特字體與紋理的絕竅之後，我能讓自己的作品擁有極高度的個性。

What is your "main idea" while producing a piece/series of work? Have it ever changed before?

My design has always been rooted in the principles of abstraction and experimentation with emphasis on modern, clean aesthetics. This, without compromising the functionality of the design and the client's goals, in the case of a commissioned project. Also, I am very keen on the slightest details; I keep my work highly customized since I have this knack for developing unique typefaces and textures.

■ 請問您認為該國最棒的是什麼？（如國家的特色或文化等）您的創作是否受其影響？

我喜歡我們菲律賓人與生俱來想追求幸福的熱忱，一種天生的樂觀流竄在我們的血液之中。我們總是有辦法找到使自己奮發向上的辦法，而不是被負面情緒給拖累。我認為這是我們國家最棒的特質——你可以選擇不要悲觀，在我成為藝術家的過程裡，我學到永遠不要停止拓展自己對新事物的熱情，以及對追求獨特設計風格的熱情，而我現在非常自豪能不斷地在自己的創作上展現菲律賓熱忱的特質。

What is the best thing in your country? (likes features or culture)
Have it ever influence your creation?

I love the fact that we Filipinos have a natural inclination for happiness and enthusiasm — a "natural high", so to speak — instilled in our blood. We always find a way to lift our spirits up rather than being dragged down by our negative emotions. I think that's just one of our best traits –pessimism is not an option. At some point in my growth as an artist, I've learned to never stop developing my own enthusiasm for new and distinctive styles of design — and I am very proud to continuously reflect this Filipino trait in my projects.

■ 請問您如何獲得靈感？

音樂、電影、旅遊，還有閱讀都是我創意的溫床。因為旅行，我能去擁抱不同的美感，也能了解它與國家根源、文化的關連，我看見的各種設計、櫥窗展示、國外的字母符號，甚至連食物外型都能讓我建立新的視角。另一方面，讀書、看電影或聽音樂讓我能廣泛接觸事物，拓展自己的想像力，使腦袋能裝下更多打破既往常理又充滿前衛性的想法。

How do you draw the inspiration?

Music, movies, traveling and reading are my breeding grounds for ideas. With traveling, I get to embrace different aesthetics and how they relate to a particular country's roots and culture. Seeing a variety of establishment designs, store window displays, foreign alphabet characters and even food presentations can build new perspectives. On the other hand, reading books, viewing movies or listening to music involving a wide range of genres allow me to expand my imagination and make room for unconventional and avant-garde ideas.

■ 請問您最近最想什麼事情？是否已經著手規劃下一階段的目標或突破了呢？

我很開心過幾個月後可能就能創業成功，變成像服飾店業者與食品業一樣的企業家，我期待有更新、更多的挑戰，因為幾個月前有我的人生開始有突破性的正面發展，順利地令人難以置信。總之，我的長期計畫還包括保持健康的生活，以及擴展我的興趣和風格，無論是個人還是專業上。

What are the things you want to do most these days? Have you started to set up new goals or breakthroughs for next period?

I'm excited on the prospect starting new ventures as a clothing store and food business entrepreneur these coming months. I am hoping for new and even more challenging work as the past few months have been unbelievably surreal and groundbreaking in a positive way. Overall, my long-term goals also include that of maintaining a healthy lifestyle and expanding my interests and styles, both personal and professional.

■ 請和我們分享您喜歡的書籍、音樂、電影或場所

任何一本羅伯特·格林的書，永遠都能替我的心靈充電。在設計的過程中，我常聽一些唱片以得到靈感，我都是從自己最喜歡的唱片公司選擇唱片，像是 Blue Note、4AD、Creation、Ghostly International、Mo'Wax、Warp 等，它甚至超越了我的創意，達到一種恍惚忘我的境界。

Share good books/music/movies/places with us.

Any book from Robert Greene is always a mind charger. I usually draw my inspiration by listening to a few records before and throughout the design process. My selections stem from my all-time favorite record labels such as Blue Note, 4AD, Creation, Ghostly International, Mo'Wax, Warp and the like. It gradually transcends my creativity into a state of ecstasy.

菲律賓 Philippines

Soleil Ignacio

hello@choleil.com

Soleil Ignacio 是菲律賓馬尼拉的時尚美容插畫家，她畢業於菲律賓大學，視覺傳達學士學位。2011 年在擔任雜誌的藝術總監後，她大膽獨立出來成為插畫家和參展藝術家。女性化的、前衛而強烈，結合起來就是她的風格，整體的筆觸稍稍帶有現實主義的感覺，以質感與留白強調插圖中特定的區塊，而且她繪製頭髮的方式非常獨特。Soleil 同時也是馬尼拉設計團體 Thursday Room 的成員。

Soleil Ignacio is a fashion & beauty illustrator from Manila, Philippines. She graduated from the University of the Philippines with a Bachelor's degree in Visual Communication. In 2011, after working as an Art Director for a magazine, she ventured out on her own as a self-employed illustrator and exhibiting artist. Feminine, edgy and strong, her style combines expressive, stylised main strokes with a touch of realism. She balances textures and negative space to emphasis certain areas of her illustrations, and has a particularly unique way of drawing hair. Soleil is also a part of Thursday Room, a design collective based in Manila.

Soleil 迷人的高貴之美，完整地內化到作品中的胴體，並濃縮在這些畫像當中。她在自然的神靈中代表著熱，而且總是伴隨著神秘的氛圍。這些自然母親的女兒們，在神話裡頭，是動物與植物們無所不在的保護者。

Soleil's fascination with exalted beauty, inherent throughout her body of work is epitomized in these portraits. Her representation of nature's deities are sultry and always with an air of mystery. These daughters of Mother Nature are preservers of flora and fauna omnipresent in all mythology.

1 2

1/ 由菲律賓購物商場委託繪製之時尚插畫。

A commissioned fashion illustration for a shopping mall company in the Philippines.

2/ 與 Tomato Time SWAP x Soleil Ignacio 合作，插畫印製於手錶錶盤面上。

For Tomato Time SWAP x Soleil Ignacio Collection. Illustration printed on Tomato SWAP watch faces.

■ 請問您對於「創作」所擁抱的理念是什麼？從以前到現在，是否有所轉變？

我認為我在創作的時候沒有理念，或者說，我不想要有。我只是依照任何從腦海中迸出美好的想法而去創作，我的腦海裡大部分的時間總是想著著美麗又堅強的女性。

■ 請問您認為該國最棒的是什麼？（如國家的特色或文化等）您的創作是否受其影響？

我喜歡我們的國家處在熱帶，所以隨處可見迷人的海灘。我猜這偷偷影響了我的作品，因為我小的時候最喜歡小美人魚，每次去游泳的時候我總是幻想自己是一條美人魚。現在回頭想想，我的藝術風格是從我的摯愛小美人魚演化而成的。

■ 請問您如何獲得靈感？

我最常從我在網路上看見的東西找靈感。

■ 請和我們分享您喜歡的書籍、音樂、電影或場所

馬特和金的日光，我永遠聽不膩的歌。

■ 請問您最近最想什麼事情？是否已經著手規劃下一階段的目標或突破了呢？

我想在紐約的 SVA 或倫敦中央聖馬丁藝術學院選修一些課程，我想學習新的東西！

What is your "main idea" while producing a piece/series of work? Have it ever changed before?

I don't think I have a main idea whenever I create something, or I don't intend to have a main idea. I just happen to create any idea that pops in my head that is beautiful. Most of the time it includes beautiful and strong women though :)

What is the best thing in your country? (likes features or culture)
Have it ever influence your creation?

I love that we're a tropical country and that there are amazing beaches everywhere. I guess it has an indirect effect with my work because as a child, I absolutely loved The Little Mermaid, and everytime we go swimming I keep thinking I'm a mermaid. Now, looking back, I think my art style has evolved a lot from my love of The Little Mermaid.

How do you draw the inspiration?

I mostly draw my inspiration from things i see on the internet.

Share good books/music/movies/places with us.

Daylight by Matt and Kim, forever my feel good song!

What are the things you want to do most these days? Have you started to set up new goals or breakthroughs for next period?

I want to take up some courses either at SVA in New York or Central Saint Martins in London. I wanna learn new things!

Singapore

新加坡

Creators

Black Mongrels

Winnie Wu

Black Mongrels

www.theblackmongrels.com *hao@theblackmongrels.com*

Black Mongrels 是一個擁有融合不同專業知識與且具備相當基礎的創意機構。他們試著在印刷與數位的領域中創立新的境界，同時又能保有扎實牢靠的功能性與實用性。他們的信念是：好的設計應該用於解決問題，而不是流於炫耀，如此自然就會嶄露出源源不絕的真實之美與創意。他們樂此不疲地遵守這項崇高的準則。他們替客戶 Blueprint——亞洲第一個與東西方交流的國際時尚交易平台所做的作品在 2011 年得到知名的設計大獎—紅點設計獎傳達設計大獎的殊榮。近期合作過的一些客戶包含：奧迪時尚節、海灣金沙藝術科學博物館、PrettyFIT、勝科海事有限公司、Sunsweet 太陽牌、新加坡旅遊局、TaFt。
Black Mongrels 是由 Hao Soh 所建立的工作室，Hao 曾在一些企業如奧美新加坡、BBH 新加坡以及其他許多本土的設計工作室工作，目前居住在新加坡，以 Hoa 這個親切的名稱為人所知。他身兼多職，扮演許多不同的角色。眼光敏銳，能抓住複雜的細節，他從每天的生活中獲得靈感並轉換成作品。也喜歡在工作室的小角落將自己的想法創造出美麗又精彩的藝術作品。

Black Mongrels is a creative agency with a convergence of different expertise and built upon the cornerstone of balance. They seek to set new boundaries in both the print and digital realms whilst keeping their feet firmly grounded in the functional and practical aspects of their work. It is their belief that when good design serves to solve and not to flaunt, true beauty blossoms and creativity thrives. This is a discipline of a high order, but one that they tirelessly abide by. Their work has been recognized in one of the most prestigious design awards worldwide – the Red Dot Design Award for Communication Design in 2011 for Blueprint, Asia's first international fashion trade platform for East-West exchange. Some of their notable clientele till date includes Audi Fashion Week, Marina Bay Sands ArtScience Museum, PrettyFIT, Sembcrop, Sunsweet, Singapore Tourism Board, Textile & Fashion Federation(TaFt).
Black Mongrels is founded by Hao Soh. Hao began his career working for agencies like Ogilvy Singapore, BBH Singapore and various homegrown design studios. Currently based in Singapore and affectionately known to his friends as Hao, he is a wearer of many different hats. A keen eye for intricate details, he gains inspiration from everyday people and life which are translated into his daily works. He also likes to craft his subjects into beautiful and wonderful works of art in his little corner of the room.

在前進之前，要先獨立 …… 一句無名的、被遺忘的，卻也相當重要的口號，是在新加坡人民的歷史中非常關鍵的章節。
「獨立吧！」這句口號常常在公共集會上被李光耀使用。第一次是在 1959 年，當李光耀多次誦讀「獨立吧！」的時候，群眾聚集在巴東慶祝新加坡得以實現自治，
人民行動黨在當年的立法議會大選中大獲全勝，擔任總書記的李光耀宣示就職成為總理。
「前進吧，新加坡！」在 1965 年獲得完全獨立時被採用為新加坡共和國國歌，團聚人民的意志，並帶領人民邁向成功與幸福。
海報上不同的字體代表獨立新加坡多元的社會底下不同的族群。致敬我國已故的建國之父，李光耀先生。

Before Majulah, there's Merdeka... An uncelebrated, forgotten, but very important slogan in a crucial episode of the story of the people of
Singapore.Merdeka was used in public rally frequently by Lee Kuan Yew. First, in 1959, when Lee Kuan Yew declaims "Merdeka!" a number of times,
leading a crowd that had gathered at the Padang to celebrate Singapore's attaining self-government. In that year's elections the PAP had won
a landslide victory in the legislative assembly general election. And the secretary-general of the PAP, Lee Kuan Yew, was sworn in as Prime Minister.
Majulah Singapura was then selected as the national anthem upon full independence in 1965 to unite and venture together towards success and
happiness.The different typefaces in the poster represent the different races in our multi-racial society upon independence.
A tribute to our late founding father, Mr. Lee Kuan Yew.#TributeToLKY

這件印刷作品是替新加坡設計師在 2014 年在巴黎杜樂麗花園和羅浮宮，里沃利街 99 號所舉行的 Premiere Classe & Tranoï 巴黎時裝周，所展出的作品收錄冊，運用前衛與當代的圖形以切合活動，反映本地設計師在作品中充滿生命力的態度，使用 Antalis Village Natural, 100gsm 的紙質，用環縫的方式裝訂。

Print collateral for Singapore Designer's showcase at Premiere Classe & Tranoï Paris Fashion Week 2014 F/W held at Jardin des Tuileries and Carrousel du Louvre, 99 Rue de Rivoli 75001, Paris. A set of edgy and contemporary graphics is adopted for the campaign to reflect the local designers' vibrant approach in their collections. Collateral printed on Antalis Village Natural 100gsm paper stock with loop stitch.

■ 請問您對於「創作」所擁抱的理念是什麼？從以前到現在，是否有所轉變？

我們一直試著想要用一個大的概念套用在每一件新的專案上，並不只是視覺上賞心悅目的美感而已，也要兼顧品牌的延續性。這個概念圍繞著客戶願景與理念的理解，每個專案必須有自己本身主要的理念，如此一來我們才可以回溯並做出整體的視覺。

■ 請問您認為該國最棒的是什麼？（如國家的特色或文化等）您的創作是否受其影響？

多樣化民族的國家，我們是由不同族群與文化組合而成的一個國家，這是我們獨一無二的地方，讓我們能夠接納不同面向的專案。

■ 請問您一路以來的創作歷程（與創意／藝術／設計／插畫的邂逅，踏上這條創作路的歷程，旅途上遇見的瓶頸與突破方式）

我們是設計背景出身，擁有共同的廣告風格。
當我們對於創作有心理障礙時，我們會利用機會四處走走，加入其他人的談話。

■ 請問您如何獲得靈感？

我們從每天遇見的人找到靈感，一起聊天，還有漂亮的風景都能讓我們獲得靈感。

■ 請問您最近最想什麼事情？是否已經著手規劃下一階段的目標或突破了呢？

我們想告訴並教育顧客還有志同道合的人們或團體一件事：良好的作品從好的設計開始，而且有了好的設計，它不僅有創意的視覺效果，還要有很好的思考過程。

What is your "main idea" while producing a piece/ series of work? Have it ever changed before?

We always try to approach every new project with a big concept. It has to not just have a visually pleasing aesthetics but as well as longevity to the brand. This concept revolves around understanding the client's vision and philosophy. Every project has to have a big master concept that we can relate back to in order to have a holistic visual.

What is the best thing in your country? (likes features or culture)
Have it ever influence your creation?

The multi-racialness of the nation. We are made up of different races and cultures and that makes us unique in embracing the different aspects of each project.

Share the story of you creating your pieces.
How did you encounter with creativity/art/design/ illustration? And what happened? Have you ever been stranded at a bottleneck? And how did you overcome?

We started from a design background with a fair share of advertising genre. Whenever we are having a creative mental block, we will take the opportunity to take a walk around the area or engaging in little conversations with other people.

How do you draw the inspiration?

We draw inspiration with the daily people we met, the little conversations we have, as well as the beautiful environment we are situated in.

What are the things you want to do most these days? Have you started to set up new goals or breakthroughs for next period?

We want to inform and educate clients and like-minded people / organisations that a good piece of communication starts with a good design. And with good design, it entails not just creative visuals but also a good thought process.

吳威 Winnie Wu

www.studiokaleido.net *winnie@studiokaleido.net*

吳威被形容是亞洲當代平面設計最前端的領導人物，大量地專注在藝術產業之創作，她在印刷與排版設計上的敏銳與創新最為人熟知。她是 KALEIDO 工作室的創意總監，KALEIDO 最近正逐漸邁向提供全面性的設計規劃與策展建議服務。

Winnie Wu is profiled as an emerging leader at the forefront of Asian contemporary graphic design with a body of work largely focused in the arts industry, and is best known for her peculiar sensitivity and innovation in print design and typography. She is the creative director of studio KALEIDO, a progressive full-service design practice and imprint currently based in Singapore.

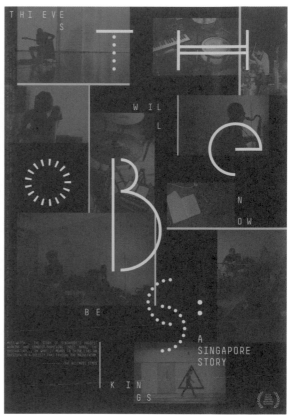

1/It's Only Talk 是以表演為基礎的展覽，透過電影鏡頭與鏡頭外的觀點探索角色的意識形態，這項專案有五位製片人加入，每個人都有不同的想法，並且與觀眾一起展開關於電影與電影院的對話。

It's Only Talk is a performance which explores the role that ideologies play through the lens of cinema and vice versa. The project involves 5 filmmakers, each with differing perspectives, who engaged audiences in conversations regarding films and cinema.

2/The Obs 是由群眾募資的天文台實驗音樂紀錄片，天文台是深具影響力的搖滾、實驗、電子樂團，組合成員大部分是 1990 年代新加坡傑出的樂團。

The Obs is a crowd-funded experimental music documentary on The Observatory, an influential art rock, experimental and electronica band consisting largely of alumni from significant 1990s Singaporean bands.

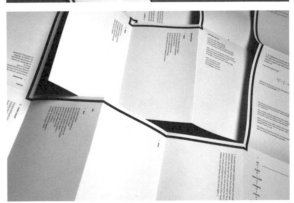

為表現出遷移和完美這兩個內容，書的形式需反映「沒有起點和終點」的想法，而且要表現出遷移的無盡循環，也就是手風琴式的設計形式，當全部展開後會變成一張呈螺旋狀的紙，我們希望讓這本書的外觀看似簡單，但內部構造其實相當複雜，反映什麼才是真正的完美——為何數學公式中的完美無法在現實中真實重現？我們把全黑的圖形印在灰色的硬紙板上，透過纖維鬆散的紙印製出原始和斑駁的效果。

Responding to the content of migration and perfection, a format was devised to reflect the idea of 'no beginning and end' and connotes the continuous loop of migration patterns—an accordion-type book which opens up to reveal a single spiraling sheet of paper. We wanted the book to be complex inside yet deceptively simple on the outside, as a reflection of what perfection really is—how it is achievable through a mathematical formula, and yet never quite achievable in reality. A full-black graphic is printed on grey chipboard, which produced a raw and speckled effect from the loose paper fibres.

■ 請問您對於「創作」所擁抱的理念是什麼？從以前到現在,是否有所轉變？

我盡可能去豐富自己的創作，像是一個沒有昂貴玩具可以玩的窮小孩，他（她）必須想出最有創意的方式去利用身邊的東西，所以能做出好的作品，和我如何不寄望客戶而能自己擠出多少預算有關。最重要的是，美感要與案子的主題相符，如果能加上自己的個性就，那就更加奢侈了。最後，我討厭做出來的作品只有設計師和有錢的人欣賞而已，所以我會在創作時盡量注意這點。

What is your "main idea" while producing a piece/series of work? Have it ever changed before?

I try my best to be as resourceful as I can. Much like a child who is too poor to have expensive toys, he/she has to come up with the most creative ways to make do with what they've been given, so making good work is really about what I can squeeze out of a budget without banking on the clout of my clients. Most importantly, the aesthetic has to fit the intent of the project, and if I can add my own personality into it, it is a bonus.
Lastly, I hate creating work that only designers and affluent people enjoy, so I try to be conscious of that.

■ 請問您認為該國最棒的是什麼？（如國家的特色或文化等）您的創作是否受其影響？

我覺得新加坡的市場流動率很高，對有錢人來說，這裡就像是巨大的遊樂場，同時對設計工作室而言這樣的氛圍也是極為絕妙。然而，只有少數的創意工作能經得起時間的考驗。在這裡有很多替活動、展覽或企業做設計的機會，屬於短期的案子（相較於專案策劃和品牌建立），或許這種模式已經下意識的讓我們的國家創造出一次性的設計文化也說不定，一個多元文化的社會，同樣這的對我們接到的工作種類也有助益。儘管我們對西方的憧憬與官方語言模糊了我們身為亞洲人的角色，然而也讓我不斷的意識到，在這樣的定位之下所產生特有的緊張感。

What is the best thing in your country? (likes features or culture)
Have it ever influence your creation?

I think Singapore has a high turnover rate for businesses, it's a playground for the rich and this is a great climate for design studios. However, there is very little premise for creating work meant to stand the test of time. There are lots of opportunities to design for events, exhibitions and businesses that don't last for an extended period (as opposed to monographs and established brands), and perhaps this has subconsciously created a culture of disposable design in our country. A multi-cultural society is beneficial to the kind of work we receive as well. Whilst our 'Asian-ness' is obscured by our western aspirations and language of administration, this position has created a unique tension that I am constantly aware of.

■ 請問您如何獲得靈感？

我獲得靈感的方式並不是透過休息或翻閱雜誌，我認為這種「技巧」是不可靠、不真實的，也不會太持久。從遇見的人和尊敬的人身上學習到的那些生活之道，才是我靈感的泉源，我們對待生活的方式可以轉化成方法和哲理到我們所選擇的工作上頭。

How do you draw the inspiration?

I don't get inspiration from taking a breather or flipping magazines, I think those 'techniques' are unreliable, unreal, or they don't last. I get my inspiration from learning about the ways of life from people I meet and respect. A lot of how we cope with life is translatable to methodologies and philosophies in the way we choose to work.

■ 請問您最近最想什麼事情？是否已經著手規劃下一階段的目標或突破了呢？

我以前曾和一些自由工作者還有實習生一起經營過工作室，但現在我縮減規模，變成自己個人的工作室，接少一點工作，才能專注在我最熱衷的案子上。另外我也在期待盡快出版作品集，讓這本書完整體現帶有我個人風格的視覺文化。這樣自給自足的生態系統，創造出一個能讓我自由發揮的平台，但我也能向朋友接下一些小的專案，所以不用擔心花費。我覺這樣的生活方式幾乎像是混合藝術家與創造適合當代的商品的獨立設計師，我想盡快達到這樣的地位。

What are the things you want to do most these days? Have you started to set up new goals or breakthroughs for next period?

I used to run a studio with freelancers and interns but I'm downsizing to a largely one-person operation right now, taking up less work so I can work
only on projects I'm most keen on. I'm also looking at publishing collectible books focused on visual culture under my own imprint soon. This self-sufficient ecosystem creates a platform in which I can do whatever I desire without owing anyone else a living, but it also means that I can work on small projects for friends without having to worry about overheads. I see it almost as a hybrid of an artisan's lifestyle and independent designer creating collaterals and goods fit for contemporary life, a position in which I hope to arrive at very soon.

Thailand

泰
國

Creators

Practical Design Studio

Practical Design Studio

www.practical-studio.com　　*practicalstudio@gmail.com*

PRACTICAL 設計工作室由曼谷的一群設計師所創立，擁有豐富的視覺傳達設計經驗與知識。
宗旨是將有建設性的想法與設計技巧運用在社會與文化上，傳達平面設計在美學方面的可貴。除了設計工作室基本的工作，
PRACTITAL 也是一個負責發起並規劃定期設計相關活動的平面設計工作室，在泰國平面設計師協會的合作下，PRACTICAL
的設計師們也會到許多大學和機構發表演說。2009 年，PRACRICAL 舉辦平面設計的計畫：「我是泰國平面設計師」，
2010 年他們在泰國與海外參加許多展覽。
他們也成立平面設計論壇「Somewhere Thai」50 個演說者要在設計作品中表現出「Thainess」的精神。最近 PRACTICAL
和日本共同合作舉辦展覽，展出日本和泰國的設計師作品。包含川島小鳥的創作『未來小妹』、第七屆、第八屆的「Here
is ZINE Bangkok-Tokyo」(和 UBIES & Enlightenment)，2014 年 PRACTICAL 發起了書籍設計展覽與工作坊，計畫名稱為
「This isn't not a book」。

PRACTICAL Design Studio was established by a group of designers based in Bangkok with experience in
professional and educational communication design.
The aim is to employ the constructive idea and design skill in response to the social and cultural to show
that the graphic design is valuable in terms of aesthetics. In addition to basic functions of a design studio,
PRACTICAL is a graphic design studio that initiated and organised the design activities on a regular basis, under
the collaboration with the Thai Association of Graphic Designer (ThaiGa). PRACTICAL's Designers also give
lectures and presentations to many universities and organisations.
In 2009, PRACTICAL organised the graphic design project "I am a Thai Graphic Designer". In 2010, They have
just joined their works to many exhibitions in Thailand and aboard.
They also organised the graphic design forum "Somewhere Thai" that included 50 speakers to represent
"Thainess" in design work. Recent years, PRACTICAL has co-organised with Japanese organisations hosting
and curating exhibitions which included Japanese and/or Thai creators, for example Mirai-Chan by Kotori
Kawashima (with Nana Roku Sha), Here is ZINE 7th Bangkok-Tokyo and Here is ZINE 8th Tokyo-Bangkok (with
UBIES & Enlightenment). Finally in 2014, PRACTICAL initiated a book design exhibition and workshop at 'practice'
new their own space that titled "This isn't not a book".

CTA:

ฉันเป็นนักออกแบบกราฟิกไทย

เราเป็นนักออกแบบกราฟิกไทย

在 2009 年，PRACTICAL 與泰國平面設計師合作，共同發起並組織一個平面設計企劃與平面設計展。
這個展覽展出泰國設計師們的照片，照片中的設計師們都拿著寫上「我是泰國平面設計師」標語的創作，製作海報是一個偉大的經驗，我們有個想法，就是將參與這次企劃的設計師們作為海報的主視覺。我們公布拍照的日子，並透過社交媒體邀請設計師，最後有兩百位設計師在那一天共襄盛舉。

In 2009, PRACTICAL, in collaboration with the Thai Graphic Designer Association, we initiated and organised a graphic design project and exhibition.
The exhibition showcased photographs of Thai designers-holding their own artwork- with the phrase "I am a Thai Graphic Designer". Making the poster is the one of great experience, we had the idea to use photos of designers who participated the project became to the key visual of poster. We announced the photo day and invited through online social media. Finally there were two-hundred persons who joined that day.

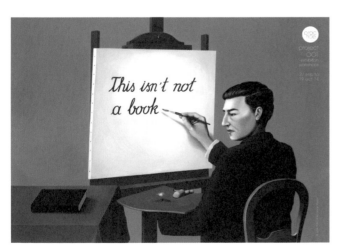

1

2

1/"Paper Matter" 是由 "Antalis" 這間紙業公司所贊助的展覽，我們負責為此展覽設計海報。這個企畫邀請藝術家與設計師們使用紙來進行創作，提供觀展人一個機會參與跟紙相關的對話。海報也是如此，它本身全部都是紙的創作。「紙會說話」！

We designed this poster for an art exhibition entitled "Paper Matter"which supported by "Antalis" a paper company. The project invited artists and designers contributed their artworks by using paper. This exhibition offered viewers an opportunity to engage dialogues about paper. Also the poster, It is all about paper itself. "Paper can talk!"

2/"This isn't not a book" 是一個關於書籍設計的展覽，內容除了展示還包含對於書本的定義與形式，互相交流觀點。我們設計的海報引用兩件知名藝術家——雷內·馬格利特的作品，作為此次展覽的概念。

'This isn't not a book' is a book design exhibition that displaying and exchanging point of views on the definitions and formats of what-is-so-called 'book'. We designed the poster by appropriating the 2 famous René Magritte artworks, representing the concept of exhibition.

■ 請問您對於「創作」所擁抱的理念是什麼？從以前到現在，是否有所轉變？

我們對於創作所抱持的理念是，透過創作去交流我們的觀點，以及為觀眾、客戶、同事，甚至是我們自己創造新的經驗。儘管每次案子的形式與成果都不盡相同，但我們的目的都沒有改變。

■ 請問您認為該國最棒的是什麼？（如國家的特色或文化等）您的創作是否受其影響？

對我們而言泰國最棒的，就是我們在此成長。我們的家人與朋友都在這裡，我們認識這個國家的人、這個國家的生活方式與文化，是這些形成我們現在的生活方法，以及我們的工作方法，尤其是我們的認知過程與品味。當然泰國還是有很多我們不太喜歡的地方，但也因為有不喜歡地方，我們才會有想要改進的期望。

■ 請問您一路以來的創作歷程（與創意／藝術／設計／插畫的邂逅，踏上這條創作路的歷程，旅途上遇見的瓶頸與突破方式）

事實上，創作的過程，時常與很多狀況有關，像是健康、心情、與對每個案子的專業程度，我們無法確定每個時候都能做到最好，其他生活中的因素對於創作也有強大的影響力，因此，我們選擇以一個團隊的身分進行工作，以便互相支援，此外也可以彼此相互幫助。團隊合作讓創作的過程開放且更加多樣化，每個團隊成員可以發揮他們的潛能，並創作出有趣的作品。這種方式幫助我們度過難關，提升作品的質量與團隊成員的關係。

■ 請問您如何獲得靈感？

對我們來說，「靈感」與「觀點」沒有什麼不同。靈感是對事物看法的下一個階段，我們常常將利用於身邊事物的看法去找到自己對於作品的觀點或想法。

■ 請問您最近最想什麼事情？是否已經著手規劃下一階段的目標或突破了呢？

在這段期間，我們對於設計教育這個項目更加有興趣了，因為我們的成員是大學以及許多組織裡的講師，我們發現還能做更多事去幫助學生與新進的設計師。現在我們正開始一項叫作「the practice」的計畫，在他們畢業後的第一年期間，以實習和工作坊的形式，增強的他們的經驗。

What is your "main idea" while producing a piece/series of work? Have it ever changed before?

The main idea of our creation is trying to communicate our point of view along with creating an experience for the audience, also customers or co-workers as well as to our own. Although form and the outcome may be different for each project. However, our intent has not changed.

What is the best thing in your country? (likes features or culture)
Have it ever influence your creation?

The Best thing of Thailand for us is that we were born and grown up here. We have family and friends here, we've known people, lifestyle and culture of this country as well. These've shaped the way of life of us. Includes the way we work. In particular, our cognitive processes and our tastes. Of course, there are many things we do not like in this country, but of the many things we do not like it. We would like to take part in improving those things.

Share the story of you creating your pieces.
How did you encounter with creativity/art/design/illustration? And what happened? Have you ever been stranded at a bottleneck? And how did you overcome?

Indeed, the creative work process, we often associated with many conditions such as our health, mood, and expertise in each project. It is no certainty that we could be ready to work best at all times. The other factor in life has a powerful influence on the creation of us as well. For this reason, we chose to work as a team. To achieve mutual support. In addition, they can help each other. Teamwork makes the creative process is open and more diverse. Each member of the team can make use of their potential performance, and makes the interesting work as well. This approach allows us to help us through a difficult situation to be both the quality of their works and relationships of team members.

How do you draw the inspiration?

For us, "inspiration" is no different from "point of view". Inspiration is the next step of opinions on things.
We often use the opinions to things around us to find our perspective or idea for our works.

What are the things you want to do most these days? Have you started to set up new goals or breakthroughs for next period?

During these later, we are more interested in design educational programs. Because of our members are lecturers for the University, and many organizations. We've found that there are many things to be added, to help prepare for students and brand-new designers.
Today we've just started a project called "the practice", a project that enhances the experience during the first year after graduation in the form of Internship and workshops.

Taiwan

臺灣

Creators

Chang Pu-Hui

Chen Hsin-Yu

DESIGNER+ARTIST

Erica Su

Filter017

Jay Guan-Jie Peng

Jing Group

Shen ZI-Huai

Tien-Min Liao

Wu Mu-Chang

張溥輝 Chang Pu-Hui

http://cargocollective.com/P_ pchangdesign@gmail.com

張溥輝，一位臺灣平面設計師。2013 年，作品曾獲得東京 TDC 入選。現為自由接案平面設計師，從事書籍封面設計及雜誌排版，與音樂專輯、藝文表演平面設計。

Chang Pu-Hui, a graphic designer in Taiwan. In 2013, one of his works: TOUR was selected into the Tokyo type directors club annual awards. Work in areas such as: graphic design, book cover, artist's book, poster, branding, exhibition.

1 2

1/ 每當遇到令人不解的事物時，我們總會將自身經驗強押上去各自解讀，即便解讀是錯誤的。也透露出自身的生活經驗能影響個人對一件陌生事物的判斷與想法。這種行為對我來說是非常有趣的一件事，便製作了一張海報想讓觀者體驗這樣的感覺。

Whenever there is something puzzling, we will always interpret it with personal experience, even if the interpretation is wrong, also it reveals that one's personal life experiences can influence the thought to a strange thing.

2/ PRISM 是大學設計系成果展的主題系列海報，取自三菱鏡將一束白光分散成 7 個顏色，象徵這個成果展若沒有許多微小的創意與作品組合再一起，無法成就這個完美的展覽。

PRISM is a theme series poster of achievement exhibition of university Design department. The concept came from a prism. Prism can separate the sunlight into seven colors, which means that if the achievement exhibition had not got many tiny creativity and works combined together, we can not accomplish this perfect exhibition.

強制推銷是臺灣旅行團的特色之一，TOUR 是重現日本觀光時被強制推銷日本藥品的經驗，做為一頁插入式廣告。

The hard sell is one feature of Taiwan's escorted tour; TOUR reproduces the experience of being forced to sell the Japan drug when traveling in Japan, as a one-page interstitial advertisement.

■ 請問您認為該國最棒的是什麼？（如國家的特色或文化等）您的創作是否受其影響？

應該是幾乎 24 小時都能買到吃的東西吧！有時趕稿到半夜時，肚子餓還能買到東西吃應該是最幸福的事了（尤其在冬天），也能藉著出門轉換一下心情。

■ 請問您一路以來的創作歷程（與創意／藝術／設計／插畫的邂逅，踏上這條創作路的歷程，旅途上遇見的瓶頸與突破方式）

由於我是設計非本科生，剛進入這塊領域時，非常多事情都處於一知半解的狀態。易焦慮的我透過不斷的大量練習，及閱讀來彌補自己不足的部份（和焦慮感）。當然，現在也還是持續進行中。

■ 請問您如何獲得靈感？

認真生活。

■ 請問您最近最想什麼事情？是否已經著手規劃下一階段的目標或突破了呢？

因為還是學生身分的關係，正在準備新一代設計展的畢業專題製作，負責整個系上的主視覺平面設計。滿腦子大概有一半都在想這件事情。我是屬於一個容易焦慮的人，所以當下的時刻只會專注在這件事情上 XD。

What is the best thing in your country? (likes features or culture)
Have it ever influence your creation?

I think the best thing in my country perhaps is we people buy something to eat almost 24 hours! Sometimes I catch draft until midnight, it is the happiest thing that can buy food when I feel hungry (especially in winter), also can change my mood by go outside.

Share the story of you creating your pieces.
How did you encounter with creativity/art/design/ illustration? And what happened? Have you ever been stranded at a bottleneck? And how did you overcome?

Since I am not an industrial design-originated student, everything was strange for me when entering this filed, I was so anxiety that I keep practicing a lot, and I keep reading to make up for my shortage (and anxiety). Of course it is still ongoing now.

How do you draw the inspiration?

Live while I'm alive

What are the things you want to do most these days? Have you started to set up new goals or breakthroughs for next period?

Because of the character of student, I'm preparing the Young Designer's exhibition, I responsible for the visual design of the entire department, now half of my brain is thinking about this. I am easy to get anxious, so I can only focus on this thing right now. XD

陳信宇 Chen Hsin-Yu

www.hsinyu-design.com *jack3020@gmail.com*

任職世界最大單一廣告公司 "DENTSU(電通)" 臺灣分公司創意部職位 , 專長範疇包括品牌、字體、書籍、編排、包裝等各項平面設計事務。個人作品曾入選靳埭強設計獎、莫斯科金蜂獎、墨西哥海報雙年展、IF 概念設計獎等國際獎項。並榮獲 2014 紅點設計獎、2015IF 設計獎、20 屆時報金犢獎金獎、2012 數位典藏與數位學習商業應用競賽首獎、第十三屆交通安全海報創作大賽金獎。近年作品更收錄於第 8 屆、第 9 屆 APD 亞太年鑑設計專書、2014 國際設計年鑑之中。服務客戶包括 PANASONIC、W TAIPEI、康是美、嬌聯、統一麵包、統一麥香、拉麵道、天下雜誌、台南市政府觀光旅遊局、嘉義縣文化觀光局、教育部 ... 等等。

Serving the world's largest single advertising company DENTSU Taiwan Branch creative department positions, areas of expertise include brand, fonts, books, presentation, packaging and other graphic design services. Individual works appeared Kan Tai-keung Design Award, Golden Bee Award Moscow, Mexico Poster Biennial, IF Concept Design Award and other international awards. And won the Red Dot Design Award 2014, IF Design Awards 2015, gold award in the 20th Times Young Creative Awards, 2012 Taiwan E-learning and Digital Archives Program Business Application Contest First Prize, the thirteenth Traffic Safety Poster Contest Gold Medal. Works publication of the APD no.8, APD no.9 and the 2014 Excellent International Design yearbook.

1 2

1/ 將臺灣百大景點圖像化，讓國際旅客能一眼明瞭此景點意涵，並加深旅客對臺灣景點的印象。

By using the graphic images for the top one hundred major tourist attraction travel sights of Taiwan, it can help international travelers to light on the meaning of this place directly, and it can also impressed them with it. Wish everyone can enjoy your trip in Taiwan!

2/ 減少碳排放，保護環境。

Carbon reduction, protection of the environment.

CD. 陳信宇 Chen Hsin-Yu / AD. 陳信宇 Chen Hsin-Yu / D. 陳青慧 Chen Cing-Huei & 翁敬堯 Wong Ching-Yao
塑膠袋的濫用, 成為廢棄物中的常客。當千年不被分解的它, 成為如同化石的在未來被發現, 不知道途中造就了多少汙染, 影響了多少生態循環。

The abuse of plastic bags has become a regular waste. A plastic bag that were never be dissolved for millenary, and will be discovered as a fossil. This causes numerous pollution that nobody will ever know.

■ 請問您對於「創作」所擁抱的理念是什麼？從以前到現在，是否有所轉變？

能以自身能力，利用設計及創作，改變社會服務大眾，為台灣及世界做點事。這理念從前至今尚未改變，也是支撐我創作及設計生涯的初衷理念。

■ 請問您認為該國最棒的是什麼？（如國家的特色或文化等）您的創作是否受其影響？

繁體中文字，有。

■ 請問您如何獲得靈感？

書籍、生活、與他人對話。

■ 請問您做過最瘋狂或最酷的事情是什麼呢？

踏入設計與廣告領域。

■ 請問您最近最想什麼事情？是否已經著手規劃下一階段的目標或突破了呢？

除本身技能外，希望能了解企劃、業務、文案、整合行銷等同儕專業部分，讓自身未來能將從多方角度切入設計，屏除盲點及未來在創作上更容易符合市場需求及美感。此外，希望能找些志同道合夥伴，一同為社會做點貢獻。

What is your "main idea"while producing a piece/series of work? Have it ever changed before?

Wish I could change our society and serve for mass, do something for Taiwan and the world. This main idea has never changed, and it also support me to create in my design life.

What is the best thing in your country? (likes features or culture)
Have it ever influence your creation?

Traditional Chinese.

How do you draw the inspiration?

Books, Life, dialogue with others

What is the craziest or coolest thing you have ever done?

Engaged in the design and advertising work.

What are the things you want to do most these days? Have you started to set up new goals or breakthroughs for next period?

In addition to design, I also want to start learning planning, business, copywriting, marketing, and other special field of study which can help me to do design at multi-angle. To dismiss my blind spot and reach the need of market with aesthetic on my way of creating in future. Besides, I want to find some partners to contribute to this society.

和設計 / 劉銘維
DESIGNER+ARTIST
wei@dxa.tw

劉銘維,視覺設計師,1981年生,畢業於台北藝術大學科技藝術研究所。早期與藝術家妻子共同創立『DESIGNER+ARTIST』,2011年正式成立『和設計』,和設計講究視覺的洗鍊感,簡單卻有著豐富的意念,希望從心出發的設計,觸動每個挑剔的靈魂,設計範疇包括書籍裝幀、網頁設計以及各大展覽活動之視覺設計。
執行過關渡藝術節、台北藝術博覽會、台北美術獎、國家文藝獎、關渡雙年展、台新藝術獎、科技藝術節 ... 等大型展覽視覺設計。曾入選靳埭強設計獎、臺灣視覺設計獎、APD亞太設計年鑑、K.T.科藝獎等獎項,並受邀參加臺北世界設計大展「潮間代」、2013貳零壹肆傑出華文漢字設計作品展、CO6臺灣前衛展。

Liu, ming-wei , a visual designer who Born in 1981. Graduate School of Arts and Technology, Taipei National University of the Arts.Early co-founded 'DESIGNER+ARTIST" with his wife. Then officially established " DESIGNER+ARTIST " in 2011. DESIGNER+ARTIST emphasize visual sharpness and clean-out feel of their design give abundant willpower to simplicity. They also hope that their heartfelt design can inspire every austere soul to examine closely. There works across range of Book design, Web design and Visual design of large exhibition.
Executed visual design of many large exhibitions such as Kuandu Arts Festival, ART TAIPEI, Taipei Arts Awards, The National Awards for Arts, Kuandu Biennale, Taishin Arts Award Exhibition, Digital Art Festival, etc. Has selected Kan Tai-Keung Design Award 2012, The Graphic Design Association of the Republic of China, Asia-Pacific Design, K. T. Creativity Award-Entry Award, and has invited to join Taipei World Design Expo 2011 - INTERTIDAL AGE - Taipei, 2013 Outstanding Chinese character Design Works Invitation Exhibition, Taiwan Avant-Garde Documenta III - CO6.

為生命帶來深沉的存在感，以記憶作為一個開啟自我的關鍵，重新回顧自己過去的追尋，面對那些失去的形體相貌，試圖停留亦或阻撓，於是蒐羅與排列組合那些缺席的事物。

To bring a deep existence for life , the memories as a key to open myself, and revisit my pursuit of past. Facing those lost of shape and appearance, I tried to stay or obstruct it, so I collected those absent things and combinated them.

第八屆台新藝術獎，此屆為第八屆，客戶希望傳達當代藝術的精神，我將目前當代藝術，不受任何媒材與不受任何的內容表現之特性，與第八屆的數字 8 橫放，在攝影上即時無限遠的意思，以這兩個概念，運用在此次的視覺設計上，對客戶提出 " 無限度 " 這個主題，無限度可以是很遙遠也可以是不受限。

The 8th Taishin Arts Award Exhibition, the customer wanted to convey the spirit of contemporary art, so I try to highlight the feature of contemporary art, which do not limited by any mediums or content, and I placed the"8"horizontally to represent the meaning "instant infinity" on photography. I used these 2 concepts on visual design, and advise customer this theme: "Infinite", it can be a meaning of far or unlimited.

no

■ 請問您如何獲得靈感？

因為學歷背景的關係，我大部分的案子多是展覽視覺，通常一個展覽都會有主題、論述、作品，所以我大多會先從這三點去找，看看自己對主題有什麼看法，再去看展覽論述有提到什麼關鍵字，再參考作品的類型與內容，綜合這三點去構思該用什麼方法去設計，或是將關鍵字 google 看些圖片刺激，也有時候會直接由電腦試排，有點像畫畫一樣編排邊想邊改，滿意就留下，做的不滿意就先放著幾天，放著幾天中，其實從醒著到睡前甚至睡著，心裡都會掛著這件事，看到什麼就會趕快記起來，然後隔天再由電腦去執行看看，所以我還滿常常提案前一天才作出稿子來……

■ 請問您做過最瘋狂或最酷的事情是什麼呢？

讀復興商工時，拿三秒膠灌老師車子的車門。

■ 請問您一路以來的創作歷程（與創意／藝術／設計／插畫的邂逅，踏上這條創作路的歷程，旅途上遇見的瓶頸與突破方式）

其實我復興商工讀的是夜間部，讀了四年有三年都在改車撞球，最後一年才開始認真學習，後來也是因為推甄成績讓我可以讀東方技術學院 (室內設計)，老實說南部的二專也是玩了兩年，唯一不同的是我常蹺課就是在租屋處學自己喜歡的軟體，從網頁學到 FLASH 動畫，插大有嘗試去考視傳科系，但都沒上，反而考上了銘傳建築，從建築設計裡學到了很多，從基地分析學習分析資料，厚紙板模型學習空間構成，也從實際的建築學習寧靜的美感，不過後來因為身體不適讀了一年就休學了，後來我就在家邊接案又因興趣邊學了 AE 特效以及 3D，後來我女友慫恿我去考北藝大的科技藝術研究所，結果考上了，老實說在校我也大都跟過去一樣沒什麼在學習，或許是因未考上的科系都不是我心目中的第一志願，所以我學習歷程中有一半是在學校，有一半是在家裡，直到我研究所畢業決定專精在平面設計上，我開始買書自學我所不會的，曾經羨慕過就讀視傳的學生，甚至很想知道視傳都上什麼課，但慢慢年紀大就不會了……，我想曾學過的建築與藝術或許也是一種養分。

How do you draw the inspiration?

Because of my academic background, most of my cases are visual of exhibition. As usual, an exhibition may have its theme, description and works, so I draw inspiration from these three aspects. To see what I think about the theme, and then find keyword from Description, finally I would consult the type and content of works, combine these three aspects to think how to design it, or just google keyword to find some pictures that are inspiring, sometimes I type directly from computer, I correcting my work while designing, in a way rather like painting, if I don't satisfy with the work, I would place it for a few days, form awaking to sleeping I always keep the work in my mind, when seeing something inspiring I would commit to memory, then conduct on computer the next day, so I usually finish my works in the previous day of proposal.

What is the craziest or coolest thing you have ever done?

When I studied in Fu-Hsin Trade & Arts School, I filled the super glue into teacher's car door.

Share the story of you creating your pieces. How did you encounter with creativity/art/design/ illustration? And what happened? Have you ever been stranded at a bottleneck? And how did you overcome?

In fact, I studied in Evening Division of Fu-Hsin Trade & Arts School before, and spend three years on modifying scooters or pooling in those four years, finally I started studying in last year, then I studied in Department of Interior Design of Tung fang Design Institute, for recommended. Honestly, I also played when studying at two-year college, the only difference is that I often skipped school and studied software in my residence from websites to Flash. I failed to pass the exam for Department of Visual Communication Design, but I was admitted to Ming Chuan University Department of Architecture, I have learned a lot from there, learned to analyze date from site analysis, learned to do spatial composition from cardboard models, also I learned the aesthetic of serenity from architecture. However, I dropped out after one year because of my illness, then I got project at my home and learned AE and 3D myself, and later my girlfriend encouraged me to test into Graduate School of Art and Technology , and I did it. But I didn't study as usual, perhaps is that those department are not my first choice in my mind, so half of my studying histories are in school and half are in home, until I decided to focus on graphic design after graduated from graduate school, I started to buy textbooks and learn the parts I didn't know; I used to envy of the students who studied in Department of Visual Communication, even wanted to know what course they studied, but slowly I would not care anymore when got old......, I think maybe the architecture and art I have learned are also a sort of nutrient.

蘇琬羚 Erica Su

https://www.behance.net/13smile *dieerica@gmail.com*

畢業於雲林科技大學研究所 , 作品曾入選 2013 adobe design achievement awards /illustration category / finalist、2013 adobe design achievement awards /print communications / finalist、2013 6th Skopje international student poster competition /50 finalist、2012 Taiwan poster awards / finalist ... 等獎項 , 近年作品收錄於《APD 亞太設計年鑑 no.9》、《EAT & GO》、《Hanzi Kanji Hanja》等設計年鑑當中。

Graduated from National Yunlin University of Science and Technology Institute. Works have selected 013 adobe design achievement awards /illustration category / finalist, 2013 adobe design achievement awards / print communications / finalist, 2013 6th Skopje international student poster competition /50 finalist, 2012 Taiwan poster awards / finalist, etc. Also her works were published by Asia-Pacific DesignNo.9, EAT & GO, Hanzi Kanji Hanja and so on.

1　　2

1/ 以漢字「人生、性、牲」探討人與牲畜間的異同，人與牲相同為世界上的 " 生 " 物，卻有不同部首的區別，有人部的人類、有牛的牲畜肉類。文字為人類所創使用，用來溝通與建造同時也帶來戰爭與爭吵，牛部的牲畜，通常被人類豢養被作為食物，肉類的來源，亦即為人類所訂定的分別，是怎樣的權利和演變使得人類變為主宰一切生物的主呢？

Using Chinese characters "life," "sex," and "animal" to explore the similarities and difference between human and animal, they are the same as the creature 'living' in the world, but their Chinese characters are different with their radical, human's radical is "people(ren)," and animal's radical is "caw(niu)". The characters are used by humans to communicate and construct, at the same time characters bring the war and brawl. On the other hand, animals are raised by humans as food, the sources o meat, they are also formulated by humans. How the right and evolution have made humans became the lord of creatures?

2/ 藉由冰溶化成水的轉變帶出溫室效應所造成生命消逝的過程。遠方流動而來的冰山碎片，近看卻是奄奄一息的北極熊們， 隨著海水漂流著向下流動，如同冰塊逐漸融化凋零，地球也同時落下了眼淚。

The creation show the vicious circle effect of global warming by moving around of earth. First time, an iceberg is melted and result to the polar bear die. After that the earth is fading away.

臺灣　Taiwan

Filter017

filter017@gmail.com

Filter017 創作團隊自 2004 年開始從事追逐夢想的奇幻工作，一路秉持著 99% 對創作的熱情，擅長將生活元素加以混合，創造出新鮮的圖像，目標是將獨一無二的圖像設計延伸到所有可能的設計範疇內！

Filter017 created since 2004.
Our team consists of Mixed Sauce & Wonder Work + 99% passion towards creation.We infuse unique graphics into all kinds of design.

1 2

1/2012 年 Filter017 推出了 "FCL OUTDOOR LAB 主題系列，在此主題下延伸混合創意，包括旅遊、戶外休閒、墾趣、童軍、野外求生、民族文化 … 等等方向，進而導出自我挑戰與環保議題的省思，也鼓勵文明的都市人群，在工作之餘，多多走向戶外，感受地球僅存的自然之美，進而喚醒人們對自然保護的意識，以及自我價值的肯定！

In 2012, Filter017 launched its subsidiary line, "FCL OUTDOOR LAB."This series embodies vintage American outdoor styles fused with ideas about leisure, travel, outdoor activities, and exotic cultures. Furthermore, this was incorporated with the themes of introspection, self-challenge, and environmental protection. The effort encourages civilized human beings who live in cities to go out and enjoy the beauty of nature instead of being consumed with work and technology. It also brings into our consciousness the importance of protecting Mother Nature and inspires people to challenge their limitations.

2/ 將 Filter017 從 2008 年到 2010 年所有的設計角色圖像集結成 Razzle Dazzle 海報。

We collected from 2008 to 2010 all characters design assembled into a Dazzle Razzle poster.

臺灣 Taiwan

彭冠傑 Jay Guan-Jie Peng

www.jayguanjiepeng.com *mail@jayguanjiepeng.com*

彭冠傑 (Jay) 是一位以臺灣台北為根據地的平面設計師。 於澳洲墨爾本皇家理工學院畢業之後，他便開始承接各類型案件，
同時也繼續進行個人的設計創作。他的作品曾收錄於 APD 亞太設計年鑑 (中國)、Asian Creatives (日本)、亞洲青年創作
平台 (香港)、新平面雜誌 (中國)、Imprint 2 (中國) 等設計出版物中。

Jay Guan-Jie Peng is a graphic designer based in Taipei, Taiwan. After the graduation from RMIT University
(Royal Melbourne Institute of Technology, Australia), he starts to work as a freelancer and also keeps working
on self-initiated projects. Some of his projects have been published in international design publications such
as Asia Pacific Design annual a.k.a. APD (China), Asian Creatives (Japan), Apportfolio Asia (Hong Kong), NEW
GRAPHICS magazine (China), Imprint 2 (China), etc.

這是利用個人肖像所延伸而出的實驗性海報系列作品。

A self-initiated poster project based on a simple portrait illustration.

1/ 為了臺灣知名藝術家梅丁衍於藝廊藝術計劃 (Art Issue Projects) 舉辦的個展所設計的海報。
A poster designed for famous Taiwanese artist Dean-E Mei's solo exhibition at gallery Art Issue Projects.

2/ GLYPH 是一本季刊雜誌，它以介紹優秀的字體設計作品以及字體學 (typography) 相關的技巧及知識為主要內容。
GLYPH is a quarterly magazine focuses on showing excellent typography design and introducing skills and knowledge.

■ 請問您對於「創作」所擁抱的理念是什麼？從以前到現在, 是否有所轉變？

我希望能夠持續創造出新的視覺與形式上的意義，雖然這在這個時代並不容易，但我仍在努力嘗試，即使有時候製作出的圖像不具有實際意義，但過程中的象徵意義對我來說更為重要。

■ 請問您認為該國最棒的是什麼？（如國家的特色或文化等）您的創作是否受其影響？

我認為臺灣的生活環境中充滿許多有趣的配色以及視覺圖像，只是仍待設計師轉化及應用。我認為自己目前的作品並未受到明顯的臺灣文化的影響，或許一方面是因為我們的國家尚未將自身文化相對應的設計風格與狀態轉化成熟，另一方面則是因為我成長於網路世代，生活經驗中充滿其他國家文化的影響，導致我的作品並未特別俱有國家特色，但我也在一路學習的過程中持續思考如何與自己生活的時代及環境聯結。

■ 請問您一路以來的創作歷程（與創意／藝術／設計／插畫的邂逅，踏上這條創作路的歷程，旅途上遇見的瓶頸與突破方式）

開始對圖像設計產生興趣是來自於 Müller-Brockmann 的 Grid System 一書，國際主義風格對我的影響甚大，網格系統曾經是我認為世界上最美且最有力的圖像規則。而在走過一段歷程後，我發現視覺圖像設計是包羅萬象且學無止盡的一門領域，因此也期望自己能於工作同時持續吸收與學習。

■
我 毫無實質意義但
有 任意一個關鍵字
在 使用的元素收藏
在 我會把電腦關
掉

■ 請 是什麼呢？

我 制自己的意識與
身 身體變形，我覺得滿帥的。

■ 請問您最近最想什麼事情？是否已經著手規劃下一階段的目標或突破了呢？

最近有一些展覽及活動的想法在醞釀中，但仍在尋找合作對象與適當機會。同時也希望能多認識一些同世代的設計師們，或是很酷的人。

What is your "main idea" while producing a piece/series of work? Have it ever changed before?

I hope I can continue to create new meaning of vision and form, although it is not easy in this age, but I'm still trying, even sometimes the images I made do not have practical significance, but the symbolic meaning of process is more important to me.

What is the best thing in your country? (likes features or culture)
Have it ever influence your creation?

I think Taiwan's living environment is full of many interesting color and visual images, but wafting for designers to convert and apply. I think my works have not been influenced by Taiwan's culture obviously, perhaps is that our country has not transformed the culture to a relative mature design style so far. One the other side, I grew up in the Internet generation, my life experience has influenced by other countries' culture, resulting my works that don't have national characteristics, but I am continuing to ponder how to link with our time and environment in the process of learn.

Share the story of you creating your pieces.
How did you encounter with creativity/art/design/illustration? And what happened? Have you ever been stranded at a bottleneck? And how did you overcome?

I started interesting in graphic design from a book "Grid System" written by Müller-Brockmann. The International style affected me a lot, I think the most beautiful and powerful graphic rule in the world is the grid system. And I found the visual graphic design filed is all-encompassing and endless, so I wish myself to learn and study while working.

How do you draw the inspiration?

I will read a lot of meaningless but funny images, videos and articles on the web, or search a random keyword on Google, and collect these elements in a folder. If I still have no idea, I will turn off my computer and go jogging or go around the street.

What is the craziest or coolest thing you have ever done?

A few months ago I controlled my awareness and stature in a lucid dream, and I can deform my body, I think it was cool.

What are the things you want to do most these days? Have you started to set up new goals or breakthroughs for next period?

Recently, I have some ideas of the exhibitions and events, but I am still seeking for the partners with appropriate opportunity. I hope to meet more designers in same generation, or some cool guys.

 Jing Group

www.jing-group.com service@jing-group.com

青團隊有著多元化的設計經驗，成員來自國內知名設計公司、品牌公司、國際科技公司，亦曾服務於國立藝術館及接洽政府專案 等，經驗十足。
他們重視與企業主交流，了解品牌與產品間的故事；認真看待每個案件，就像回到初心般的熱忱；對此，以一貫之的態度，是青團隊凝聚的原因。

Jing group has a wide range of design experience. Members from the well-known design companies, brand, international technology company, and has served on the National Museum of Art, also approached the government project, etc. full of experiences.
They focus on the communication with the client, to understand the story of the brands and the products. They take each case to heart, with the enthusiasm just like back to the beginning. Thus, the consistent attitude is the reason link jing group together.

PANTONE
7534 C

PANTONE
335C

毛孩的蔬果樂園，是毛孩最嚮往的田園生活，一起呼朋喚友，享受一片在地自然栽作的健康食材。
Natural 10 is a brand which provides the freshest food for your furry friends.
The life in vegetable yard is what the furry friends desire the most, and they can enjoy the local natural healthy food with good buddies.

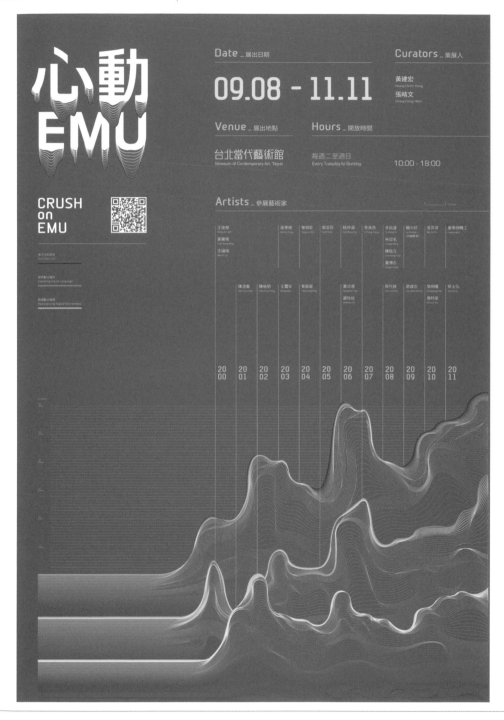

展覽將台灣近十年科技藝術領域作品集結，以紀實及回顧為其展出型態，如此展覽的風貌，該如何種方式投射到設計上？我以資訊可視化 (datavisualization) 的方式將國內新 媒體藝術發展十年的資訊依類別化作圖表，波形的圖像從視覺上傳達策展人所描述：「未知航道」的意象，亦呈現藝術的數位型態。

"Crush on EMU" is co-curated by curators, Huang Chien-Hung and Chang Ching-Wen. While the title, EMU, uses the initials of Electronic-Mobile-Ubiquitous to point out the change and formation of the three stages of the digital era, it also simultaneously corresponds to the French term, ému (as in "Je suis ému"), as an epitome of modern peoples' reliance on the humanitarian environment and vision of the new digital technology.

■ 請問您對於「創作」所擁抱的理念是什麼？從以前到現在, 是否有所轉變？

創作時探索細節的習慣沒變，隨增長的經驗，現在反而會讓自己稍微「粗心」，有時候過於細膩容易鑽牛角尖，不時張望四周，減緩神經緊繃，也探訪一下大格局，增加自身感受度。

■ 請問您認為該國最棒的是什麼？（如國家的特色或文化等）您的創作是否受其影響？

每個地點都有很豐富的文化。臺灣因為地較小，從甲地到乙地車程相對較小，每個地點在在都顯示其特色。又尤其在發展上曾經歷代工時期，二級工業產業在國內對容易找尋，對近期這股 maker 風氣，臺灣在亞洲並不失世界潮流的新創力。

■ 請問您一路以來的創作歷程（與創意／藝術／設計／插畫的邂逅，踏上這條創作路的歷程，旅途上遇見的瓶頸與突破方式）

從很平面經驗轉介到網路思維。瓶頸是一直存在的，畢竟香檳噴灑出的過程，這是必經的道路。

■ 請問您如何獲得靈感？

靈感來自閱讀以及和他人交流。每項個問題點，其實答案就在發出疑問的人身上。我們的角色在於聆聽與回覆，從他人講述問題中，點出他們自己都沒發現的答案。譬如設計師的自身創作之於自身探索，而業主的需求亦同，往往在相互對答中出現。

■ 請和我們分享您喜歡的書籍、音樂、電影或場所

比起某某大師告訴你怎麼做，know-how 的書籍更讓我們喜歡。尊敬的日本設計師——杉浦康平 老師 著作之對談集「亞洲之書‧文字‧設計」至今是收穫最多的書籍，無非來自智者們對談流露的珍貴寶藏。
音樂，則與設計同屬感受性的創作過程，最喜歡 indie rock。主流音樂我們抱持欣賞及學習，而 indie 音樂豐富見聞探索。

■ 請問您最近最想什麼事情？是否已經著手規劃下一階段的目標或突破了呢？

across. 般的混種交流。設計師相遇是意趣相投的一群人做事，那是講究某個領域的完美之結果，但在傳遞給眾人的目標下，更期望跨界與不同領域的人們進行合作，目前正與工程師或在職業上屬互補端的同伴們進行合作。

What is your "main idea" while producing a piece/ series of work? Have it ever changed before?

The habit of exploring the details when creating has never changed, but with the growth of experience, now we are try to make ourselves to be "uncareful", sometimes we are too careful on details that it will be beating a dead horse. Then we will look around from time to time, it helps ourselves relaxing, and increasing our feeling when we visit the overall pattern.

What is the best thing in your country? (likes features or culture)
Have it ever influence your creation?

The rich cultures everywhere. Because of the small territory, it is near to go from A place to B place by car in Taiwan. Each place has its feature. In particular, Taiwan's history once had the period of Original Equipment Manufacturer before; it is relatively easy to find secondary industry at home, as to the recent trend of "maker." Taiwan does not lose the new creativity of global trend.

Share the story of you creating your pieces.
How did you encounter with creativity/art/design/ illustration? And what happened? Have you ever been stranded at a bottleneck? And how did you overcome?

From the flat experience transfer to network thinking.
The bottleneck has always exist. After all, the spaying process of champagne is a necessary way to pass.

How do you draw the inspiration?

My inspirations come from reading and talking to others. In fact, the answer lies in the people who ask.
Our role is to listen and reply to them, point out the answer they can't find themselves through the process they describe the question. For example, designers explore themselves to create, so as the client, the answer is the question.

Share good books/music/movies/places with us.

We prefer the know-how books than XX master told you how to do.The respected Japan designer - Sugiura Kohei. So far, we has gained the most from his book " 亞洲之書‧文字‧設計 ". The dialogue of wises is nothing less than a precious treasure.
Music is a sensitivity creative process like design, we like indie rock most. We appreciate and learn from pop music, and indie music rich our horizons.

What are the things you want to do most these days? Have you started to set up new goals or breakthroughs for next period?

Across conversations. The group of designers is people work together with the same interest, it is a perfect result of paying attention to one field. But in the target of conveying to the crowd, we want to cooperate with people from different field, currently we are working with engineer and so on.

洋蔥設計 Onion Design Associates

andrew@oniondesign.com.tw *feverchu@gmail.com*

黃家賢,香港出生,畢業於 University of Houston, 主修平面設計與字形學。1999 年在台北成立洋蔥設計,作品「泥灘地浪人」入圍第 57 屆美國葛萊美獎「最佳唱片包裝」,入圍 25 屆金曲獎「最佳專輯包裝獎」。除設計之餘,尚於學學文創 開授 Typography 課程,同時參與田田圈文創工作群之裝置創作和策展工作。策劃活動包括「黑鄉作樂音樂節」、「台北村落之聲入口網站」平台、與龔維德共同策展「瘋字形 - 文字藝術創作展」等。

Andrew Wong is co-founder of Onion Design Associates, a multi-disciplinary design studio in Taipei, Taiwan. He culti- vated a passion for typography while studying graphic design at the University of Houston, and has worked in Houston, his native Hong Kong and his current base of Taipei, where he has lived since 1997. When he's not teaching typography at Taipei's prestigious Xue Xue Institute or leading his team at Onion on a wide range of both commercial and non-profit projects, Andrew exerts his creative whims with Tien Tien Circle Creatives, a group of artists, architects and designers devoted to exploring the connections between design, modern society, and interior spaces.

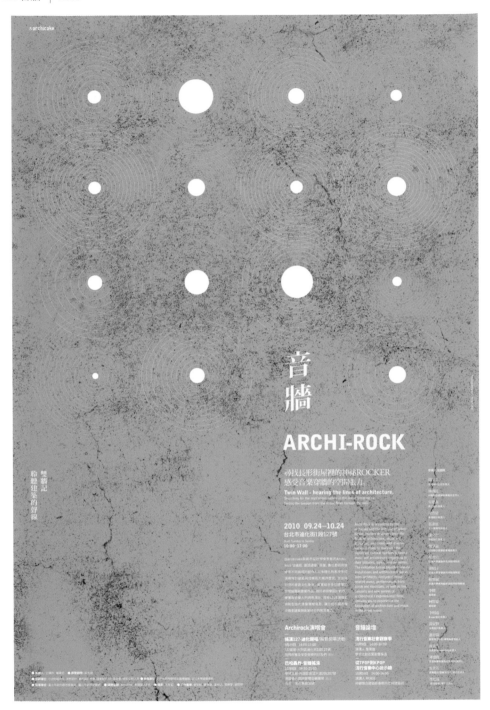

ArchiRock 為一個跨界合作的展覽；大膽的結合音樂、藝術、設計與建築界專業人士一同參與。共同為這個 空間注入強大而美好的力量。 創意的開端來自展覽場地：127 長屋，來自一座座的長牆，藝術與建築，設計 與音樂穿越厚牆，穿越藩籬與界限，穿越人的距離，那聲線彷彿從畫面中的灰牆似強還弱地躍出眼前。

Archi-Rock is organized by the archicake and the institute of urban design, inviting designers from the fields of architecture, visual art, digital art, and music with diverse interpretations to representthe significant cultural symbols between music and architecture regarding their histories, styles,and emories. The exhibition brings together several installations and architectural works fromarchitects, designers' music related works, perfor- mances from bands and musicians, as well aslive concerts and new genres of achitectural / experimental films, allowing you to experience the fascination of architecture and music in the street house.

沈子淮 Shen ZI-Huai

https://www.behance.net/sumpdesign *sumpdesign@gmail.com*

沈子淮 Zi Huai Shen Tainan/Taiwan。1985 年生。崑山科大視覺傳達設計系畢。平面設計師。專注於品牌、包裝、各項平面視覺設計工作。曾獲 2009 金點設計獎與 2010 臺灣視覺設計獎等獎項,並獲選上海設計師俱樂部５０／１００新銳——全球 80 後 100 位華人設計師。作品入選貳零壹參 - 傑出華文漢字設計作品展及收錄於 2013APD 亞太設計年鑑、TOPGRAPHICDESIGN 等設計專書。現為 SUMPDESIGN 創意總監。

Zi-Huai Shen, 1985 was born in Tainan, Taiwan. He graduated Kun Shan University Visual Communication Design Taiwan (R.O.C.) in 2009. Graphic designer, areas of expertise for the brand, packaging, visual design of the graphic design work. has gotten the 2009 GOLDEN PIN DESIGN AWARD /Golden Pin Design Mark International Visual, Golden Prize for Taiwan Visual Design 2010, and Was selected as one of the 100 Outstanding Post-80s Chinese Designers in 2012 SHDC-50/100 Cut-ting-edge Exhibition, 2013 Outstanding Chinese Character Design Works Invitation Exhibition, 2013 ASIA-PACIFIC DESIGN NO.9 , World Top Design Year Book 2011. SUMP DESIGN, Creative Director

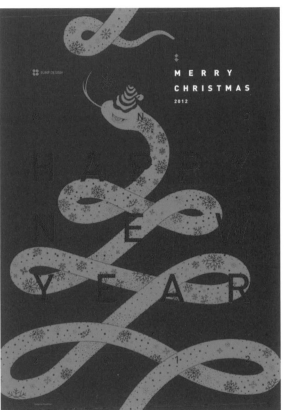

1 2

1/ 晨曦 - 黎明時刻，一天之中最早的陽光，語意希望；花悅 - 花開延展的生命力，美好愉快。兩者結合，語意早春初始，充滿無盡希望令人愉悅！
Dawn - the first sunlight in a day which represent the hope; flowers - the bloom extending the power of life, which brings beauty and happiness. These two words combined together are the semantics of early spring, they are full of endless hope and delightful!

2/MERRYCHRISTMAS 2012 - 東方蛇年造型與西方聖誕樹造型做結合，從聖誕節的歡樂延續到蛇年的過年節慶氛圍，運用現代手法將兩者結合，構成強烈的視覺張力。
MERRYCHRISTMAS 2012 combined the shape of Eastern Snake Year and Western Christmas tree, and lasted the joy atmosphere of festival from Christmas to New Year. Used modern way to combine two of these festival, and construct a strong tension of visual.

廖恬敏 Tien-Min Liao

tienminliao.com *tienmin.L@gmail.com*

臺灣台北出生。2013 年畢業於紐約普瑞特藝術學院溝通設計研究所。目前於 Siegel+Gale 品牌設計策略公司紐約總部擔任設計師,同時在庫柏聯盟設計學院進修字體設計學士後學程。

Tien-Min is a New York based designer focused on graphic design and branding with enthusiasm for typeface design. In 2013 she received her MS in Communication Design from Pratt institute. Her work has been featured in many design portals, magazines and design annuals, such as, IdN magazine, Asia-Pacific Design Annual, The Typographic Universe and many. She has also been profiled in "Asian Creatives: 150 Most Promising Talents" published by PIE Books, Japan. She is currently working at Siegel+Gale and attending the postgraduate typeface design program in The Cooper Union.

QUOTES ON PASSION

lettering by TienMin Liao

一系列實驗性的 letting 海報 , 測試「單寬度的線條」的 letting 在複雜情況下的可辨識性 (legibility)。 利用顏色界定字母和裝飾線條的界限。
並將原本只具有功能性顏色的延伸為整體風格。

A series of experimental lettering poster that challenges the legibility of mono-width lettering. Instead of separating the letters
and swashes by their stroke width, color is playing the role of differentiating the forms here.

臺灣 Taiwan

吳穆昌 Wu Mu-Chang

http://cargocollective.com/murphywu aa6655230@gmail.com

2014 年畢業於臺南崑山科技大視覺傳達設計研究所，近兩年致力於人權議題相關之視覺平面創作，並專注於以感性、有機型為主等手繪媒介作品。並於 2011 年獲選為上海 50/100 新銳展 - 全球 80 後 100 位華人設計師之一。作品曾先後於澳門、廣州、上海、四川、臺灣、美國、韓國等地參與展覽、競賽獲獎，並陸續曝光於 Asia-Pacific Design、APPortfolio、Graphic Arts Bimonthly、CUTOUT Magazine、Portfolio Design、Computer Art Issue、Art in Book 等書籍。

Get into the Institute of Visual Communication Design of Kunshan University in 2011, researching in graphic design. For nearly two years, specially working on the issues of social human rights as the researching direction. And selected as one of the 100 outstanding post-80s Chinese Designers in 2012 SHDC-50/100 Cutting-edge Exhibition. Works have been displayed, competed or awarded in Macao, GuangZhou, ShangHai, SiChuan, Taiwan, USA, and Korea etc. Works have also been included in "Asia-Pacific Design", "APPortfolio", and "Graphic Arts Bimonthly", " CUTOUT Magazine", "Portfolio Design", "Computer Art" .

In this design, I experimented with using the face to symbolize a person's identity, status, gender, or ethnicity. The face is then blurred to visually create an image to stare silently into the biological characteristic of the "red hair", mocking our conformity to societal structure created by our experiences allowing us to see only the specific differences we chose to see. The red hair strands are like thorny vines wrapping around everyone as if they were born in sin, thus causing suffering from social inequality and discriminating repression.

詮釋西方社會對紅髮人仍存在的歧視為題，設計師藉由獨特的視覺表現處理，使畫面靜默地凝視其生物性特徵，諷刺現代社會藉由所建構出的規則而凸顯出的異處，使髮色如同荊棘般的在此族群中纏繞猶如與身俱來的原罪而有所壓抑。

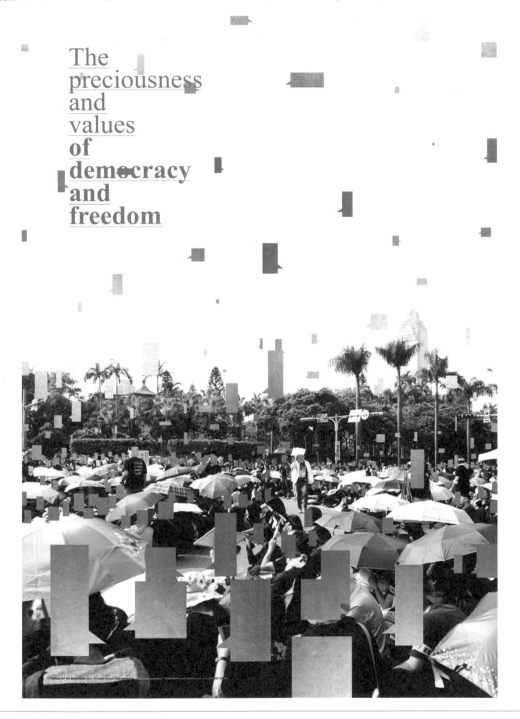

從臺灣學運看見言論因著民主自由下的珍貴如同金子一般，設計師在畫面上便以此金屬質地呈現大大小小的聲音，此起彼落地散落在畫面中，看似向上擴散至各地將聲音傳播出去，又如來自八方群聚於一地共同發聲的概念。

Every word was priceless, like gold, so precious, so valuable. This image uses metallic materials to present the textures of voices. Between action and settlement, voices were scattered throughout the image. It conceptually seems like the voices congregate and spread to every single corner, but united at one place from all places. Talks, because of democracy and freedom, make the rights people fight for more glorious. Chromatically, the black-and-white background makes the importance of the voice stands out. The dialogue between the peaceful and rational crowd in the image and the vibrant passion within their hearts creates a strong contrast.

■ 請問您對於「創作」所擁抱的理念是什麼？從以前到現在 , 是否有所轉變？

身體像是一只感知的容器，分別裝載著視覺、聽覺、嗅覺、觸覺以及味覺，當滿載時就要懂得尋求一個出口，這是一種自然而然的出和入的關係。從來就不因為什麼，也無須去改變些什麼。

■ 請問您如何獲得靈感？

現階段是游泳，我覺得我在水裡總是能夠特別放鬆並且想些有的沒的，總之做些與目前最重要卻無關緊要的一些事情，別讓自己待在同個狀態裡太久。

■ 請和我們分享您喜歡的書籍、音樂、電影或場所

最近在看的書是原研哉的《為什麼設計。》、音樂是原住民的合音表演、電影滿喜歡看些關於時尚、時裝產業的紀錄片、傳記等。至於場所，我認為台南有許多老屋欣力的案子都挺不錯的。

■ 請問您做過最瘋狂或最酷的事情是什麼呢？

至今仍沒有做過瘋狂或是最酷的事，我覺得這就還滿酷的。

■ 請問您最近最想什麼事情？是否已經著手規劃下一階段的目標或突破了呢？

2015 年年初因緣際會下來到臺東服役，過了跟以往很不一樣的生活也認識很多原住民朋友，記得高中畢業後因為求學與實習的因素曾經在苗栗、新竹、臺南生活一段時間，也常在台中高雄兩地往返 , 對於這些城市有了很多感動是不同於從小就熟悉的臺北。退伍後，我會特別針對這些地方與臺灣特有的原住民文化、傳說作為新創作的題材。

What is your "main idea"while producing a piece/ series of work? Have it ever changed before?

Body is like a vessel of sensibilities. It contains five senses: sight, sound, smell, touch and taste. When all of the senses are occupied, they need an exit to release: this is a natural relationship of input and output. It does not need a reason or to be changed.

How do you draw the inspiration?

For now, I search for inspiration by swimming. I feel like staying in the water relaxes me and keeps my mind clear. All in all, I will do something important, but irrelevant. I do not stabilize myself in the same situation for too long.

Share good books/music/movies/places with us.

I have been reading Dialogue In Design by Kenya Hara X Masayo Ave, listening to Taiwanese aborigine chorus and watching fashion-industry-related documentaries or biographical movies. As for places that I like, I think a lot of "Old House with New Life" projects in Tainan are pretty good.

What is the craziest or coolest thing you have ever done?

I have not done anything crazy or cool yet, which I think is pretty cool already.

What are the things you want to do most these days? Have you started to set up new goals or breakthroughs for next period?

Coincidently I came to Taitung to serve my military duty at the beginning of 2015. I am living a different life than before, and I have met a lot of aboriginal friends. I still remember the time after I graduated from high school; I had lived in Miaoli, Hsinchu and Tainan for a while for schooling and internships purposes. I had traveled back and forth between Taichung and Kaohsiung often. So the emotions for these cities are different from Taipei, where I was raised. After my military service, I will use these cities, combing Taiwanese unique aborigine cultures and folk tales, as my new creating materials.

CTA∙ **Apr. 2015 no.1**

CTA 亞洲創意對話 Creative Talk in Asia

總編輯 Chief Editor	陳育民 Chen Yu Ming
編輯團隊 Editing Team	張立妍 Chang Li Yen
	張芳瑀 Chang Fang Yu
	張譽靜 Chang Yu Ching
	程婉菁 Cheng Wan Jing
出版者 Publisher	陳育民 Chen Yu Ming
地址 ADD	807-72高雄市三民區汾陽路20號一樓 1F., No.20, Fenyang Rd., Sanmin Dist., Kaohsiung City 807, Taiwan (R.O.C.)
電話 TEL	0926-600-147
出版時間 Publishing Time	104年4月 Apr. 2015

國家圖書館出版品預行編目(CIP)資料

CTA亞洲創意對話／陳育民總編輯.--高雄市：陳育民,民
104.04
面；公分
中英對照
ISBN 978-957-43-2468-2(精裝)
1.設計 2.創意 3.亞洲
960 104008158